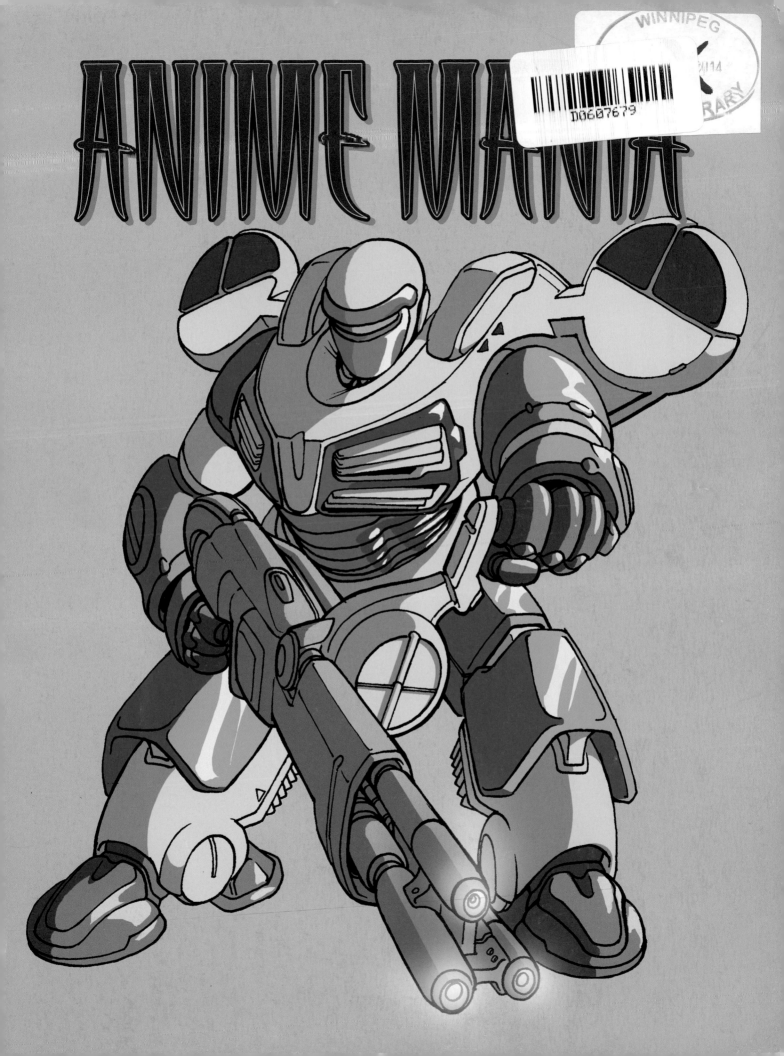

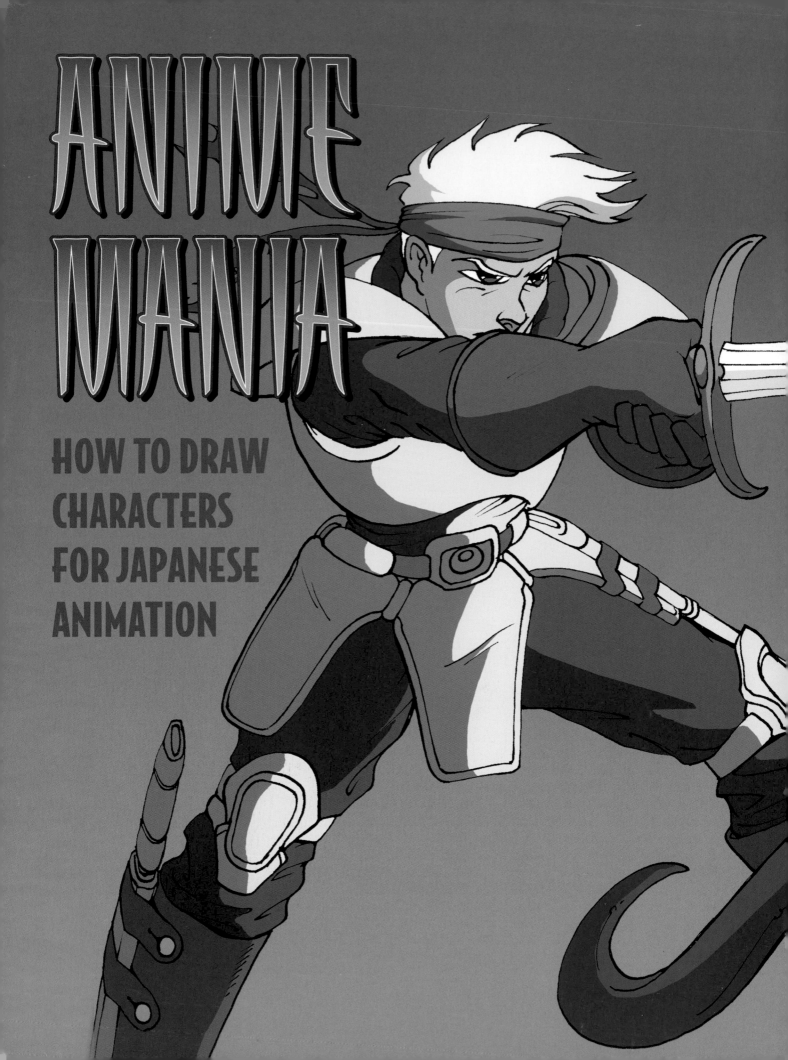

ANIME MANIA

HOW TO DRAW CHARACTERS FOR JAPANESE ANIMATION

CHRISTOPHER HART

WATSON-GUPTILL PUBLICATIONS/NEW YORK

To all present and future anime artists,
who with only a pencil in hand, save the earth
from giant robots, evil demons, and other cool enemies

SPECIAL THANKS TO:

BILL FLANAGAN
of Viz Communications,
for lending his expertise;
HIROMI HASEGAWA,
for her generosity
and helpfulness;
MAHIRO MEADA,
for sharing his valuable
insights with my readers
in an exclusive interview;
and, of course, everyone
at Watson-Guptill Publications,
for making this book possible.

CONTRIBUTING ARTISTS:

Colleen Doran: 34 (bottom left), 44, 53 (left), 54–58, 64–67, 102, 130, 132
Lee Duhig: 1, 2–3, 59, 68–69, 71–73, 84–89, 92–101
Christopher Hart: 132–138, 140, 142
Mike Leeke: 8–27
Ruben Martinez: 6, 28–35, 52, 90, 91, 118–123
Pop Mhan: 36–43, 45–51, 53 (right, top and bottom), 60–63
Howard Shum: 9 (inks), 10 (inks)
Sean Song: 103–117, 124–129
Dave White: 70, 74–83

Color by J. J. Abbott, Brimstone

Senior Editor: Candace Raney
Project Editor: Alisa Palazzo
Designer: Bob Fillie, Graphiti Design, Inc.
Production Manager: Ellen Greene

First published in 2002 by Watson-Guptill Publications
Nielsen Business Media, a division of The Nielsen Company
770 Broadway, New York, NY 10003
www.watsonguptill.com

Library of Congress Cataloging-in-Publication Data
Hart, Christopher.
 Anime mania : how to draw characters for Japanese animation / Christopher Hart.
 p. cm.
 Includes index.
 ISBN 0-8230-0158-X (pbk.)
 1. Comic books, strips, etc.—Japan—Technique. 2. Drawing—Technique. I. Title.
 NC1764.5.J3 H369 2002
 741.5'8'0952—dc21

 2001006388

Manufactured in China

4 5 6 7 8

VISIT US AT
www.artstudiollc.com

CONTENTS

INTRODUCTION

Anime, that unique style of animation that is distinctly Japanese, is everywhere—and growing in popularity. Even if you're not a die-hard anime fan, you've no doubt seen such famous anime as *Digimon, Sailor Moon,* and *Pokémon.* The Cartoon Network's popular *Toonami* show features tons of anime. Many westerners were thrilled by *Princess Mononoke,* Hayao Miyazaki's animated feature film, which was released in the United States to wide acclaim. And all over the country, anime imports can be found in video stores.

What makes anime such an instantly recognizable style? Certainly, the character design is unique, focusing on large eyes and subtle features. But beneath it all is a philosophy that captures the essence of the anime spirit.

Western-style animation expresses itself primarily through movement. The more a character moves, the "better" the animation is thought to be. So, it's not surprising that animation producers in the West typically redesign comic book characters for television, simplifying them to allow for greater movement. Although anime characters are also licensed from comic books, emphasis is placed on retaining the integrity of the original comic. The detail and subtlety in the drawings are not sacrificed to allow for greater movement. As a result, anime has the appearance of a real comic book come to life!

So, the difference is that anime doesn't move with the fluidity of western animation. But that's not what it's all about. Japanese budgets for anime are usually less, per episode, than western animation budgets. Anime makes up for that with greater emphasis on character design, pacing, and intensity, creating scenes that appear to burst with action while the actual movement is limited.

Very little of the actual *animating* (the repetitious job of drawing one pose after another in sequence)

of anime-style cartoons is done in the United States. The labor is just too costly. Mostly, this work is shipped overseas to Korea, the Philippines, China, and Indonesia. However, the character designs, storyboards, and directing may be done domestically.

So, rather than offer instruction on animating in the anime style—when there is little animating, per se, being done domestically—this book will cover the art of anime character design. Character design is the foundation of anime. Almost everybody involved in a production must know how to draw the characters. So most people are primarily interested in learning how to draw characters, and this book will show you, step by step, how to draw the coolest anime characters from the widest selection of popular styles. You'll be introduced to high-tech punks, who live in a world of the future, and to teen characters, with their troubled relationships at school, at home, and on the street. You'll meet mighty monsters and beasts in the fantasy section. And you'll run for cover when you get to the mecha section on giant robots that battle for supremacy! You'll also learn to draw incredible special effects, including amazing explosions and other perils, such as submarines being sucked into giant whirlpools. Plus, there's a section on character design, the art of pencil sketching, and storyboarding that you won't want to miss.

And because anime and *manga* (Japanese comic books) are so closely intertwined, this book will serve to increase your skills as a manga artist, as well. You can pick it up many times and continuously discover new things as your ability grows. Anime is such a rich subject that no matter what your favorite subjects, you'll always find plenty of cool things to draw. If you've ever wanted to draw anime, then you're about to embark on a fantastic journey. The adventure begins today. Anime awaits.

BASIC CHARACTER CONSTRUCTION

Undoubtedly, one of the coolest styles in anime is the high-tech punk look. But I'm starting with high-tech punks not just because they're huge in anime, but also because they're based on realistic human anatomy. This makes their construction easier to understand than that of characters with highly exaggerated proportions. High-tech punks provide a good way to illustrate basic body construction.

High-tech punks are intense, cutting-edge characters. Sometimes, they use their knowledge of technology to save the world. At other times, they're outlaws, using technology to undermine a tyrannical government.

Good or bad, they inhabit a cynical, war-ravaged world of the future, where nothing less than the very survival of the planet is at stake. Let's start with the basic high-tech punk head structure.

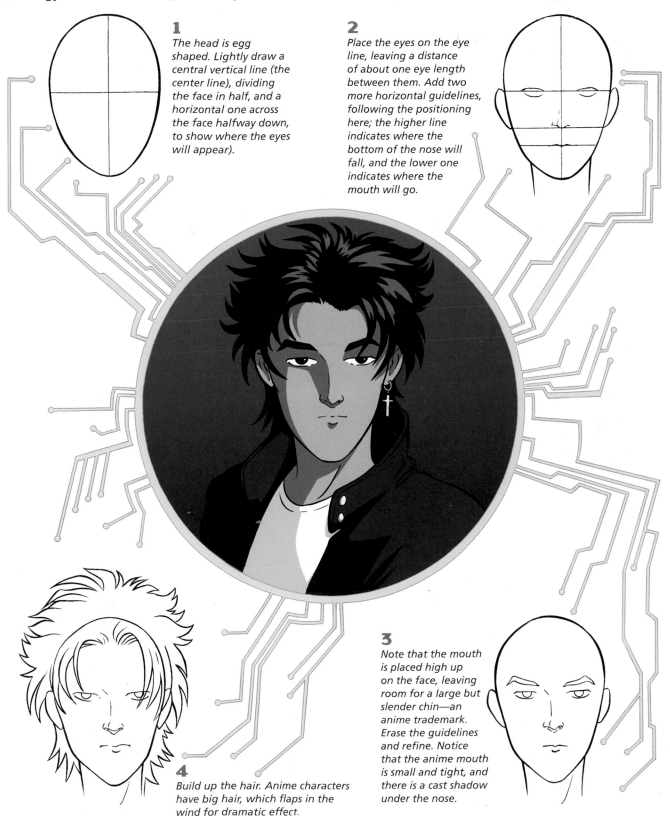

1
The head is egg shaped. Lightly draw a central vertical line (the center line), dividing the face in half, and a horizontal one across the face halfway down, to show where the eyes will appear).

2
Place the eyes on the eye line, leaving a distance of about one eye length between them. Add two more horizontal guidelines, following the positioning here; the higher line indicates where the bottom of the nose will fall, and the lower one indicates where the mouth will go.

3
Note that the mouth is placed high up on the face, leaving room for a large but slender chin—an anime trademark. Erase the guidelines and refine. Notice that the anime mouth is small and tight, and there is a cast shadow under the nose.

4
Build up the hair. Anime characters have big hair, which flaps in the wind for dramatic effect.

HIGH-TECH GAL

The high-tech punk gal is trained in all sorts of sophisticated military operations. She's always in contact with her team members, communicating with them even while in the middle of enemy territory.

1
Start with the egg shape and the two main guidelines.

2
The eyes are slightly larger than those of the high-tech punk guy. Also note the full upper and lower lips, and smaller nose.

4
A female character's hair should frame her face, surrounding it with wild energy.

3
Go heavy on the upper eyelids, omit the bridge of the nose, and erase the guidelines once everything is in place.

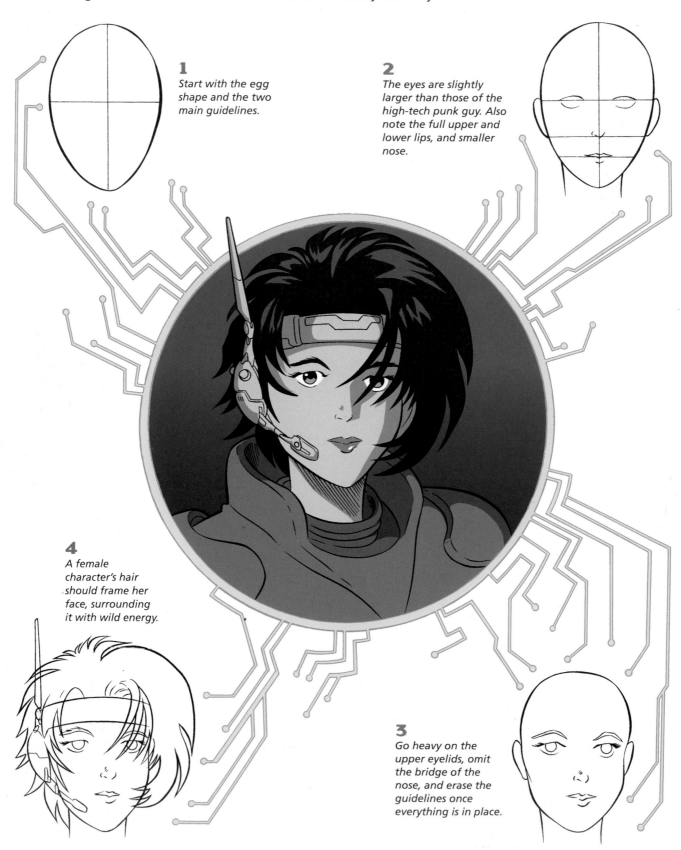

Before we move on to drawing the figure, I want to mention character casting. The idea of "casting" your characters is one of the least-discussed principles in how-to-draw books. As an artist, *you* are the casting director. You've got to consider the personality, age, gender, and role of a character in the story.

Some artists sketch first, then, having established a preliminary character, go back and refine it, moving down the list of considerations just mentioned. Other artists figure out exactly who their character will be before putting pencil to paper. You'll discover which is the most comfortable method for you.

As far as casting goes, tech renegades are no different than any other character type; whether they work for a network of spies or operate alone as rogues, each must have a defined purpose. Is she a computer specialist? Is he a part of a security team? If you don't know the answers, your audience won't either. When you decide on the casting, find a way to show it to the reader by adding visual clues.

For example, suppose you want a female computer specialist. What comes to mind? First, she should be young, because younger adults are generally more computer savvy than older adults. Then, you'd consider giving her glasses, a stereotype for intelligence. You wouldn't give her the build of an intense athlete, because her work isn't physical. But you might make her attractive, because she's perhaps the girlfriend of the group or team leader. In this manner, you are *casting* the role before you even begin to draw.

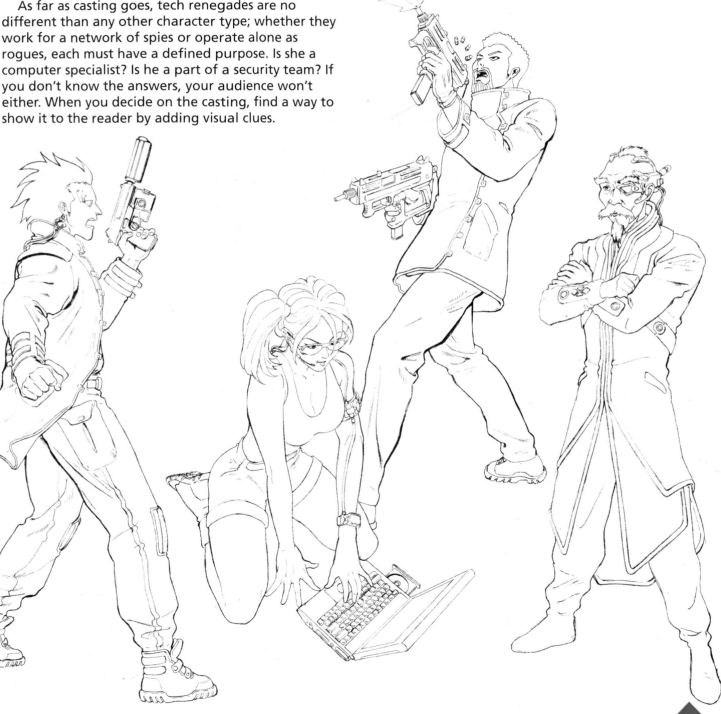

THE BODY

No matter how cool a pose is, it still has to be built on a solid foundation. The three key words are: simplify, simplify, simplify! It's much easier to draw a pose if you first break down the elements into a simplified artist's-mannequin form, as shown below. (You can buy a posable mannequin model in most art supply stores.) Again, I'm using a high-tech warrior character to illustrate the basic body construction because the anatomy is more realistic, and therefore more logical, than many other anime characters.

When you draw a pose that seems close to what you want but just isn't working, the temptation is to keep tinkering with it in order to "make it right." This approach is often doomed to fail. A better one is to check to see if the basic construction is in place. Often, it's the basics that aren't working, and no amount of style and flair can fix that.

The mannequin-type body breakdown is a great foundation. It's simple, easy to visualize even if you don't have an actual mannequin, and it works. Just sketch *lightly*. Keep in mind that this is only a first step that you will ultimately draw over and erase. The upper body is composed of two major masses: the rib cage and the wall of abdominal muscles. On the mannequin, this translates to a large elliptical shape. For the limbs, think cylinders and ball joints. Note that the hips have dimension (like a box), which is needed to house the internal organs of the body. In addition, the thighs attach to the hips at 45-degree angles. The upper body is not stacked directly on top of the legs like a crate resting on two chimney stacks, as some beginners mistakenly believe.

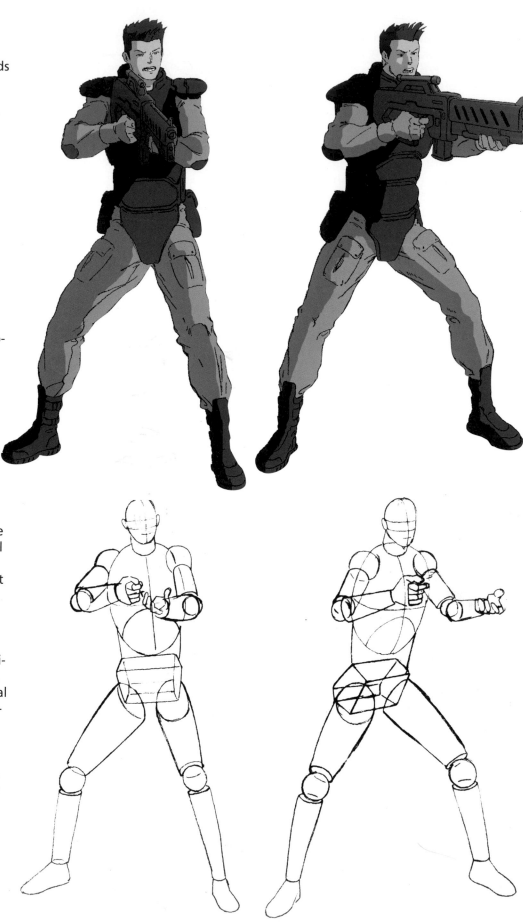

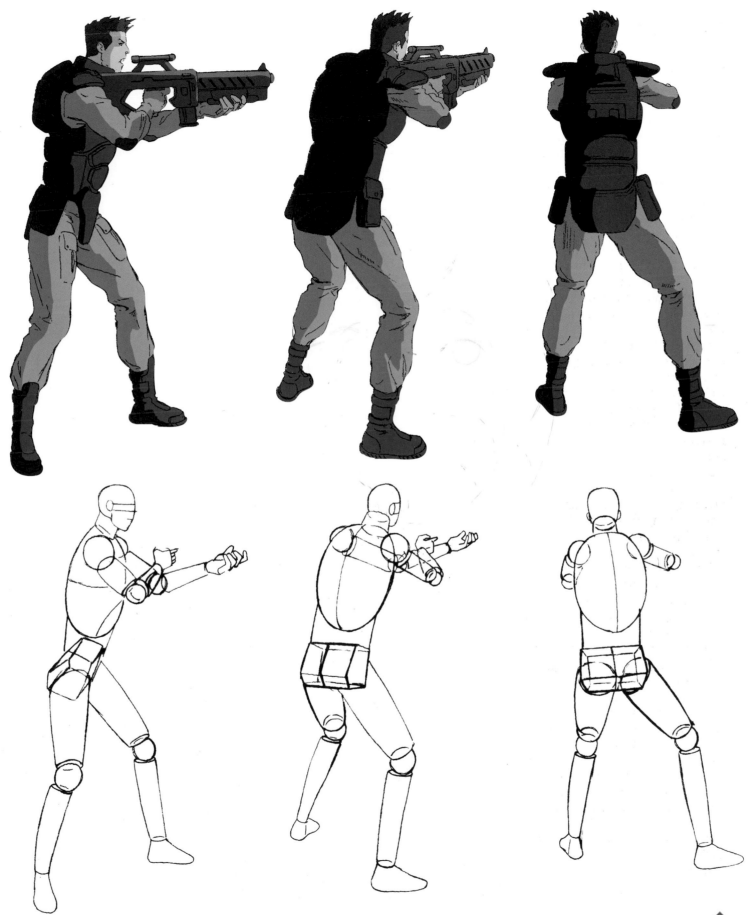

HIGH-TECH BATTLE GAL

Draw her hips wider than her shoulders. This won't make her look fat since the waste is narrow. Note that her rib cage is slightly shorter than that of a man, and that her hips tend to tilt forward more than those of a man, giving more sway to her lower back.

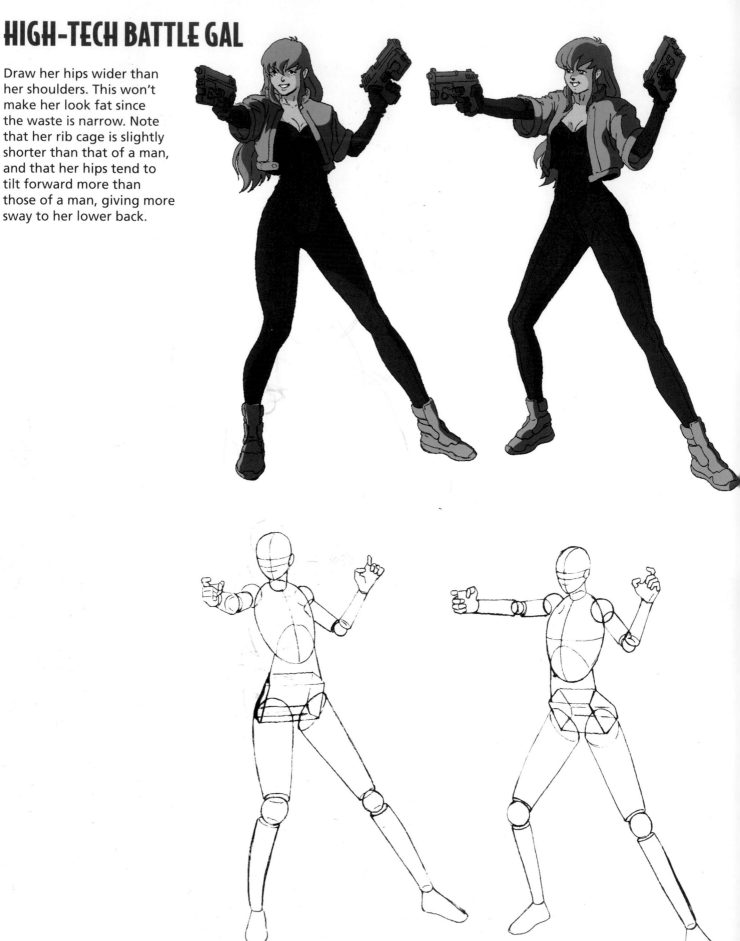

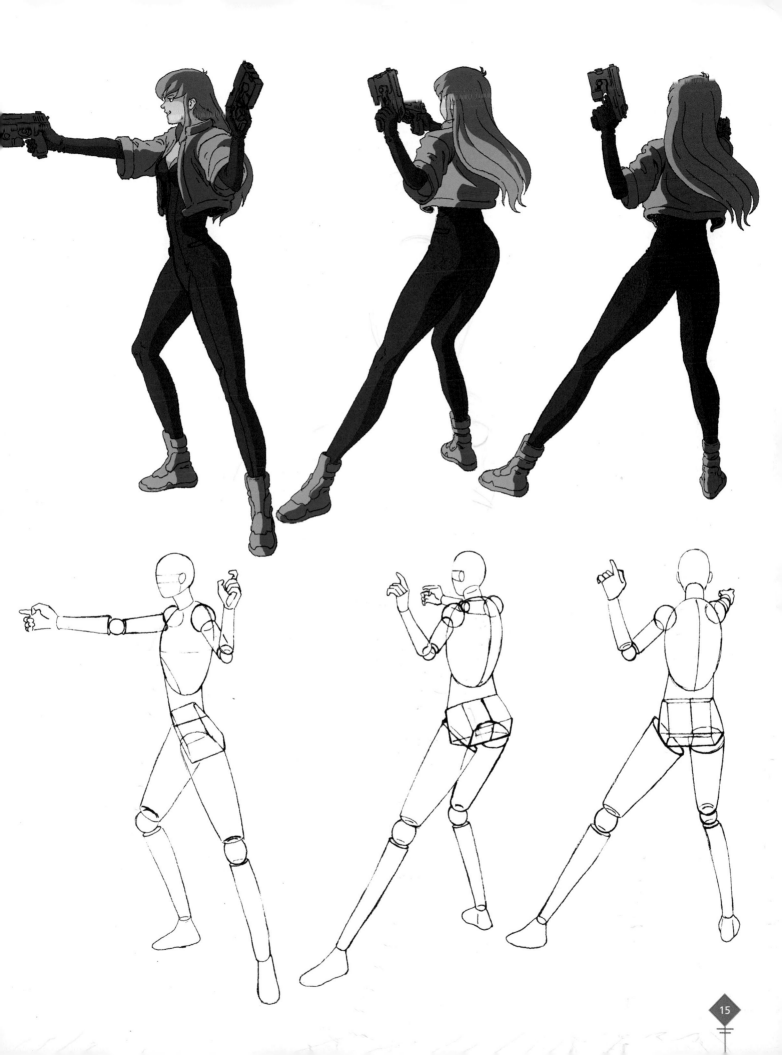

STANDING POSES

Here's the deal with standing poses: It's all about which leg is bearing most of the weight. People rarely stand with equal weight on both feet. And the people who do are usually saluting. It's just not comfortable to stand that way for more than a few seconds. People automatically shift their weight to one foot. For drawing purposes, this shift also increases viewer interest because it creates asymmetry, rather than symmetry and redundancy.

The leg bearing most of the weight will be straight and locked at the knee. This will force the hip on the same side of the body to rise, which, in turn, will cause the hip on the other side to lower and the leg on that side to bend at the knee or shift away from the body. Don't be fooled into thinking that the bent leg bears most of the weight because it is bending under the pressure. The opposite is true. The bent leg is the one getting off easy, resting. It's the straight leg that is flexed and doing all of the work.

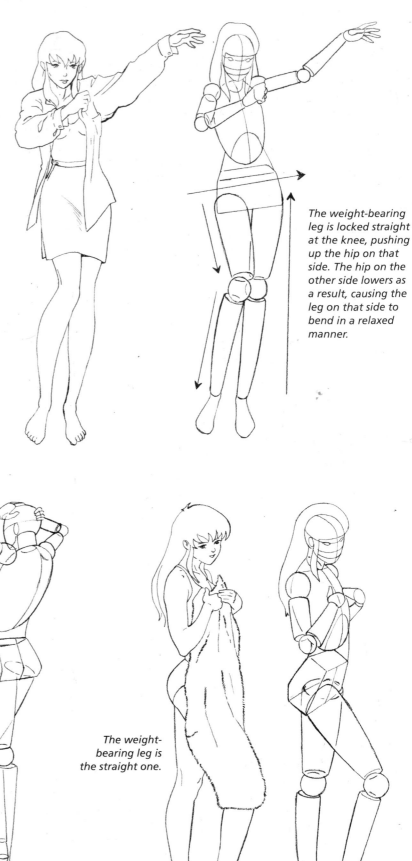

The weight-bearing leg is locked straight at the knee, pushing up the hip on that side. The hip on the other side lowers as a result, causing the leg on that side to bend in a relaxed manner.

The weight-bearing leg is the straight one.

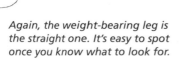

Again, the weight-bearing leg is the straight one. It's easy to spot once you know what to look for.

Seated poses are known to give artists headaches. Here's the deal: Make up your mind whether you want your character to be leaning forward or backward. No one sits at attention, unless they're in a classroom with a mean teacher wielding a wooden ruler. The seated body is actually in a state of action. However, it's only the upper body that is doing the leaning. The lower half of the body is static. Generally, in most seated poses, these two halves of the body are doing two different things.

And always, always sketch the chair before you begin to draw the person sitting in it, otherwise your figure may show telltale signs that it was initially drawn sitting on air. A chair tends to flatten out the bottom and the legs of the person sitting on it. It also serves as a force against which the body adjusts.

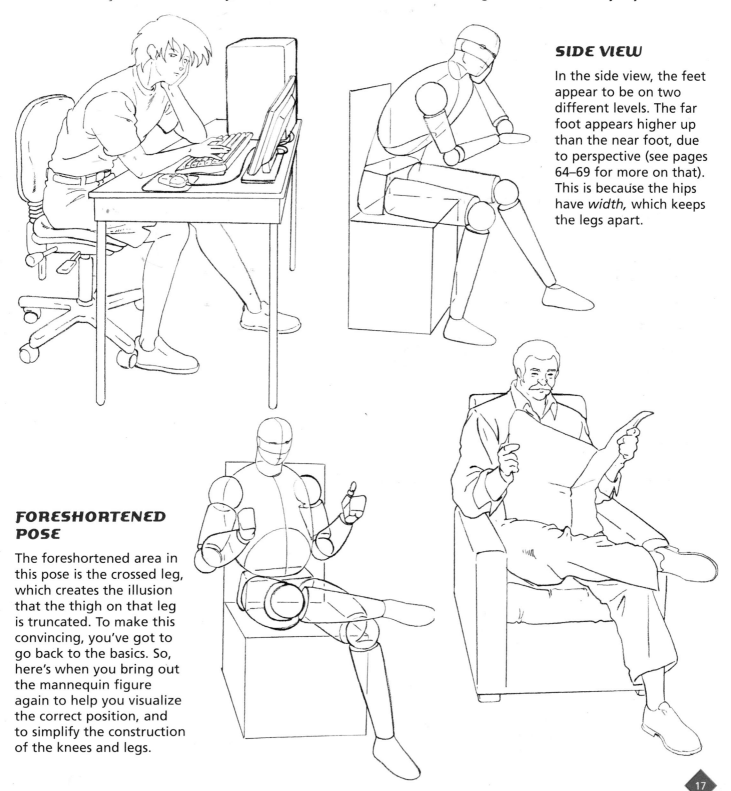

SIDE VIEW

In the side view, the feet appear to be on two different levels. The far foot appears higher up than the near foot, due to perspective (see pages 64–69 for more on that). This is because the hips have *width*, which keeps the legs apart.

FORESHORTENED POSE

The foreshortened area in this pose is the crossed leg, which creates the illusion that the thigh on that leg is truncated. To make this convincing, you've got to go back to the basics. So, here's when you bring out the mannequin figure again to help you visualize the correct position, and to simplify the construction of the knees and legs.

RECLINING POSES

In reclining poses, where a person either lies on his or her stomach or back, the body tends to flatten and widen out. When a person is laying on his or her side, the height of the hips and rib cage prevent the body from flattening. Surprisingly in such a pose, the hips and rib cage, are almost always at different angles to each other. You'd think that they would flow together—as this would make artists' lives easier— but it's rarely the case. As shown by the mannequin breakdown of the pose, the block-shaped hips tilt away from the rib cage.

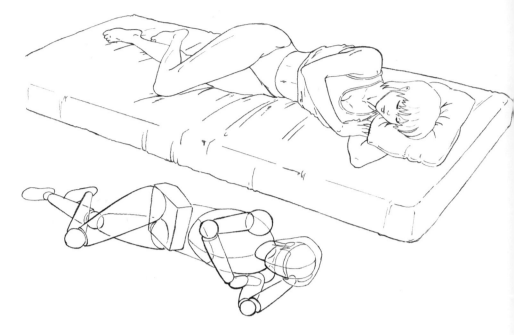

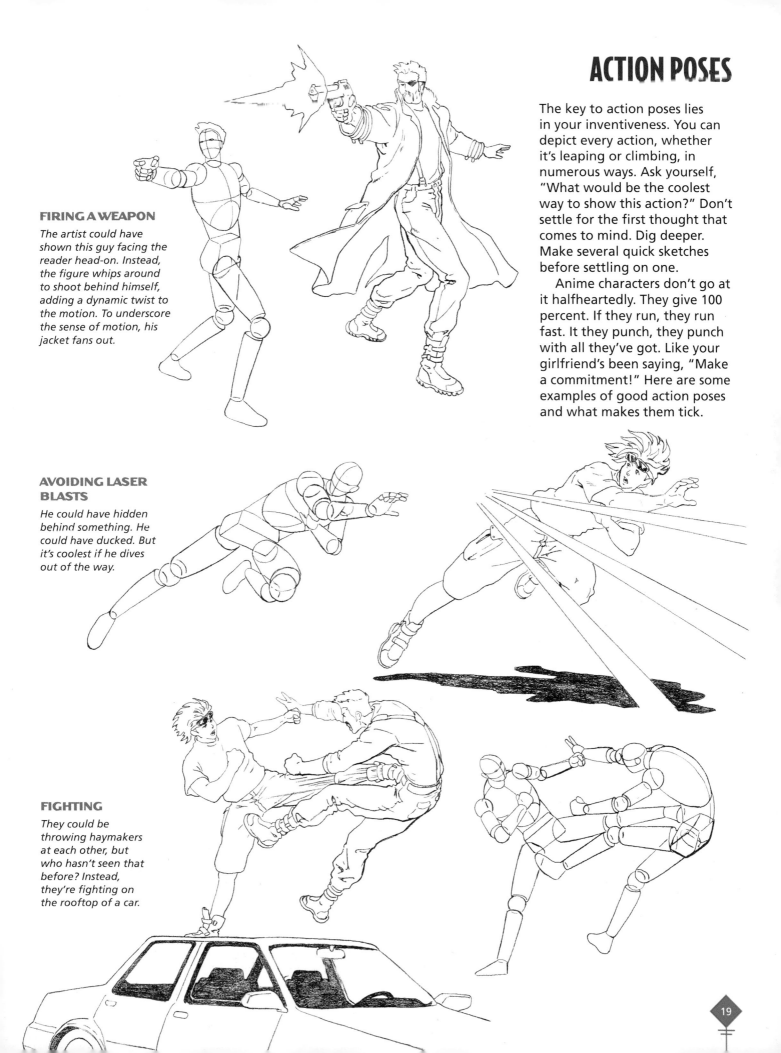

ACTION POSES

The key to action poses lies in your inventiveness. You can depict every action, whether it's leaping or climbing, in numerous ways. Ask yourself, "What would be the coolest way to show this action?" Don't settle for the first thought that comes to mind. Dig deeper. Make several quick sketches before settling on one.

Anime characters don't go at it halfheartedly. They give 100 percent. If they run, they run fast. It they punch, they punch with all they've got. Like your girlfriend's been saying, "Make a commitment!" Here are some examples of good action poses and what makes them tick.

FIRING A WEAPON

The artist could have shown this guy facing the reader head-on. Instead, the figure whips around to shoot behind himself, adding a dynamic twist to the motion. To underscore the sense of motion, his jacket fans out.

AVOIDING LASER BLASTS

He could have hidden behind something. He could have ducked. But it's coolest if he dives out of the way.

FIGHTING

They could be throwing haymakers at each other, but who hasn't seen that before? Instead, they're fighting on the rooftop of a car.

19

RUNNING

For a medium that is thought to show limited actual animation, anime characters run with extreme body motion and intensity. The strides are long, and the body tilts forward at a severe angle. And the arms pump back and forth big time. Be sure that the hair trails behind, blown back as if in a wind tunnel. The typical anime run is exciting to watch and spices up any action sequence.

FRONT VIEW

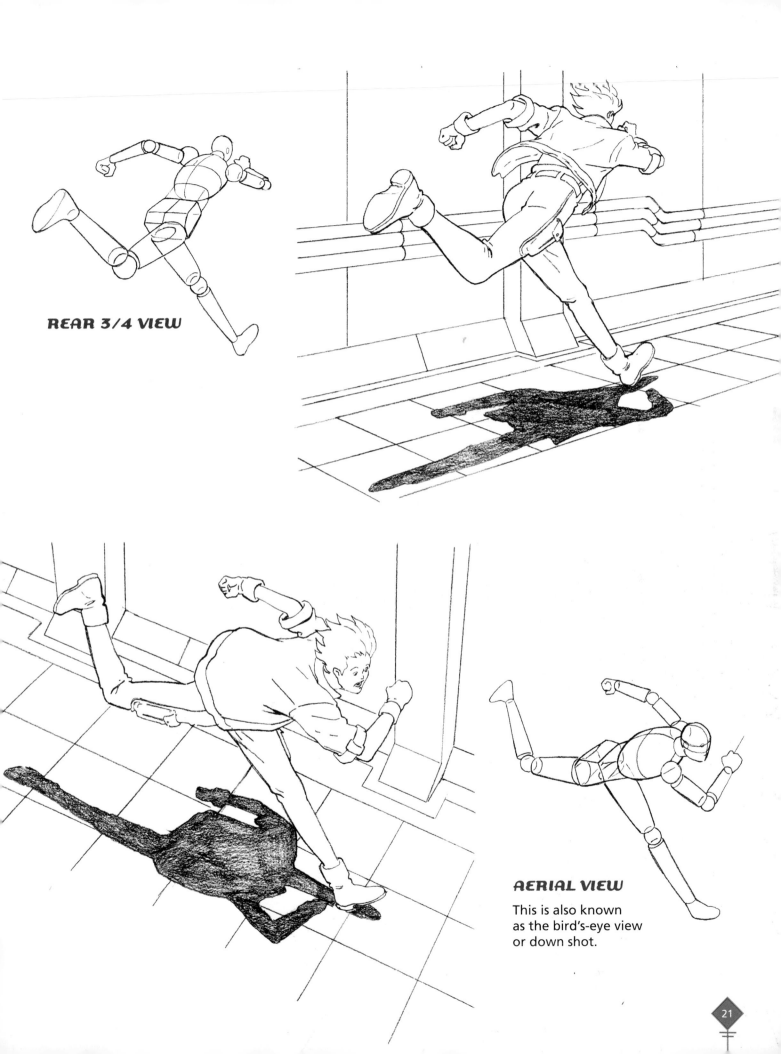

REAR 3/4 VIEW

AERIAL VIEW

This is also known
as the bird's-eye view
or down shot.

WALKING

Sometimes, I think the best thing about the typical anime walk is the sound effect. The lonely sound of footsteps echoing through an empty corridor is charged with atmosphere.

Whereas the typical anime run is portrayed as an all-out panic, the anime walk is restrained. The body is upright and stiff. The walk is used mainly during conversations between characters in which they coolly discuss the strategic problems of waging a war against their enemies. Note: Placing shadows beneath the figures also serves to heighten the atmosphere, so don't leave them out.

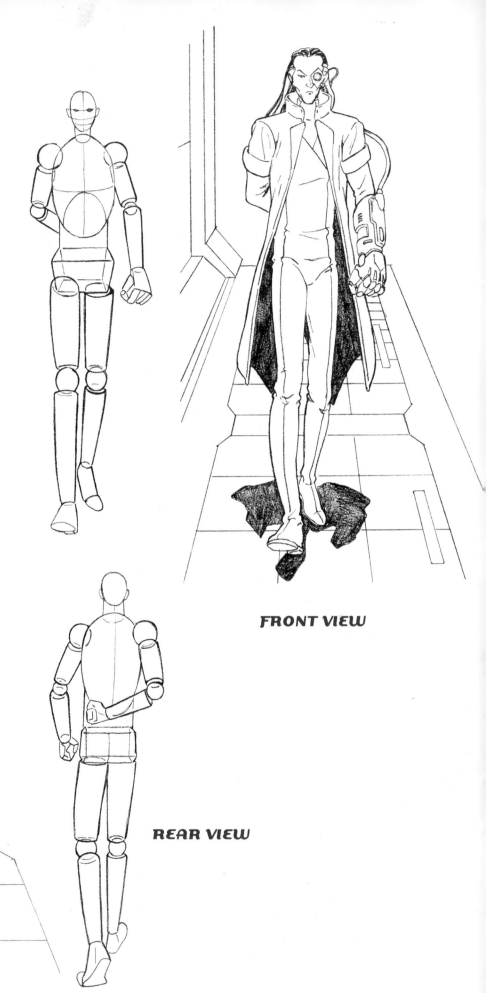

FRONT VIEW

REAR VIEW

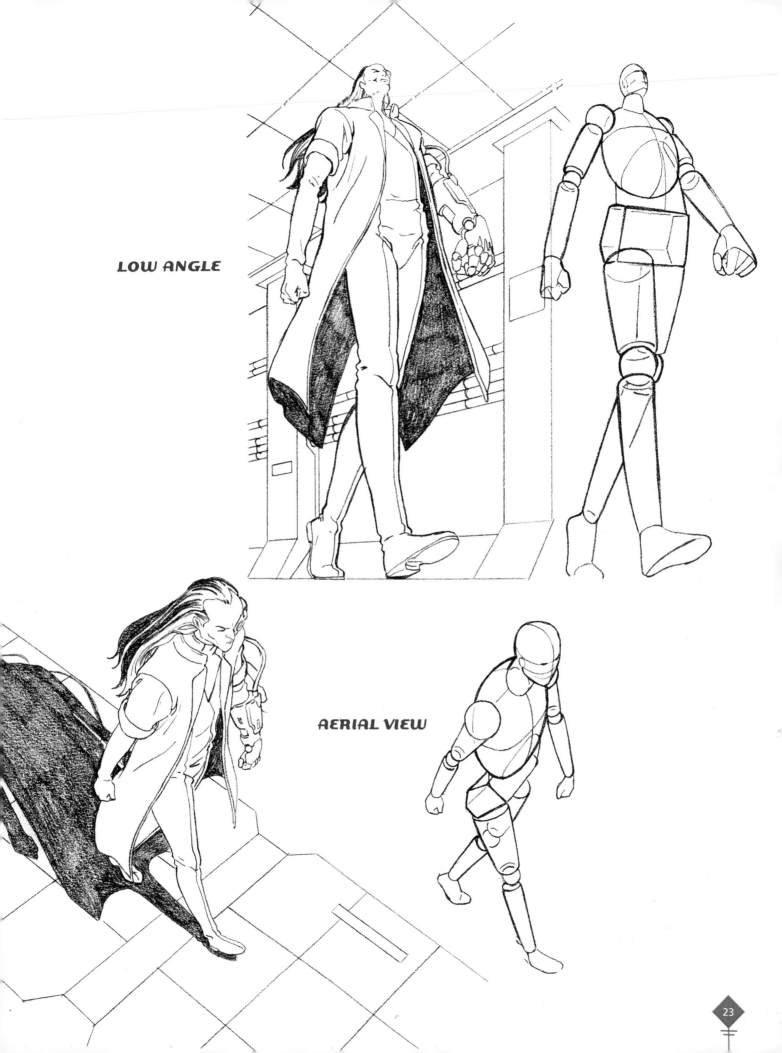

LOW ANGLE

AERIAL VIEW

23

HANDS IN ACTION

Most books on drawing only show empty hands. But that doesn't solve the problem of characters gripping objects and doing things. In order to accurately portray a hand in action, first draw the *entire* hand, especially the part you won't see in the final drawing. You'll be amazed at how this small step will often solve problems that had seemed baffling.

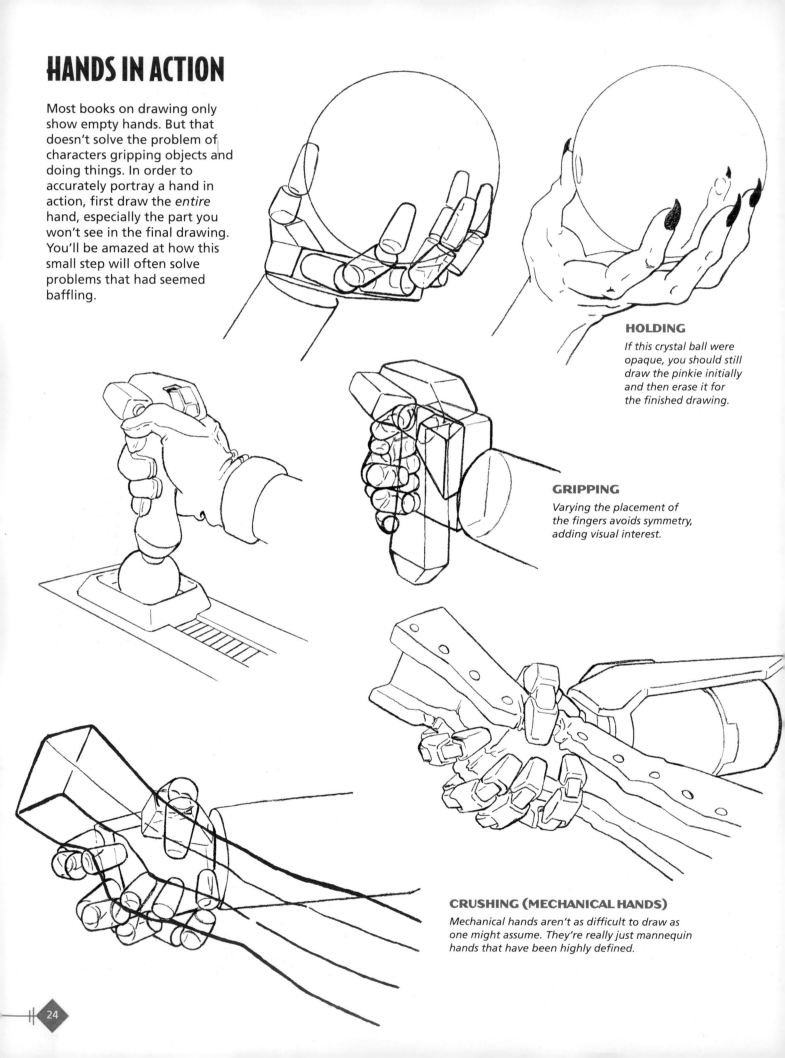

HOLDING

If this crystal ball were opaque, you should still draw the pinkie initially and then erase it for the finished drawing.

GRIPPING

Varying the placement of the fingers avoids symmetry, adding visual interest.

CRUSHING (MECHANICAL HANDS)

Mechanical hands aren't as difficult to draw as one might assume. They're really just mannequin hands that have been highly defined.

TYPING

Note the narrow palm, which gives a woman's hand its femininity.

WRITING

This is a tricky one, and here's the trick: The thumb and the forefinger are both bent inward when writing.

CASTING A SPELL

Can you tell what makes this pose effective? It's that we get to see the palm of the hand as well as the back of the hand in the same pose. This inside/outside view of the hand is highly dramatic. Plus, the widely spread fingers are evocative of evil. Note: In many dramatic hand poses, the pinky will be positioned higher or lower than the rest of the fingers.

TURNING AN ORDINARY CHARACTER INTO A HIGH-TECH ONE

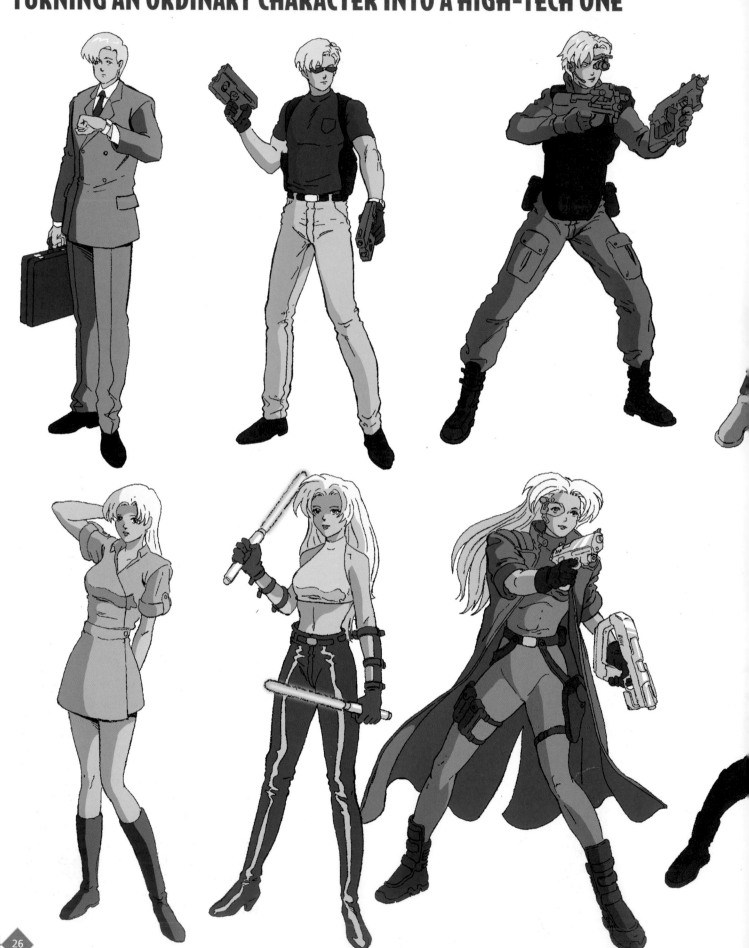

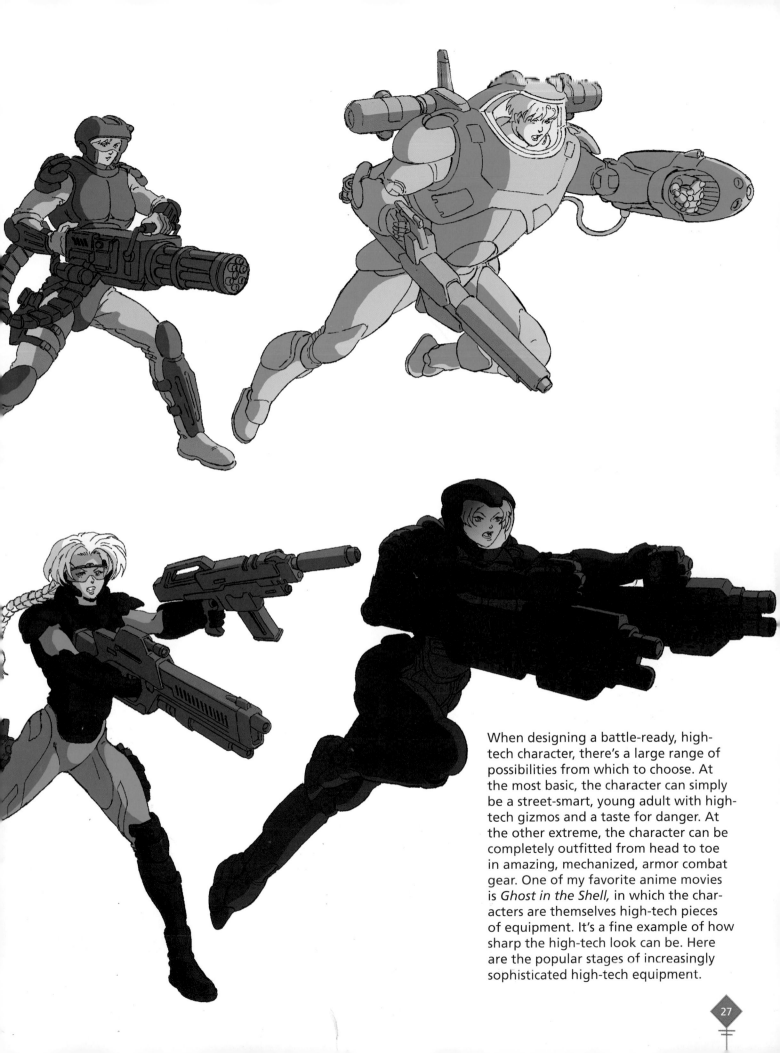

When designing a battle-ready, high-tech character, there's a large range of possibilities from which to choose. At the most basic, the character can simply be a street-smart, young adult with high-tech gizmos and a taste for danger. At the other extreme, the character can be completely outfitted from head to toe in amazing, mechanized, armor combat gear. One of my favorite anime movies is *Ghost in the Shell,* in which the characters are themselves high-tech pieces of equipment. It's a fine example of how sharp the high-tech look can be. Here are the popular stages of increasingly sophisticated high-tech equipment.

TEEN CHARACTERS

The stars of the majority of anime shows are teens, so this section gives you all the tools you'll need to master this essential area of anime. Teens make good subject matter because they feel their emotions with great intensity, they're idealistic, and they have a network of friends (a built-in supporting cast).

The teenage face is a face in transition. It's youthful but not childish, sleek but not slender. The eyes are large and set wide apart—hallmarks of youth. The forehead is typically festooned with a reckless hairstyle. The face tapers to a delicate point at the chin. The nose is upturned and small. The mouth is also small.

The eyes of an anime character should be brilliant, and teens are no exception to this. The iris and pupil take up a huge proportion of the space in the eyeball, leaving less for the whites of the eyes. Indicate large

"shines," or highlights, that overlap both the iris *and* the pupil.

Usually, thick eyebrows are desirable because they draw attention to the eyes. However, thin eyebrows work best for delicate characters or characters aimed at young audiences.

Avoid drawing skinny necks on teens merely because they are youthful characters. The neck should have volume. Reserve the skinny-neck treatment for small children.

FRONT VIEW

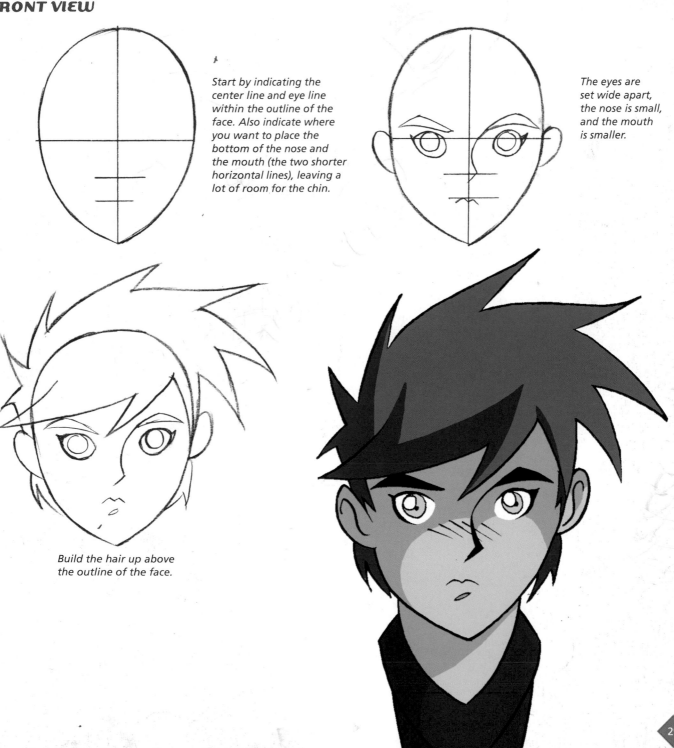

Start by indicating the center line and eye line within the outline of the face. Also indicate where you want to place the bottom of the nose and the mouth (the two shorter horizontal lines), leaving a lot of room for the chin.

The eyes are set wide apart, the nose is small, and the mouth is smaller.

Build the hair up above the outline of the face.

3/4 VIEW

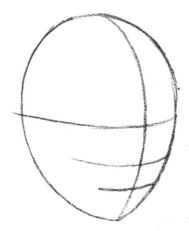

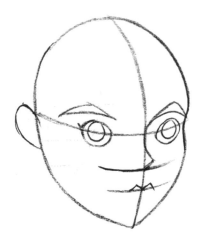

In the 3/4 view, the center line shifts over to the right but still wraps around the face.

Note that the far side of the face indents slightly where the cheekbone meets the forehead.

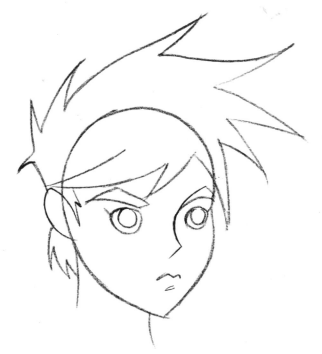

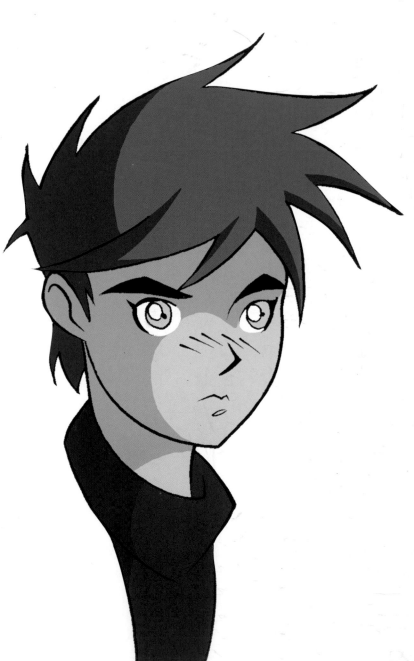

The neck now appears further back on the character, due to the 3/4 angle.

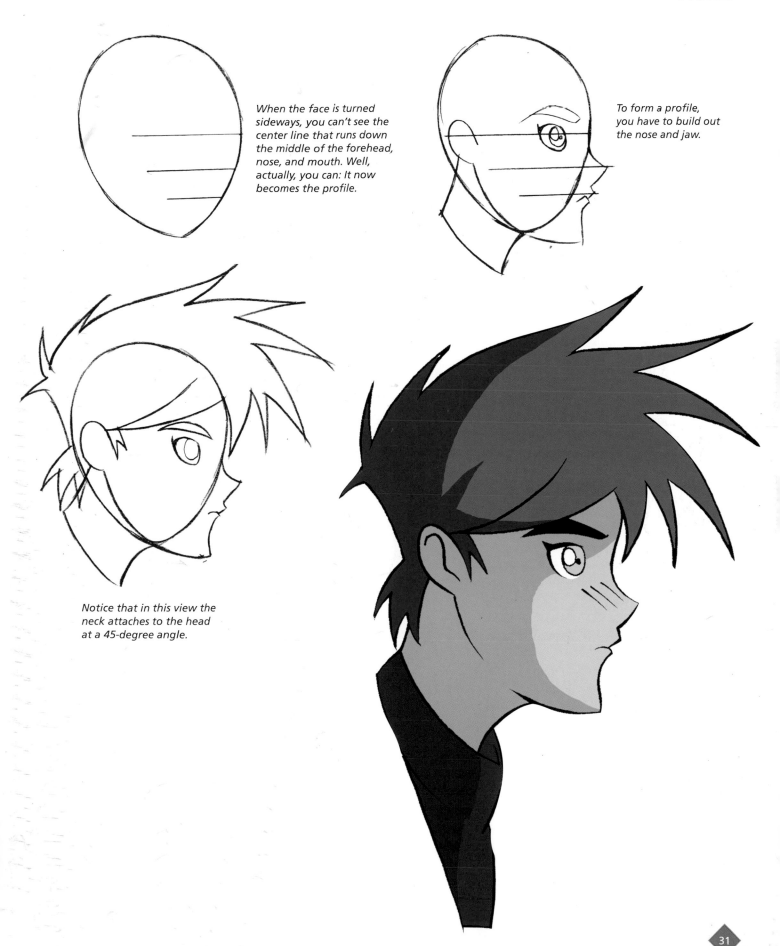

When the face is turned sideways, you can't see the center line that runs down the middle of the forehead, nose, and mouth. Well, actually, you can: It now becomes the profile.

To form a profile, you have to build out the nose and jaw.

Notice that in this view the neck attaches to the head at a 45-degree angle.

THE FEMALE HEAD

When drawing a girl's face, think delicate, wistful, elegant. The jaw is somewhat more tapered, and the features are tweaked—especially the eyes, which are "taller," vertically, than those on a boy. The iris and pupil take up an even greater area here, and feature numerous shines. The eyelids are drawn with heavier lines and eyelashes at the edges. Also, the lashes tilt up just a touch at the ends. The eyebrows, while still thick, are more streamlined than those of a boy. And, the neck is thinner. But it's the hair that really makes the difference. It is just massive, with layering everywhere. There are bangs, buns, and sections of hair draping in front of, and behind, the ears.

The same steps apply for drawing the teenage girl in 3/4 view as do for the boy. But notice, however, what happens in the third drawing: The hair buns are repositioned so that the far bun is partially hidden from view, overlapped by the head, while the near bun is nudged in a bit closer to the face.

The astute anime artist knows that the nose on most anime characters is very small—even tiny—in the front, as well as the 3/4, view. But notice that in the side view, the nose takes on a tremendous sweep and appears quite pointed. Also important is that the eye in profile is recessed in the head, not positioned flush against the bridge of the nose.

FRONT VIEW

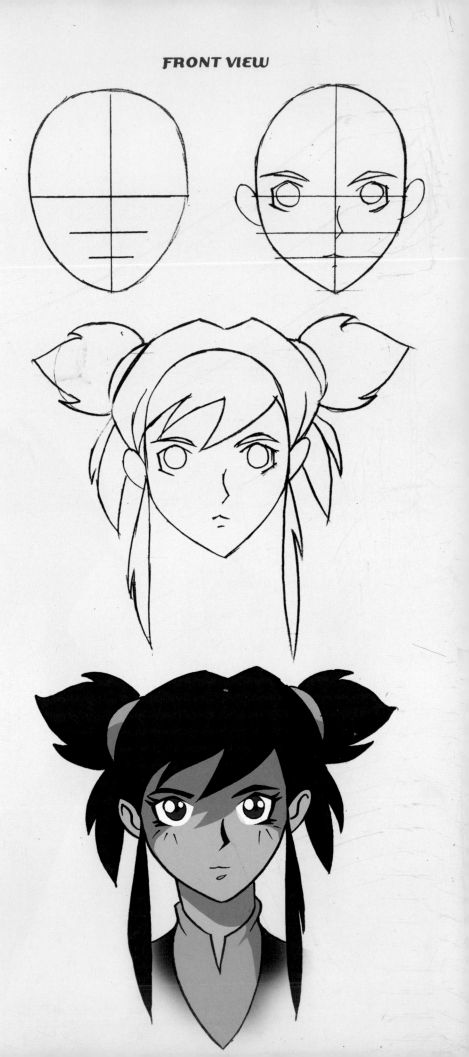

3/4 VIEW

PROFILE

THE BODY

Typically, teen bodies are long and loose-limbed, and free and breezy in posture. They're also typically trim, reflecting the high-energy lifestyle of a teenager. They've lost their baby fat and are in a new development stage, but haven't yet filled out. Of course, some teen characters will be built differently; for example, a bully character might be big and brawny. Still, the stereotypical teen is a wispy version of an adult.

One of the important tasks of a character designer is to create a set of poses for a given character from different angles. This is called a *character model sheet* in animation, or a *turnaround* in comic books. These guides are given to the animators so that they can emulate the standard look of the character in any pose, rather than each animator doing a personal interpretation of the character.

Another reason for creating character model sheets is that they familiarize you with the character. Animation artists spend time sketching new characters in a variety of poses and expressions before they officially begin to work on them. It's the equivalent of warming up in a sport. And, it's also good for personal reference. Many artists keep files of character sketches; if a difficult pose presents itself, sometimes the reference material will help to solve it.

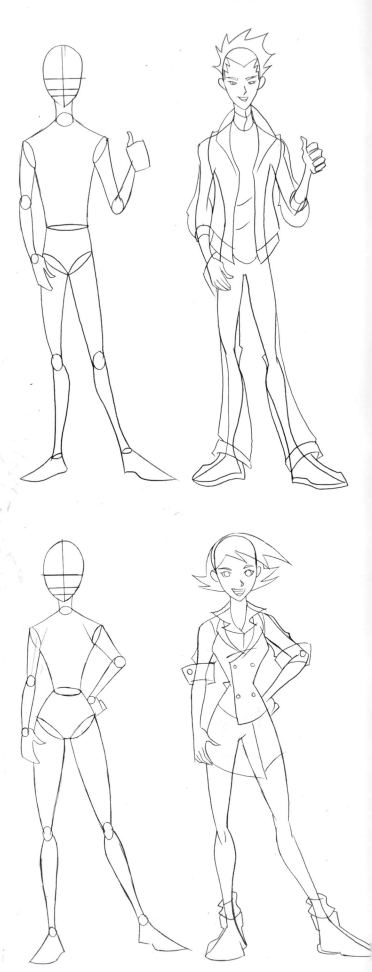

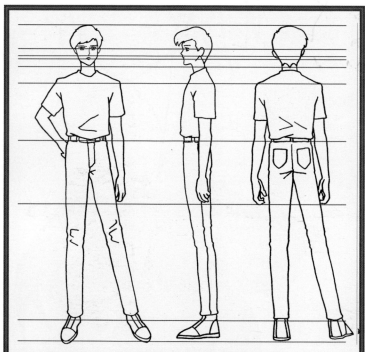

MAINTAINING CONSISTENT PROPORTIONS

Character model sheets are essential to maintaining the correct proportions from pose to pose. Without consistent proportions, characters might appear taller in one scene and shorter in another, or have bigger heads or longer arms in subsequent scenes. By drawing horizontal lines through the poses, along the major landmarks of the body, you will consistently maintain the proportions of your character.

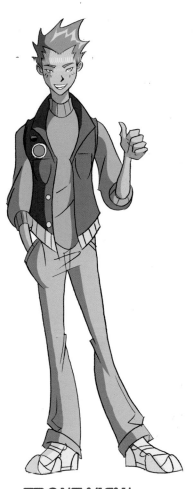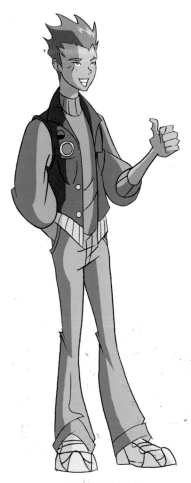

FRONT VIEW　　　**3/4 VIEW**　　　**REAR VIEW**

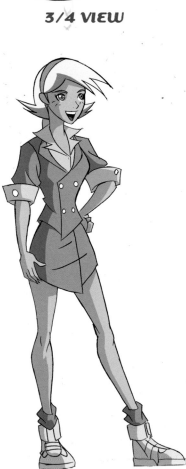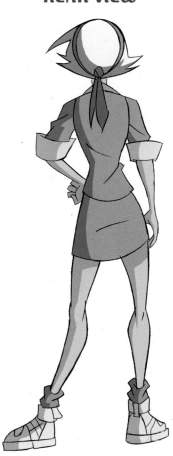

ANIME'S MOST POPULAR TEENAGE CHARACTERS

Teen-driven shows are the bread and butter of anime, and many of them center around high school. High school creates a canvas for the soap opera of teenage life with its secret crushes, adventures, and cliques.

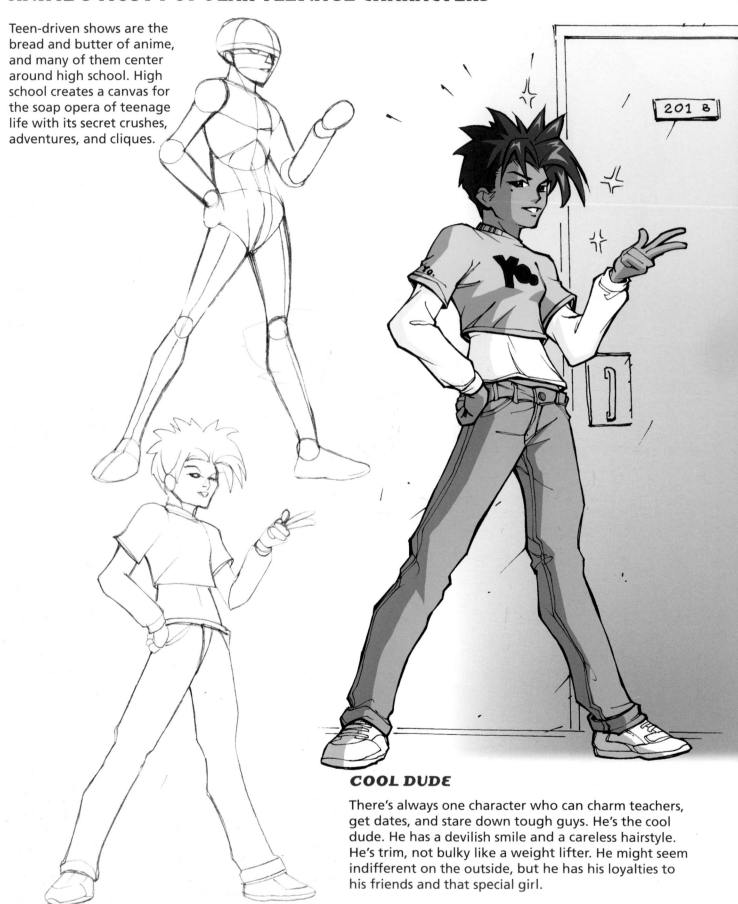

COOL DUDE

There's always one character who can charm teachers, get dates, and stare down tough guys. He's the cool dude. He has a devilish smile and a careless hairstyle. He's trim, not bulky like a weight lifter. He might seem indifferent on the outside, but he has his loyalties to his friends and that special girl.

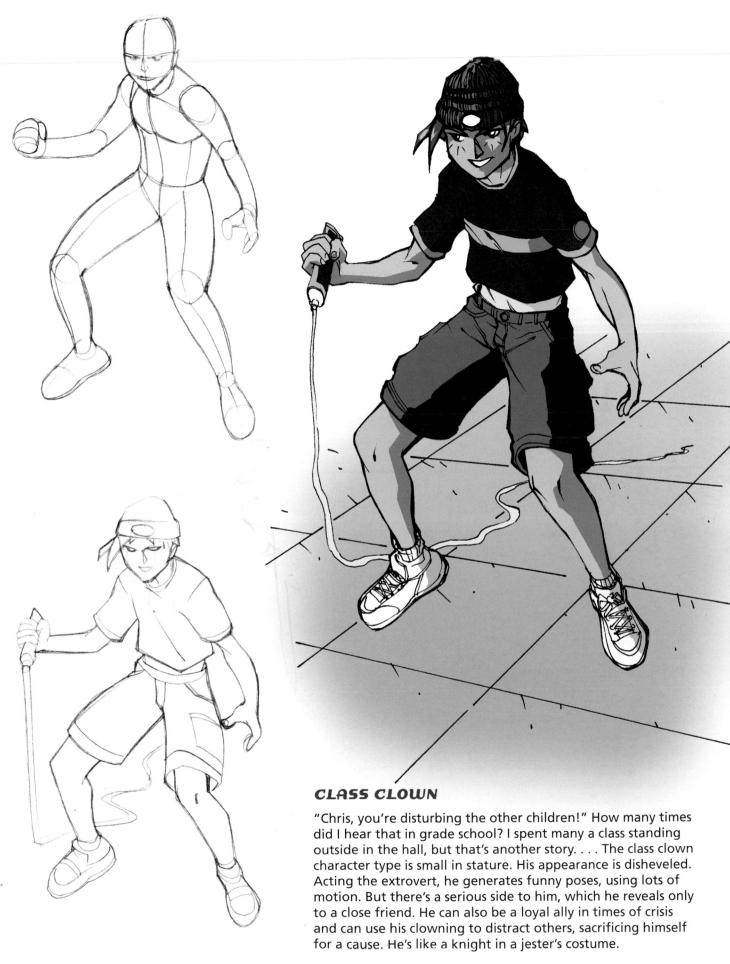

CLASS CLOWN

"Chris, you're disturbing the other children!" How many times did I hear that in grade school? I spent many a class standing outside in the hall, but that's another story. . . . The class clown character type is small in stature. His appearance is disheveled. Acting the extrovert, he generates funny poses, using lots of motion. But there's a serious side to him, which he reveals only to a close friend. He can also be a loyal ally in times of crisis and can use his clowning to distract others, sacrificing himself for a cause. He's like a knight in a jester's costume.

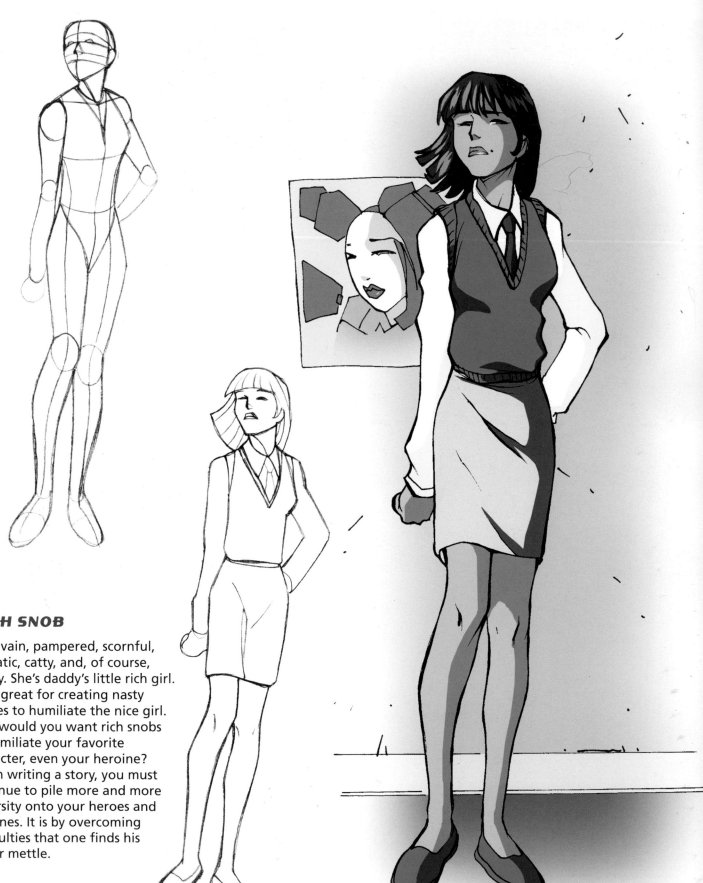

RICH SNOB

She's vain, pampered, scornful, operatic, catty, and, of course, pretty. She's daddy's little rich girl. She's great for creating nasty cliques to humiliate the nice girl. Why would you want rich snobs to humiliate your favorite character, even your heroine? When writing a story, you must continue to pile more and more adversity onto your heroes and heroines. It is by overcoming difficulties that one finds his or her mettle.

CHEERLEADER

Hey, one of these characters has to show a little school spirit around here, and this gal's the one. Neatly groomed, squeaky clean, and bright eyed, the cheerleader is a popular student among her classmates. She has lots of friends with whom she discusses every little thing that happens to her or to anyone else. She takes everything personally, especially in the area of relationships.

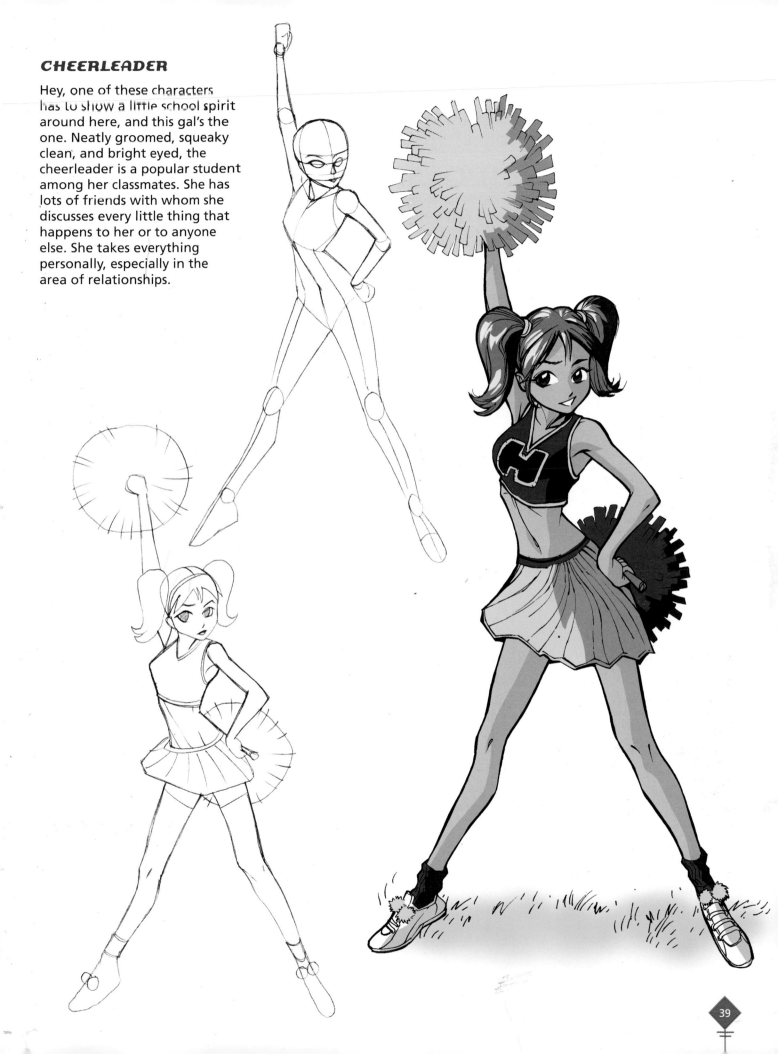

TOMBOYISH LONER

She's an introverted character who would be pretty if only she believed in herself. A loner, she has few friends. But she is often creative and bright, observing everything but sharing none of her thoughts. She may have a crush on a boy, but he will never know it. Sometimes she has special skills, such as being a whiz at the computer. These skills can be used in a story line in which other classmates recruit her to help them. Once having saved the day, she sinks into the background rather than joining the group. She thinks no one likes her, but that's not true.

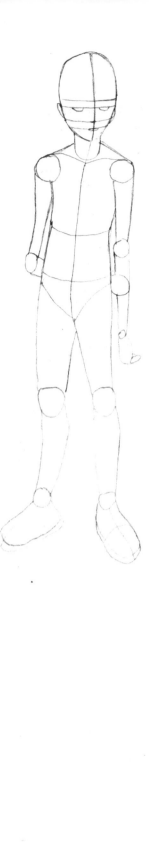

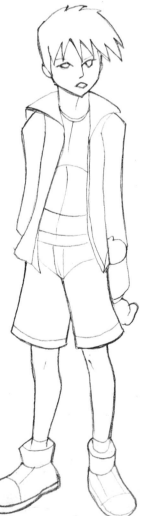

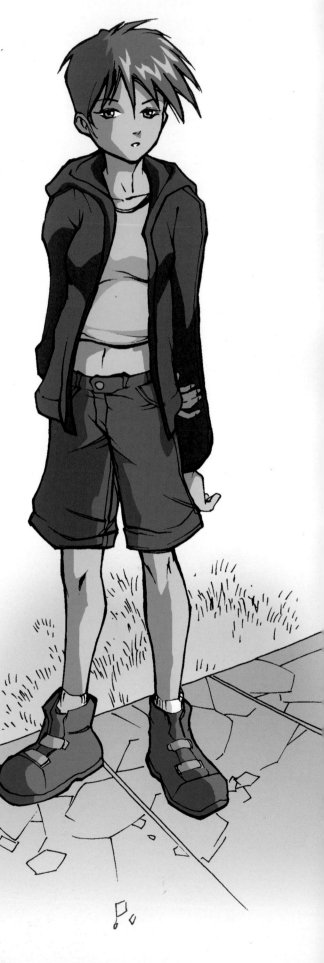

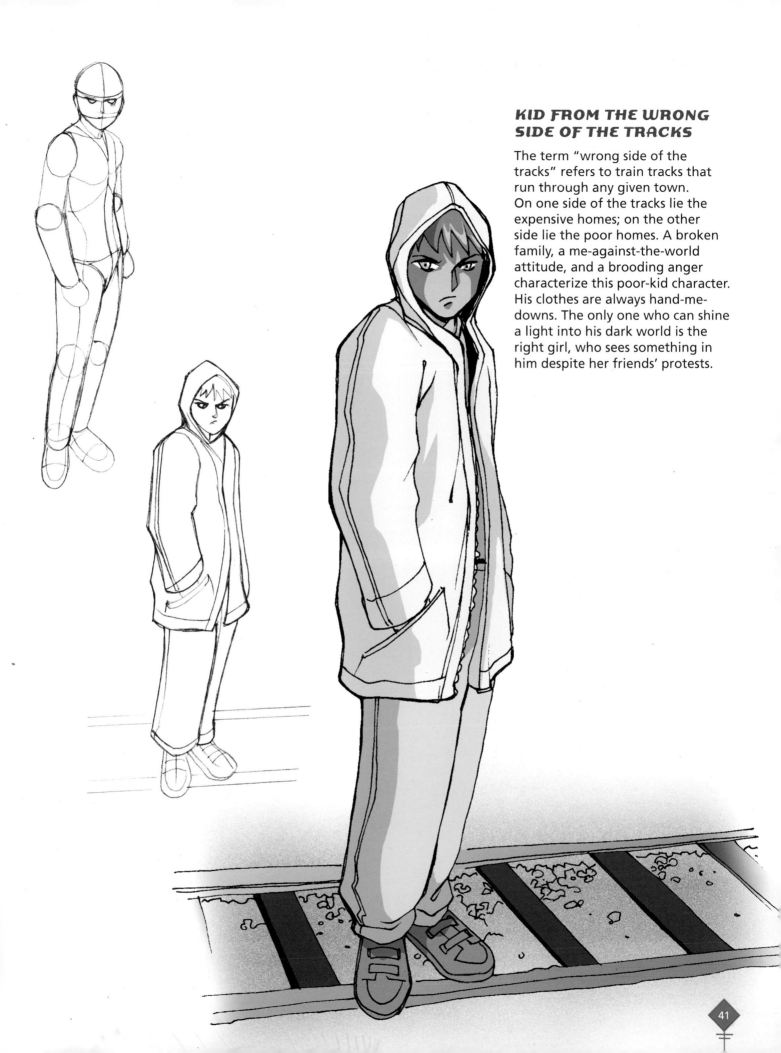

KID FROM THE WRONG SIDE OF THE TRACKS

The term "wrong side of the tracks" refers to train tracks that run through any given town. On one side of the tracks lie the expensive homes; on the other side lie the poor homes. A broken family, a me-against-the-world attitude, and a brooding anger characterize this poor-kid character. His clothes are always hand-me-downs. The only one who can shine a light into his dark world is the right girl, who sees something in him despite her friends' protests.

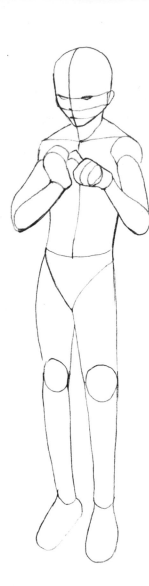

BRAINY KID

Brainy kids are often shown wearing glasses, a visual indication that they do a ton of reading. This kid's clothes are conservative, and his hair is short. He's slight of stature and unobservant when it comes to social skills, like an absent-minded professor off in his own head solving problems. Brainy kids can never be sure if other kids like them for themselves or for a quick peak at their homework.

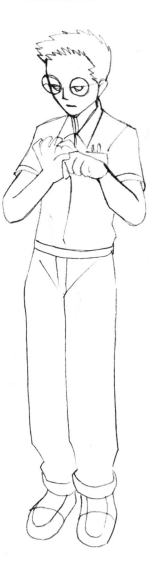

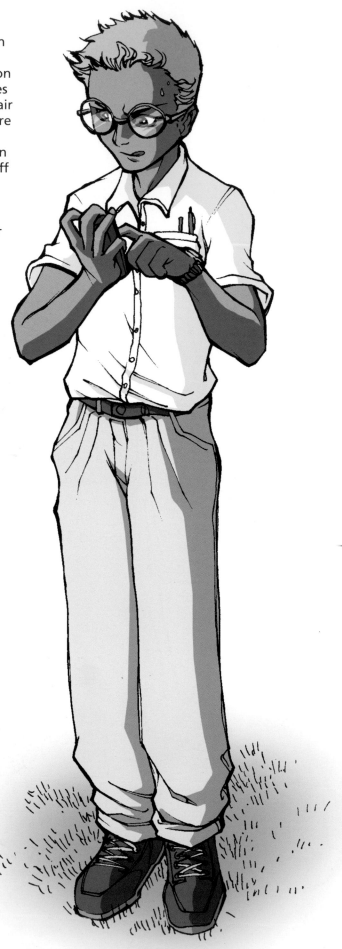

SCHOOL BULLY

Here's an out of control pituitary gland for you. He's the only one of the bunch who isn't built like a typical teen. He's wide and massive, with clublike hands and feet. His neck is either short and thick or nonexistent, with his head fused to his shoulders. He's always tall, which allows for use of dynamic angles, such as when he's towering over smaller students whom he loves to intimidate.

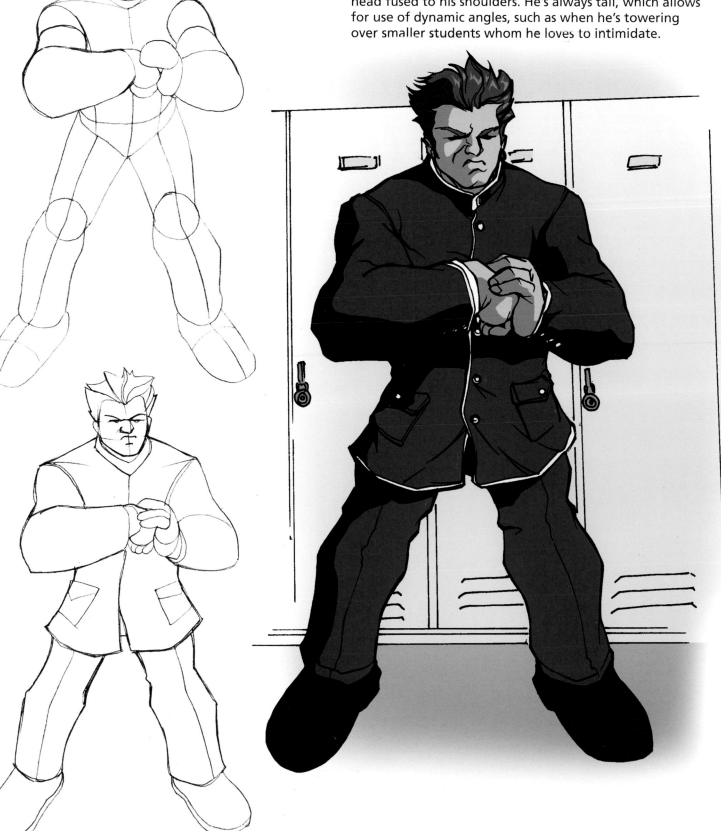

FANTASTIC CREATURES

Dark magic and fantastic creatures await all who venture deep into the netherworld of anime. We have now left teen heartache and adventure behind, and have plunged headfirst into the forces of evil that must be defeated if the human race is to survive. Like junkyard dogs, monsters, beasts, and demons protect the underworld and its dark lords from all that is good. However, in this strange land there also dwell beings that are pure of heart, from fantasy warriors to enchanted creatures.

TRAINING THE BEAST

Here dragon, dragon. Hey, someone's got to teach that overgrown lizard how to bring in the morning paper. Dragons often come with trainers who command them. These trainers are cruel, heartless masters who have no mercy for their enemies or even for those who obey them. You can try training a dragon by offering praise, but if that doesn't work (and it won't), carry a *big* weapon.

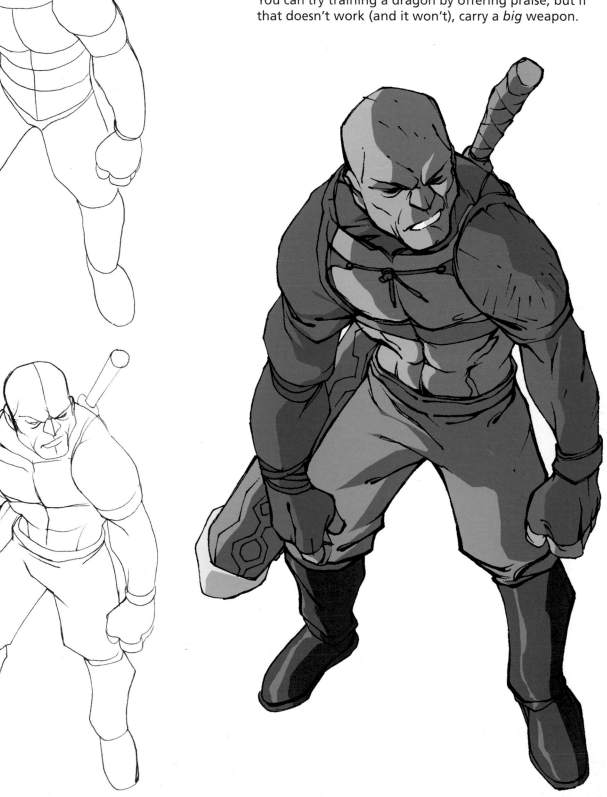

DRAGONS: THE ULTIMATE DARK POWER

With its great height, huge wingspan, elongated neck, and astounding jaws, the dragon is the epitome of evil. It's the great white shark of the netherworld. It has the neck of a snake, the upper body of a bird, the lower leg structure of a canine, and a lizardlike tail.

Give the underbelly striations. Place triangular flaps on the dragon's neck, back, and tail. The skin is old and scaly. There's an odd combination of muscularity and boniness. Be sure the dragon has claws for both "hands" and "feet." Some dragons, but not all, have ears. The bottoms of the wings usually have spiny protuberances, which are similar to the vestigial fingers seen in the wings of bird skeletons. The spiny protuberance on top of the wing represents the vestigial thumb.

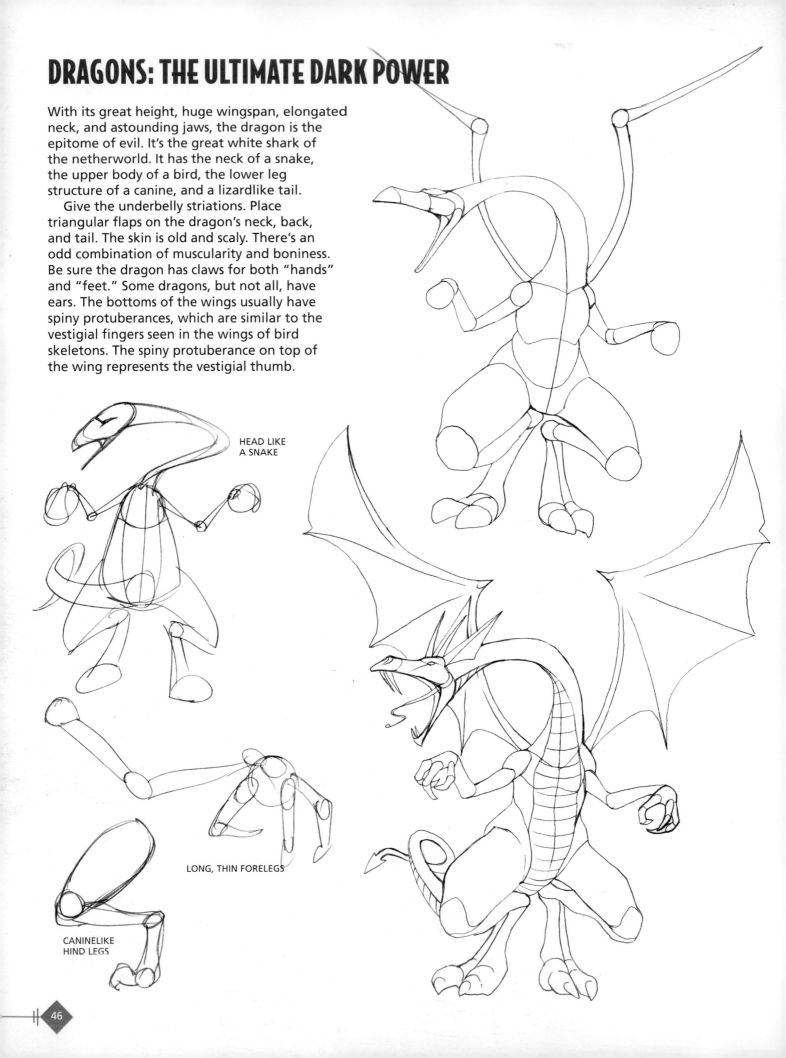

HEAD LIKE A SNAKE

LONG, THIN FORELEGS

CANINELIKE HIND LEGS

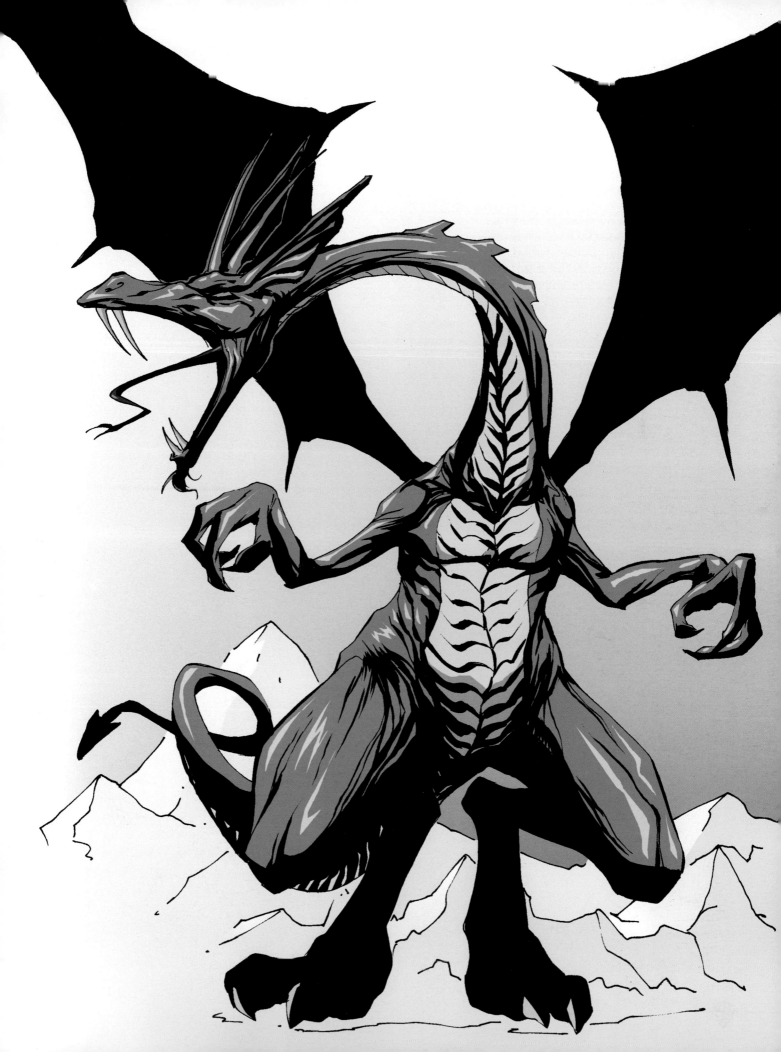

EVIL BEASTS

Demonic creatures are tremendously popular in anime. One reason is that they get a great deal more screen time in anime than they do in western animation, where evil monsters, dragons, and the like are saved for the climax of a film.

These beasts are oversized, repulsive, and ugly. They frequently have weapons protruding from their bodies, such as the deadly horns and claws on this guy. Massive shoulders and a relatively small head are representative of evil, as are eyes drawn without pupils.

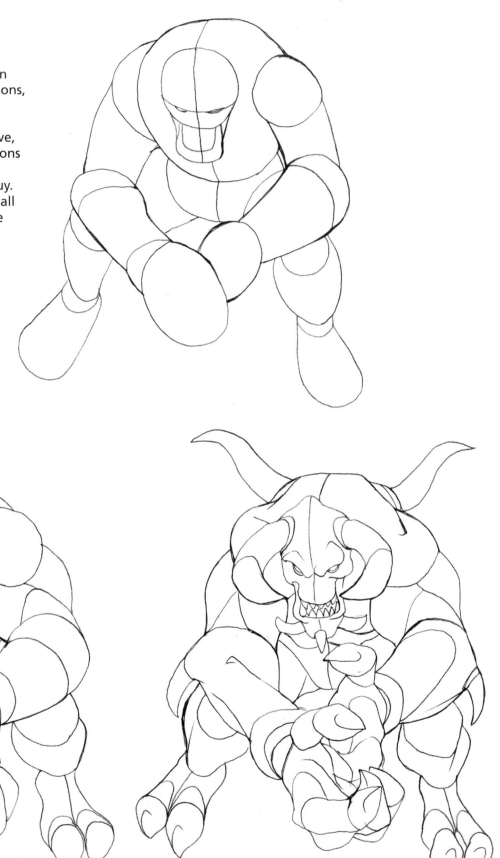

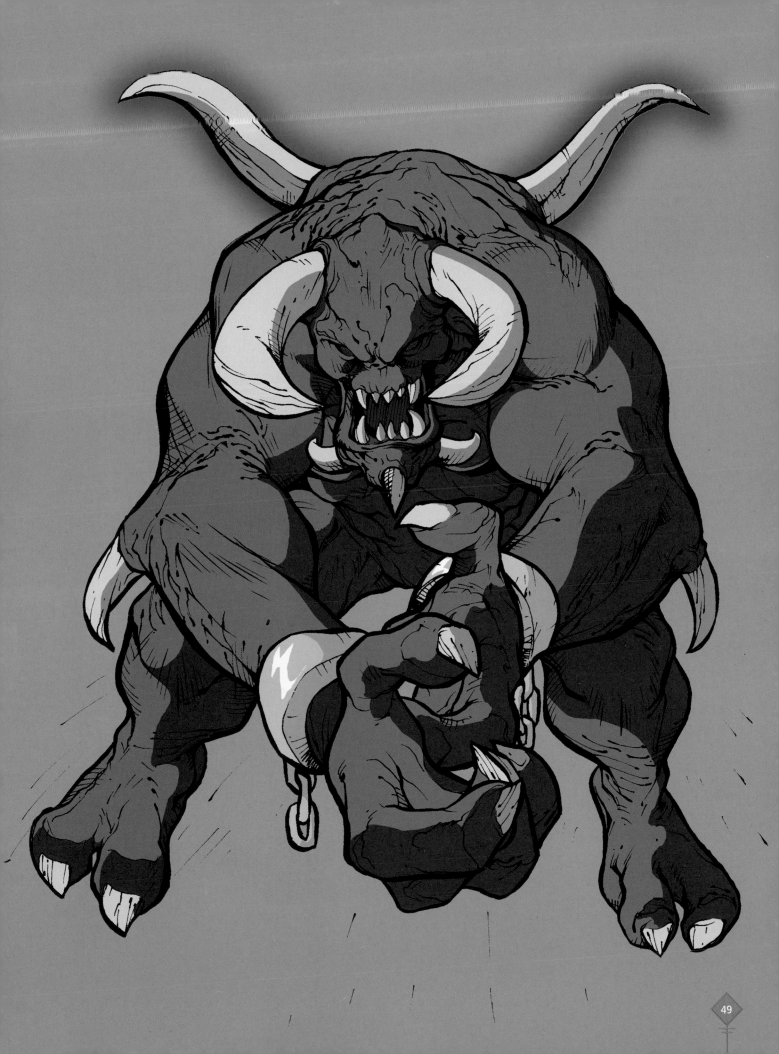

GOBLIN MONSTERS

Watch out for tiny, little, ugly guys with weird powers. They may look harmless, but they can cause strange things to happen— and, they hold grudges. Goblins are like elves having bad hair days. They're conniving little creatures with hunched backs, crooked noses, pointy ears, sagging knees, and pointy feet.

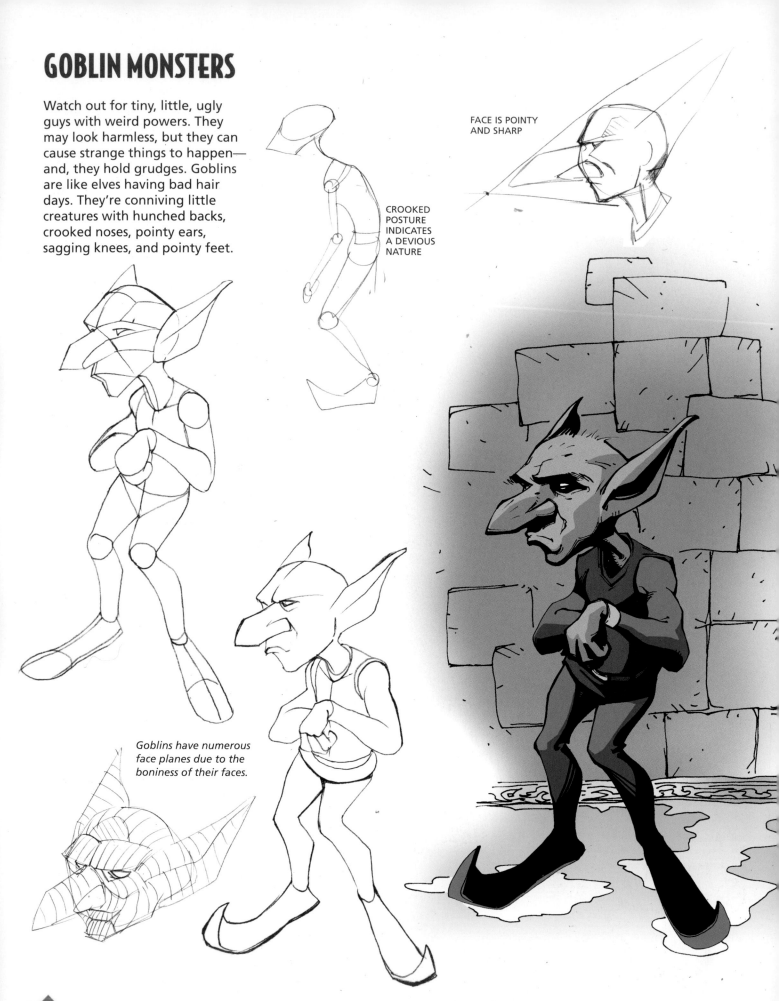

CROOKED POSTURE INDICATES A DEVIOUS NATURE

FACE IS POINTY AND SHARP

Goblins have numerous face planes due to the boniness of their faces.

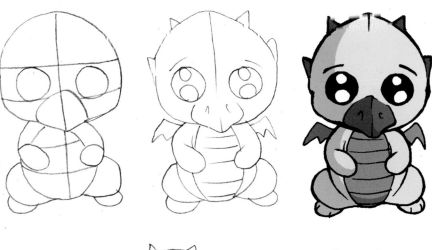

FRIENDLY CRITTERS

Not all monsters are bad. Some are good, even cute, kind of like puppy dogs for fantasy warriors—except that they don't have accidents or chew up the furniture. You can even turn the most notorious villain of all fantasydom, the dragon, into something warm and fuzzy. Cute critters are usually short and chubby, with relatively large heads compared to their bodies (the same proportions as you find on babies). They have huge, open eyes and small mouths. Good monsters are often helpers to their human companions and have considerable powers for their diminutive sizes.

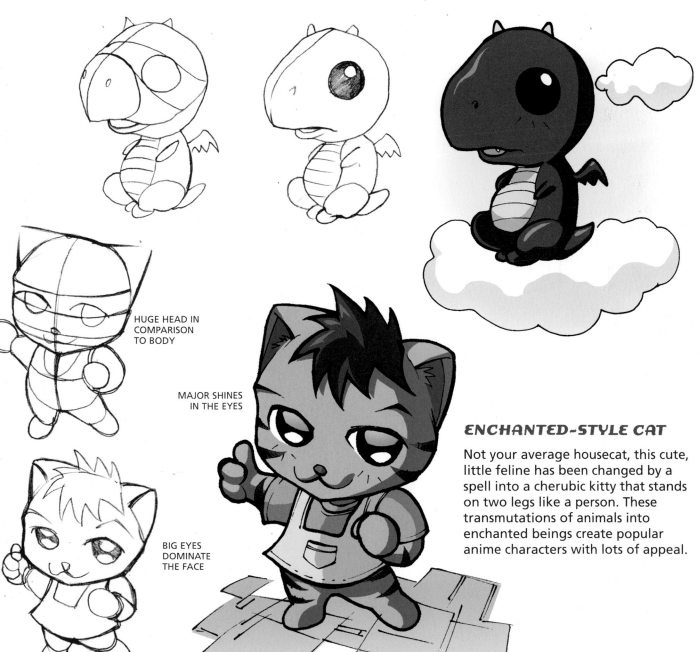

HUGE HEAD IN COMPARISON TO BODY

MAJOR SHINES IN THE EYES

BIG EYES DOMINATE THE FACE

ENCHANTED-STYLE CAT

Not your average housecat, this cute, little feline has been changed by a spell into a cherubic kitty that stands on two legs like a person. These transmutations of animals into enchanted beings create popular anime characters with lots of appeal.

A BOY AND HIS MONSTER

In anime, a boy and his dog are replaced with a boy and his monster. Boys and girls often have magical, outright silly, tiny monster companions. Their heads and bodies are made up of a variety of kooky shapes and strange proportions. There are no rules for drawing these little pals. Just let your imagination run wild.

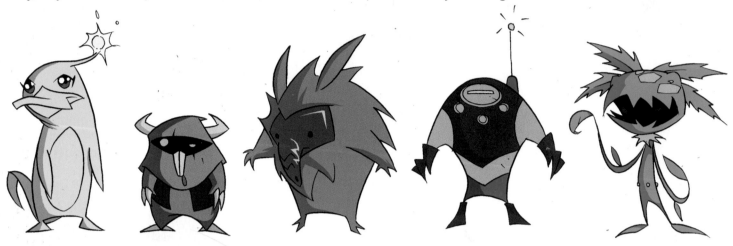

EXPRESSIONS

Tiny monsters typically go way over the top with their emotions, carrying them to hilarious extremes.

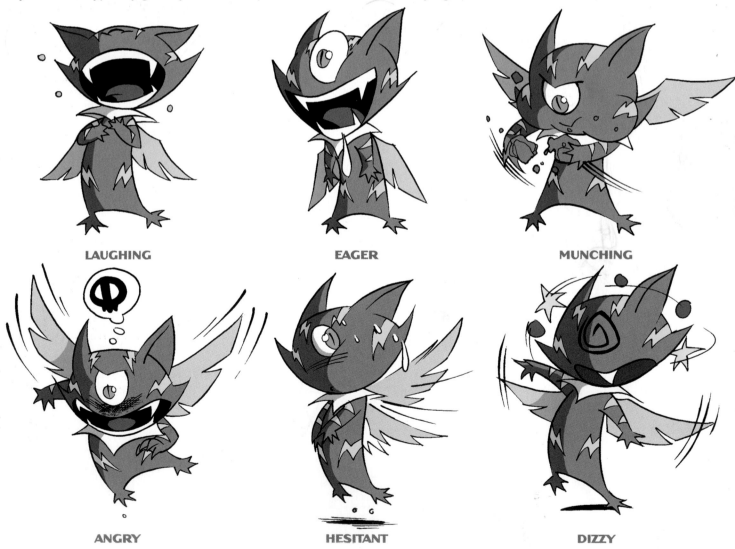

LAUGHING **EAGER** **MUNCHING**

ANGRY **HESITANT** **DIZZY**

Elves are good guys. Trolls and goblins are bad guys. Elves are thin, somewhat delicate spirits of nature. They have pointy ears of considerable length, small noses (or none at all), small mouths, and faces that taper to a point. Their clothes are earthy, made up of loose-fitting garments that look as if they come from the Middle Ages.

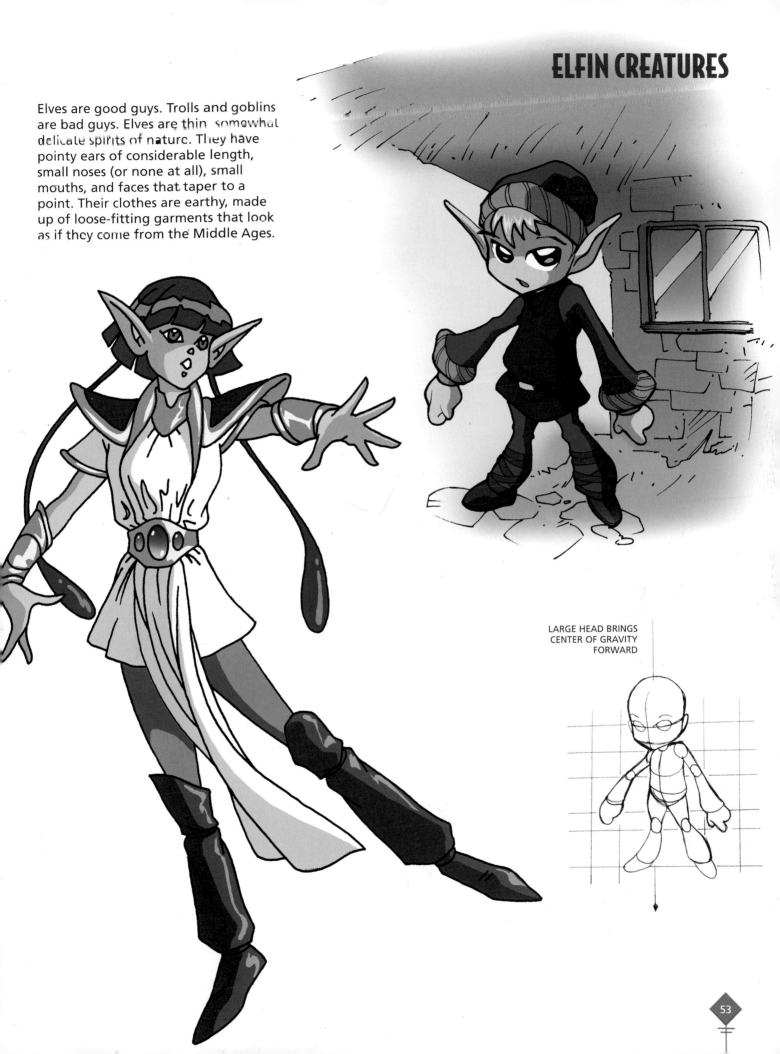

LARGE HEAD BRINGS
CENTER OF GRAVITY
FORWARD

FANTASY WARRIORS

The costumes of fantasy warriors are more ornate and lighter than those of classical knights. A real knight's armor was unbelievably bulky and heavy, and not as tailored as that of the fantasy warrior.

Bulky armor with spikes sticking out all over is better suited to a villainous character. A heroic character, such as the one here who sports a cape for dramatic flair and a winged helmet, is like David fighting against Goliath.

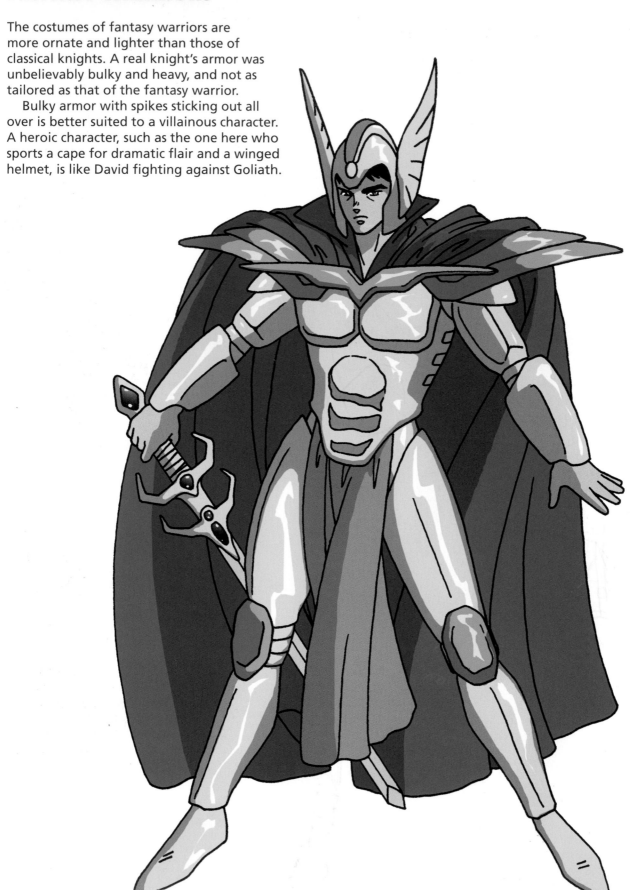

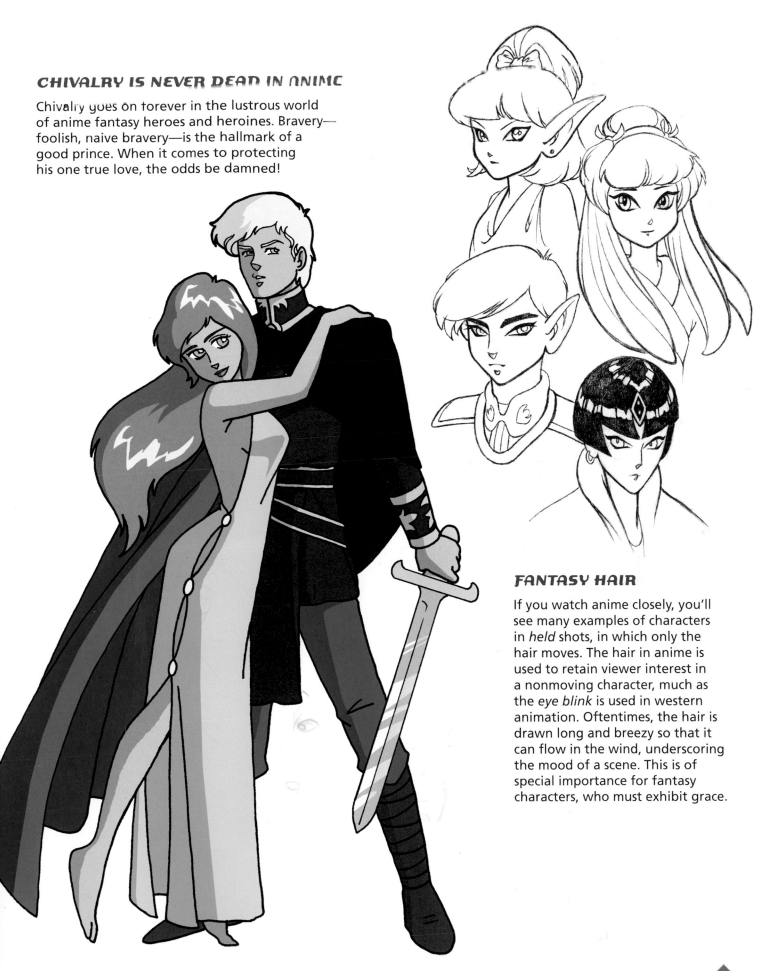

CHIVALRY IS NEVER DEAD IN ANIME

Chivalry goes on forever in the lustrous world of anime fantasy heroes and heroines. Bravery—foolish, naive bravery—is the hallmark of a good prince. When it comes to protecting his one true love, the odds be damned!

FANTASY HAIR

If you watch anime closely, you'll see many examples of characters in *held* shots, in which only the hair moves. The hair in anime is used to retain viewer interest in a nonmoving character, much as the *eye blink* is used in western animation. Oftentimes, the hair is drawn long and breezy so that it can flow in the wind, underscoring the mood of a scene. This is of special importance for fantasy characters, who must exhibit grace.

FURRY FOLKS

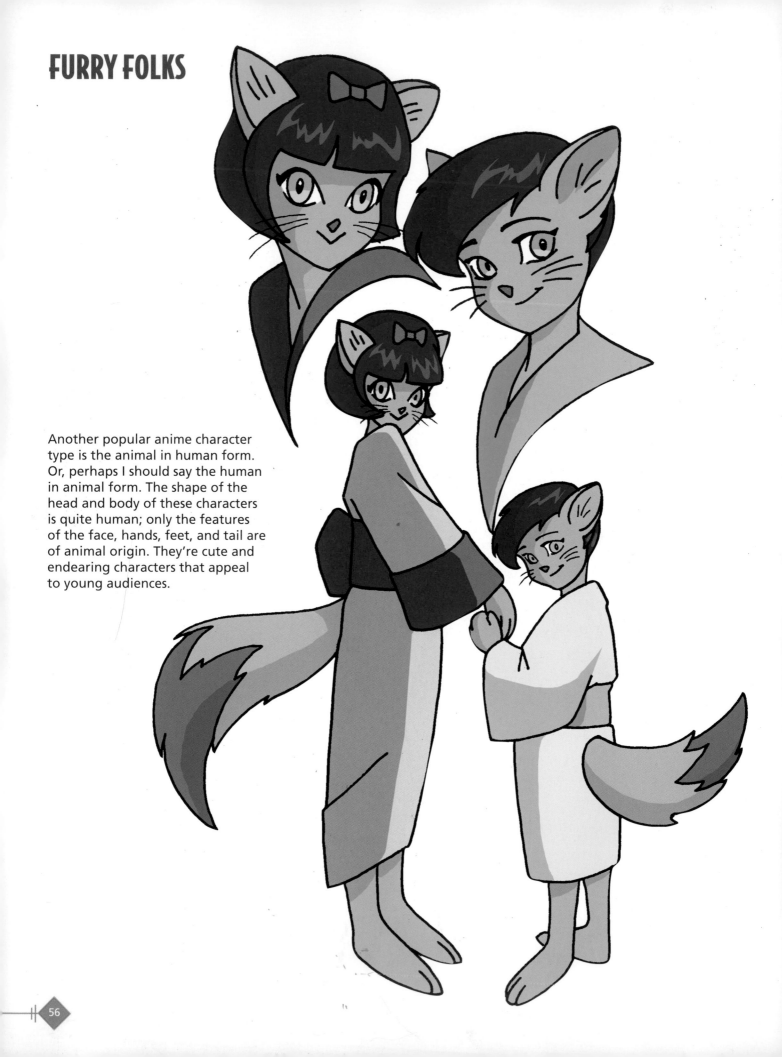

Another popular anime character type is the animal in human form. Or, perhaps I should say the human in animal form. The shape of the head and body of these characters is quite human; only the features of the face, hands, feet, and tail are of animal origin. They're cute and endearing characters that appeal to young audiences.

Any warrior on horseback takes on a mythical quality and is, therefore, popular in the fantasy genre of anime. Note that the horse, as well as the man, is costumed. Always sketch in the basic outline of the horse first—never the rider. It's the same principle as with drawing a seated person: Never draw the person before you draw the chair in which he's sitting.

The horse is a massive creature. When sketching its outline, indicate large areas for the shoulders and rump. Leave room for a sizeable, barrellike chest. Give it lots of volume. The neck is massive and joins to the body at a 45-degree angle.

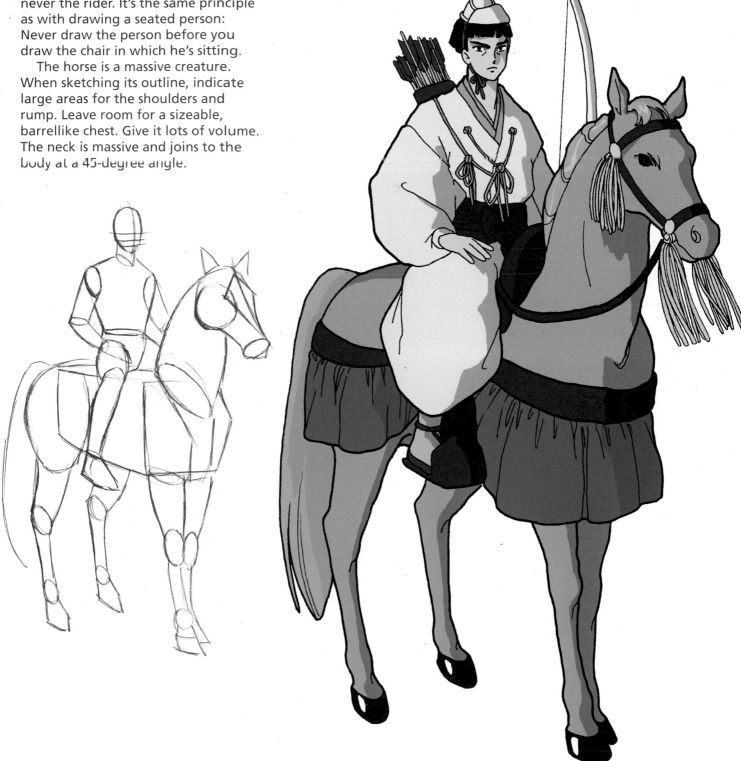

BASIC HORSE CONSTRUCTION

Like all challenges in drawing, it's easier if you attack the problem by breaking it down into its simplest components.

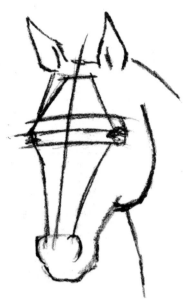

HEAD

The front of the face is flat, with eyes set very wide apart. The flat, front of the face is shaped like a very elongated marquise-cut diamond.

BODY

The horse's body is quite sturdy and elongated. Note the triangular shoulder area and the huge thigh muscles that connect to very thin legs. The chest protrudes a considerable distance past the forelegs. And the pelvis (rump) slopes down at an angle toward the tail.

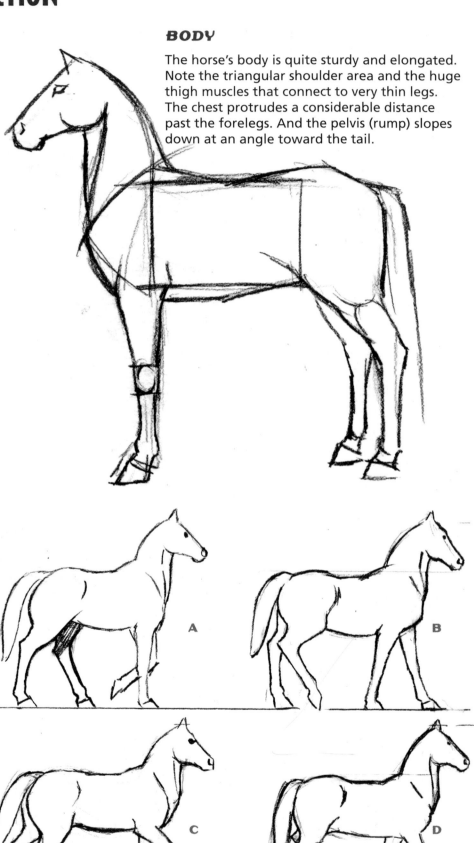

THE HORSE'S WALK

At first, the horse's walk looks impossible to fathom, but it's actually quite simple and logical. At right is a walk cycle. Cycle is an important term in animation; it indicates that a motion starts (first at point A here), proceeds (to points B and C), and finishes (at point D). The cycle then repeats itself, so here point D is then followed by point A again, then points B, C, D, A, B, C, D, A, and so on, so that it becomes a continuous cycle of motion.

The horse walks the same way as a cat or dog, moving a hind leg first, followed always by the foreleg on that same side. Beginning at point A, the horse's left hind leg has moved forward already, so the left foreleg is beginning to take a step. Then at point B, the left foreleg hits the ground and, since both limbs on the horse's left side have moved, the right hind leg begins to move. (Remember: The hind leg moves first.) By point C, the right hind leg has hit the ground, so the right foreleg starts to step. At point D, the right foreleg hits the ground, and the cycle starts all over again at point A.

LOW-TECH WEAPONS

In the world of anime fantasy dragons and monsters, intrepid knights use weapons that rely more on the physical skill of the user than on fire power. Survival depends on an indomitable spirit. The weapons should be ornate and cool looking, never simply functional. So, a sword is not a flat shaft of metal but a carefully crafted blade with ridges and a finely worked handle.

SWORD

SHIELD

CLUB

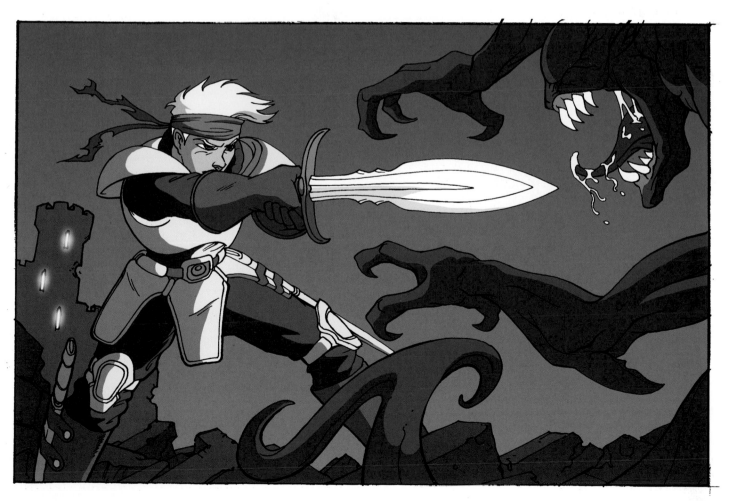

CREATING A FANTASY SCENE

Many individual elements and overarching themes are employed to create an effective scene. Here's a scene (opposite) with impact that really draws you in. You feel the energy, the fear, the imminent battle. It's a real *moment*. Let's look first at how to draw the characters, then explore the specific techniques that make a scene such as this so effective.

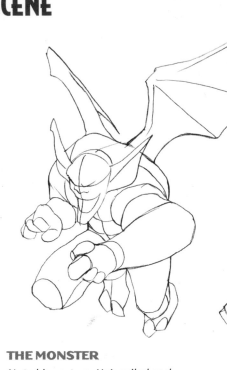

THE MONSTER

Note his posture: He's coiled and ready to pounce, giving the scene the important element of anticipation. Due to perspective (see pages 64–69) and the pose, the nearer wing looks fuller while the far one is more slender.

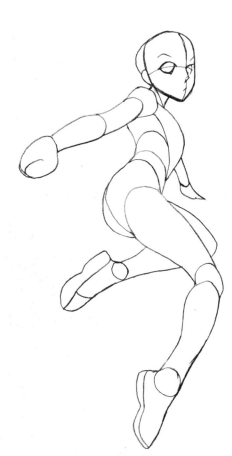

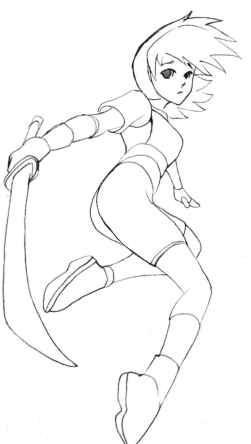

THE PROTAGONIST

In this case, this is our heroine. She is shown from a dynamic angle. She's being "squeezed"—always a good dramatic device—between the unseen monster behind her (whose crushing metal hands frame the scene and draw the eye into it) and the one in front of her. This squeeze makes you want to see what happens next. She turns back, giving the viewer a good look at her, but maintaining a forward-leaning posture, ready for action.

Her eyes are big, which immediately tells us she's an innocent.

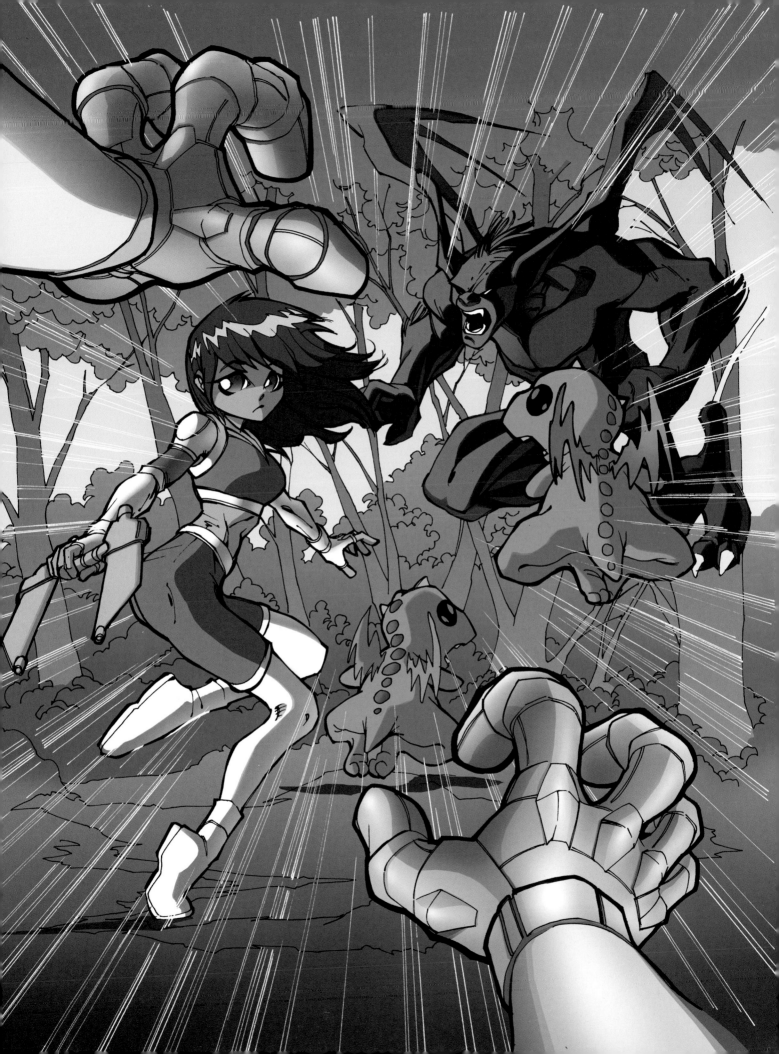

HOW THE SCENE IS DESIGNED

Many decisions go into creating a cool scene. You want to grab the audience's attention, focus it at a certain point in the scene, and redirect the eye so that it inevitably returns to that focal point. This scene is purposely set off center, which brings the audience from left to right—the direction in which people read.

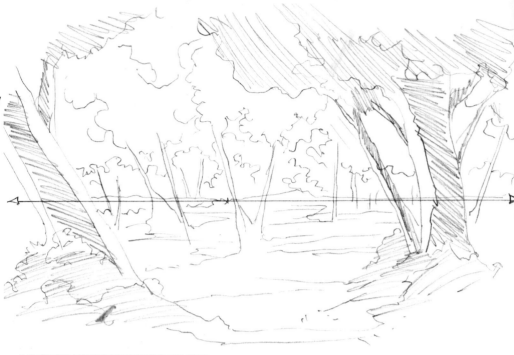

LOCATING THE HORIZON LINE

First, decide where you want to put the horizon line (where the sky meets the ground). Put the horizon line too high, and the characters flatten out against the background. Put it too low, and you lose most of the background. In this scene, the horizon line falls across the middle of the picture—but, it is closer to the ground to avoid dividing the picture evenly in two, which would create symmetry. It's a general rule that symmetry is graphically uninteresting.

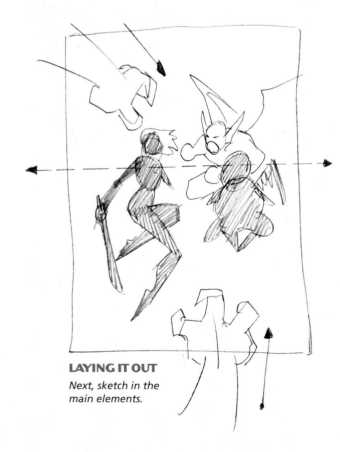

LAYING IT OUT

Next, sketch in the main elements.

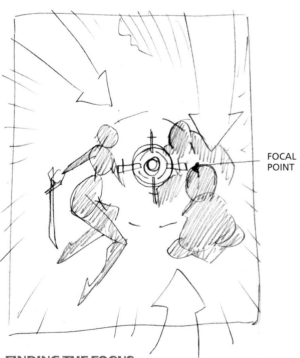

FOCAL POINT

FINDING THE FOCUS

At this point, it's a good idea to determine the focus of the scene. Once you do this, you can work to lead the viewer's eye to that point. Here, the huge hands work almost like arrows, leading the eye toward the three central figures, who are the focal point. No matter where the eye wanders, it inevitably moves away from the corners and toward those three figures.

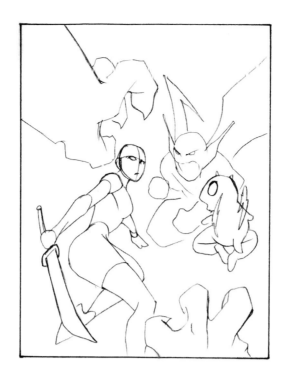

BLOCKING OUT THE ELEMENTS

Once everything is in place, you're ready to begin sketching the figures as you want them.

SHINING A SPOTLIGHT

Choosing to make certain figures dark and shadowy while hitting others with light creates its own dynamic. Here, the forces of good are bright, while the forces of evil are bathed in shadow. Darkening the shadow areas is sometimes referred to as laying down the blacks.

THE PENCIL DRAWING

Some changes were made to this pencil drawing before it appeared in its final form (on page 61). The sword was changed to a futuristic weapon to make it more unique. The clawlike hands were changed to robot hands so as to not repeat the motif of the central monster. And, more "power" lines were added to make the scene radiate with energy.

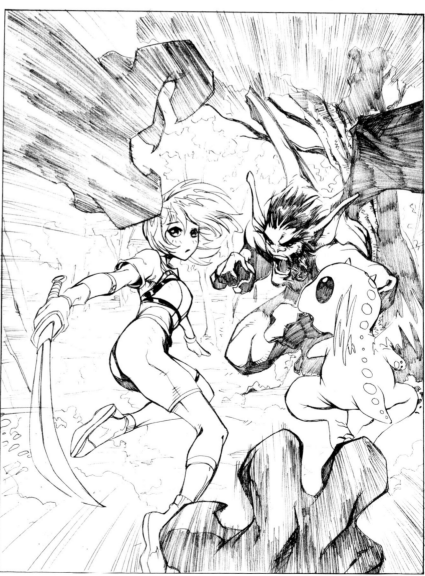

A CRASH COURSE IN PERSPECTIVE

You need some familiarity with the basic concepts of perspective in order to correctly draw the geometric shapes that make up giant robots, cool spaceships, and ultrafast submarines. Some images have so much impact that you want to duck out of the way when you look at them. This is often due to the power of perspective. It's an awesome tool to add to your repertoire of drawing techniques.

FLATNESS VS. DEPTH

There's nothing wrong with flat shots. They can be highly effective. So, please don't get the idea that every shot requires the use of exaggerated perspective and a strong feeling of depth and dimension. The story line generally determines the execution of each scene—specifically, whether a heavy use of perspective is warranted or not. If you were to draw a scene of a person casually strolling down the street window-shopping, creating exaggerated perspective would look inappropriate, even weird. But, if you were to draw a mammoth spaceship flying overhead, you would be almost required to use a great deal of perspective because this type of subject cries out for maximum impact.

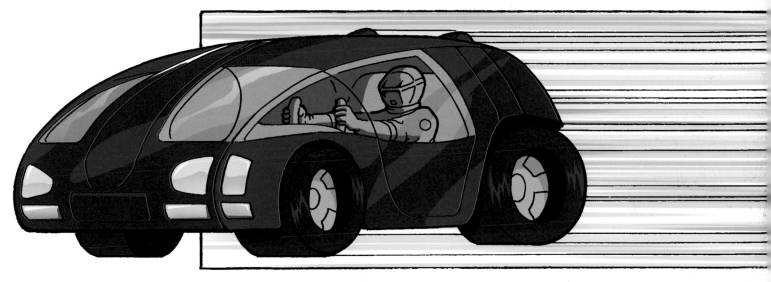

FLAT VIEW

This is a good, flat side view of a race car. It allows for the use of speed lines, which emphasize that the vehicle is moving quickly.

DIMENSIONAL VIEW

Building a strong sense of perspective into the drawing changes the subject from just a car driving fast to a car driving right past us. Now the car has proximity to us; we feel the impact of the drawing—heck, we even feel the breeze as it blows by us.

VANISHING LINES

Vanishing lines. Sounds like a magic trick, doesn't it? Well, it is a trick, of sorts. *Vanishing lines* are a set of guidelines that artists sketch around an object to help them visualize that object in perspective. When something is drawn in perspective, its *overall shape and size* diminishes along a set of guidelines, or vanishing lines, that converge at a single point on the horizon, called a *vanishing point*.

The object itself may not extend all the way to the vanishing point, but if you extend the vanishing lines of the object, the lines should all converge at a single vanishing point. You can see this on the high-speed train below. All these vehicles look as if they're really moving, even without speed lines, because they are drawn in perspective. If they were drawn flatly, they would seem motionless.

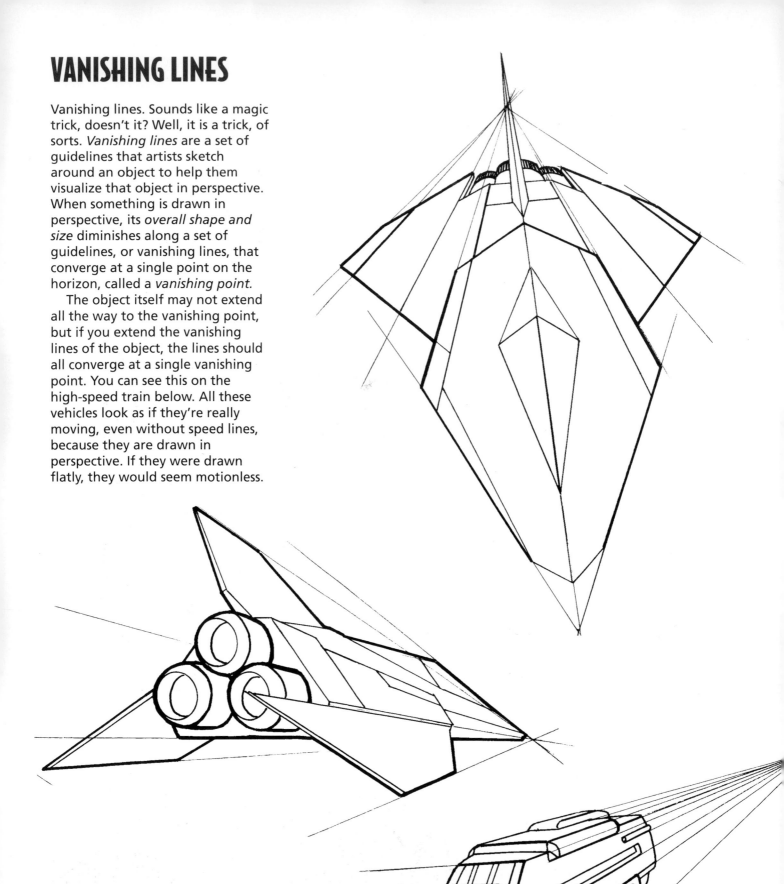

THE CLOSER IT IS, THE LARGER IT LOOKS

Vanishing lines convey a useful principle of perspective, but they shouldn't be used like a straight jacket. It's the concept they represent that's important. Take a look at the standing robot to the right. The artist hasn't drawn it rigidly, along a perfect set of vanishing lines that lead to a specific vanishing point, but the basic principles of perspective are still at play.

Vanishing lines emphasize the basic fact that objects that are close to us appear larger than objects that are further away. The reverse is also true. In anime, a common stylistic approach is to overexaggerate the largeness of the thing closest to the viewer, which, in the case of this standing robot, is its right foot. The other part of this approach is to overexaggerate the smallness of the thing furthest from the viewer, which, in this case, is the robot's head.

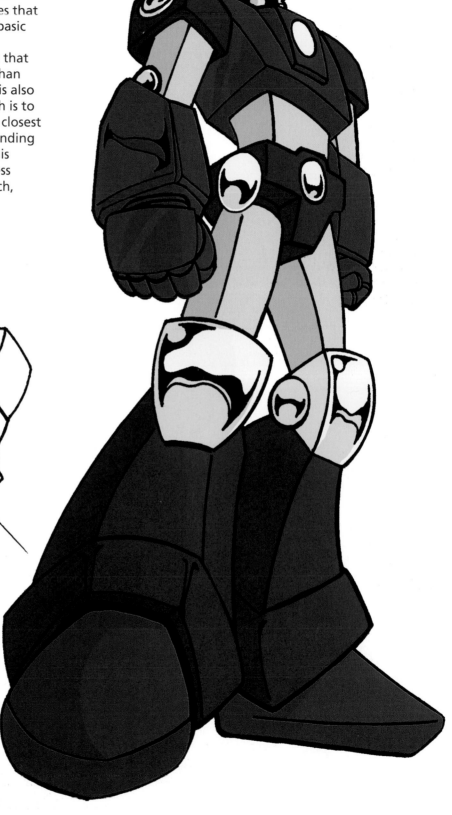

The drawing above was done in strict linear perspective, while the drawing at right employs the same principles of perspective without interpreting them so literally.

FORESHORTENING IN PERSPECTIVE

An object will appear longest when shown in a flat side view. From all other angles, the object will appear shortened to some degree. This is called *foreshortening*. It's a device that gives the illusion that an object is extending toward or away from the viewer.

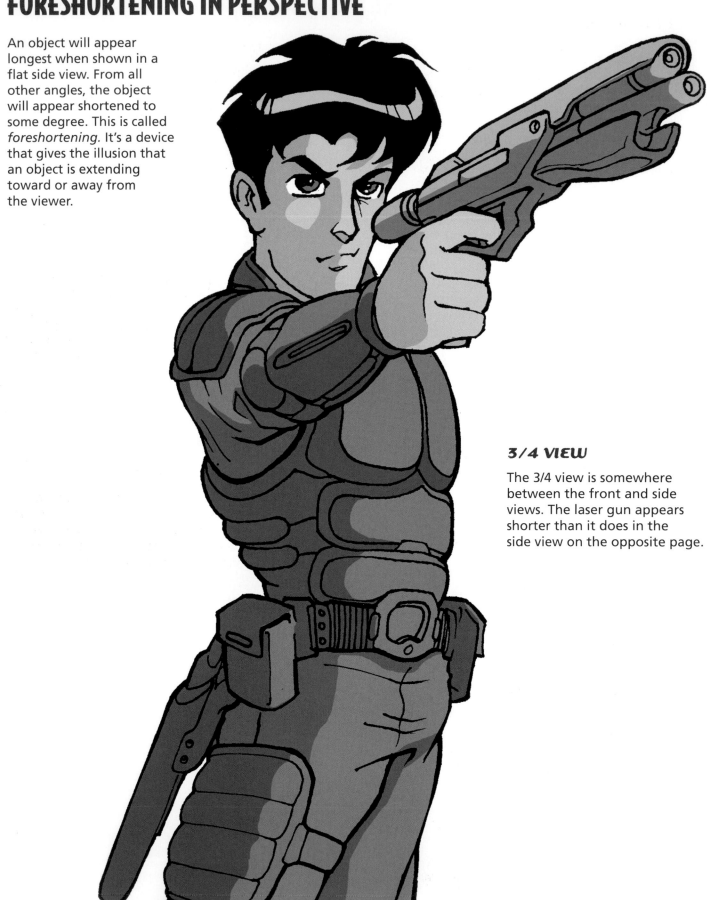

3/4 VIEW

The 3/4 view is somewhere between the front and side views. The laser gun appears shorter than it does in the side view on the opposite page.

SIDE VIEW

There is no foreshortening or exaggeration in the side view. It's flat and, as such, shows the most details about the gun.

REAR 3/4 VIEW

The gun is pointed—only slightly—toward the rear. As a result, we can see some of the rear workings of the gun, including the lens in the rear-mounted eyepiece.

FRONT VIEW

A perfect front view (or rear view) is the most foreshortened angle there is. The gun appears totally compressed.

MECHA MADNESS!

What is mecha? Just the coolest part of any anime show. It's anything having to do with high-tech robots, futuristic weaponry, space wars, special effects, vehicles, and battle armor. From the boldly confident men and women who command giant robots to the brave fighter pilots who attack fortified positions against impossible odds, mecha is the undisputed king of excitement. For many anime artists, mecha is their specialty.

ENEMY SOLDIER

If you see this guy, you'd better duck behind a desk—then say goodbye to the desk. Enemy soldiers are the first on the scene to secure an area or board a vessel. They are heavily armed and armor encased. Their armored uniforms are not formfitting like the costumes in western-style comics. Their helmets should keep them anonymous. The facelessness underscores their relentlessness, like a machine on a mission. That's not meant to say that these soldiers are always successful. Often, the hero can run faster, jump higher, and hide and dodge better. Cleverness and heart can beat out technology—but just barely.

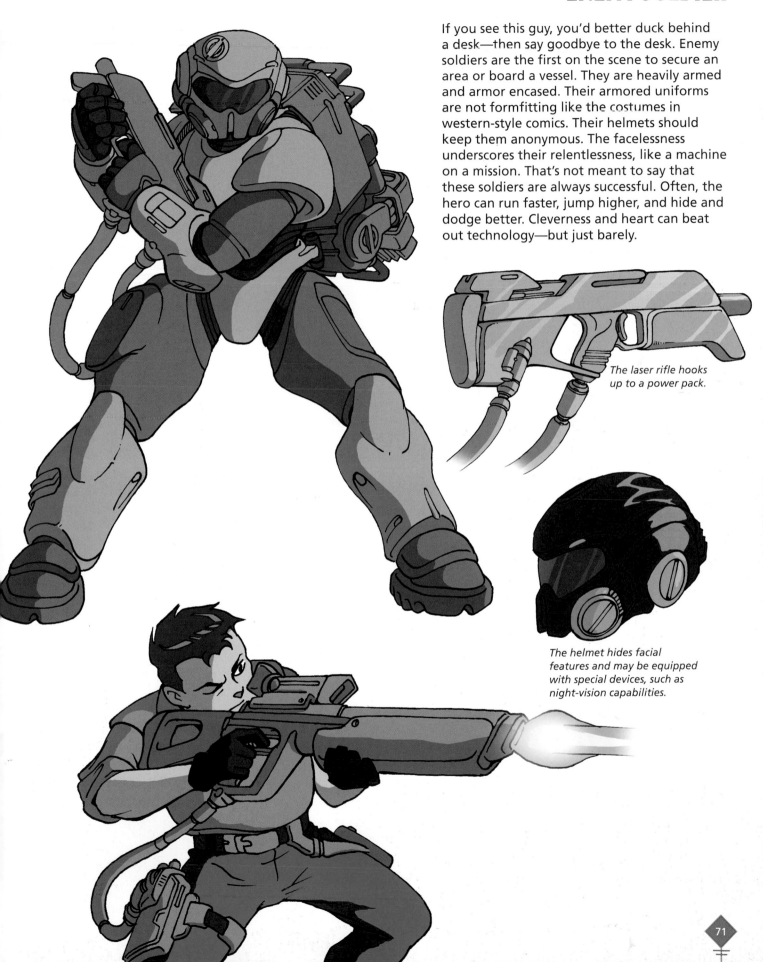

The laser rifle hooks up to a power pack.

The helmet hides facial features and may be equipped with special devices, such as night-vision capabilities.

MECHA IN SPACE

Mecha is huge in anime. In the same way that American action movies frequently feature car chases, anime has its mecha battles. But, instead of taking up only two to three minutes of screen time, as car chases do, mecha battles can fill the majority of an anime episode. It seems that the more mecha, the better!

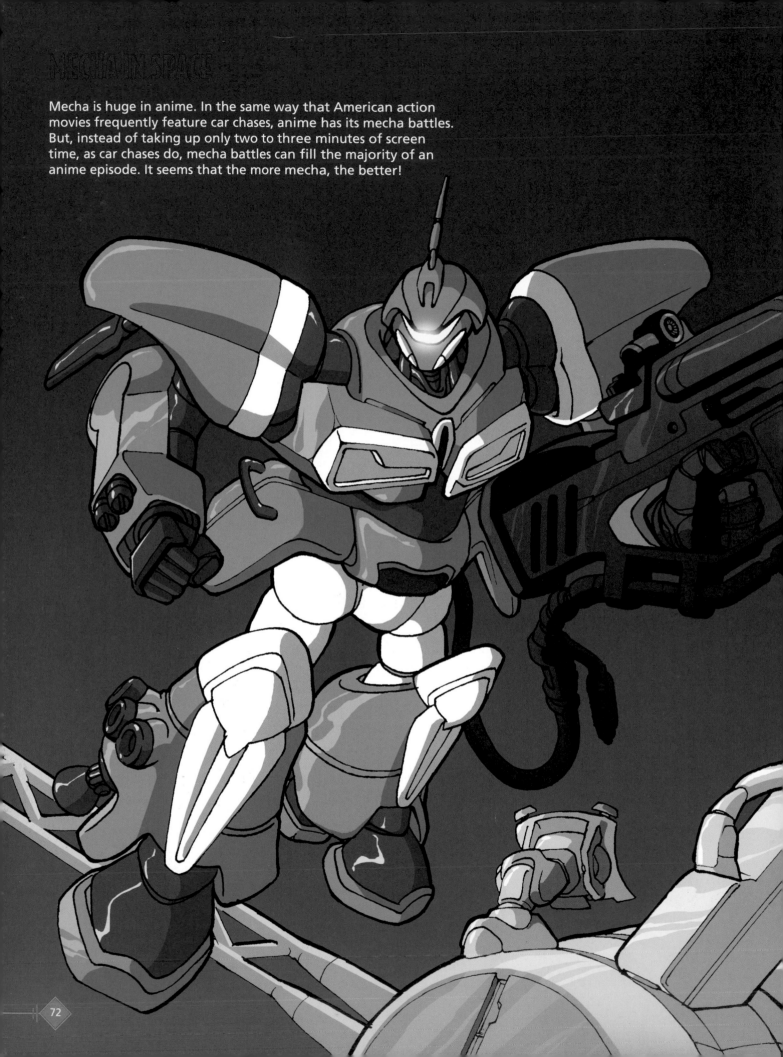

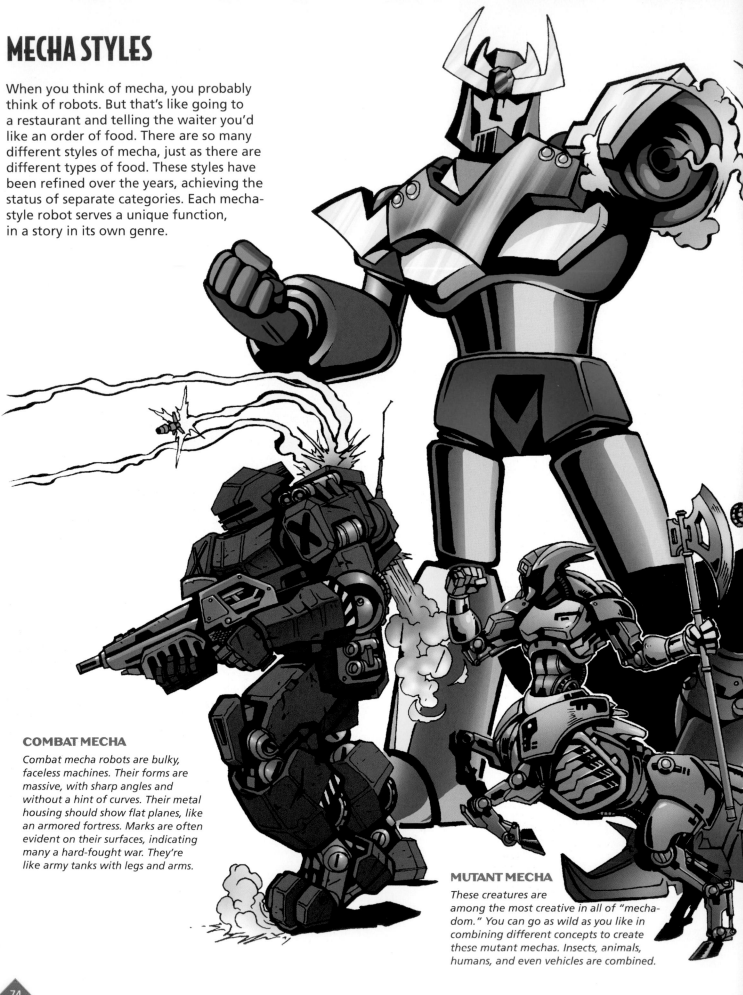

MECHA STYLES

When you think of mecha, you probably think of robots. But that's like going to a restaurant and telling the waiter you'd like an order of food. There are so many different styles of mecha, just as there are different types of food. These styles have been refined over the years, achieving the status of separate categories. Each mecha-style robot serves a unique function, in a story in its own genre.

COMBAT MECHA

Combat mecha robots are bulky, faceless machines. Their forms are massive, with sharp angles and without a hint of curves. Their metal housing should show flat planes, like an armored fortress. Marks are often evident on their surfaces, indicating many a hard-fought war. They're like army tanks with legs and arms.

MUTANT MECHA

These creatures are among the most creative in all of "mecha-dom." You can go as wild as you like in combining different concepts to create these mutant mechas. Insects, animals, humans, and even vehicles are combined.

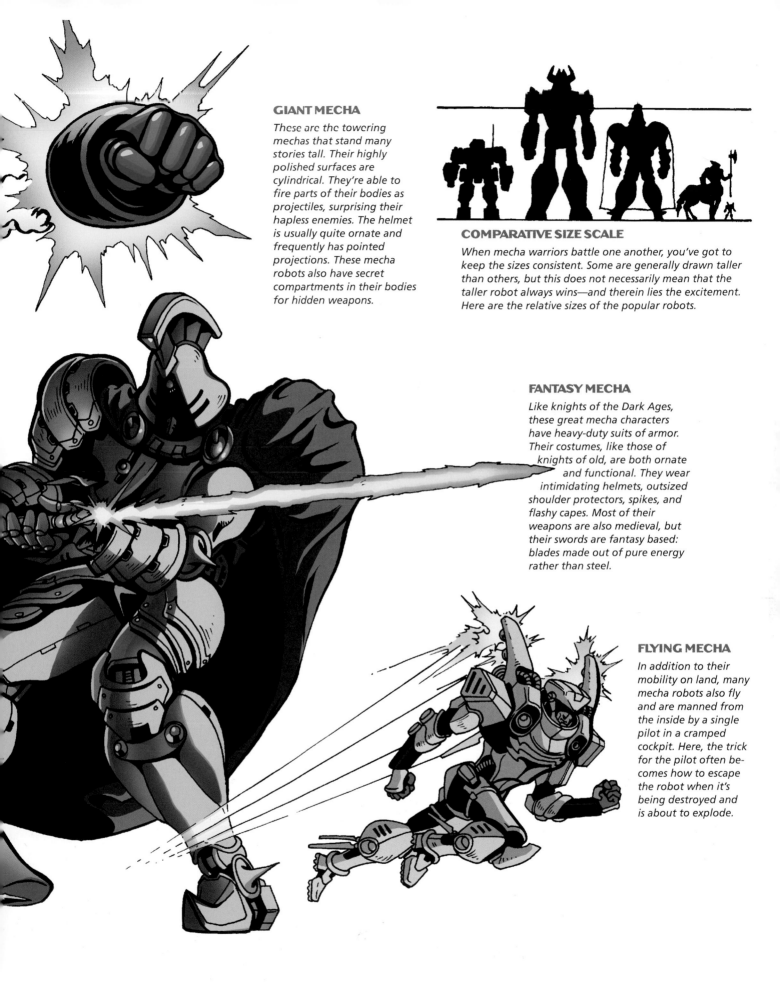

GIANT MECHA

These are the towering mechas that stand many stories tall. Their highly polished surfaces are cylindrical. They're able to fire parts of their bodies as projectiles, surprising their hapless enemies. The helmet is usually quite ornate and frequently has pointed projections. These mecha robots also have secret compartments in their bodies for hidden weapons.

COMPARATIVE SIZE SCALE

When mecha warriors battle one another, you've got to keep the sizes consistent. Some are generally drawn taller than others, but this does not necessarily mean that the taller robot always wins—and therein lies the excitement. Here are the relative sizes of the popular robots.

FANTASY MECHA

Like knights of the Dark Ages, these great mecha characters have heavy-duty suits of armor. Their costumes, like those of knights of old, are both ornate and functional. They wear intimidating helmets, outsized shoulder protectors, spikes, and flashy capes. Most of their weapons are also medieval, but their swords are fantasy based: blades made out of pure energy rather than steel.

FLYING MECHA

In addition to their mobility on land, many mecha robots also fly and are manned from the inside by a single pilot in a cramped cockpit. Here, the trick for the pilot often becomes how to escape the robot when it's being destroyed and is about to explode.

INTERNAL WORKINGS

During fight scenes, mecha robots may face destruction: Metal plating is torn, limbs are damaged, parts may need to be reassembled. It's essential to establish what the interior of the robot (the mechanical workings and the control room) looks like so that it doesn't change from episode to episode—or from animator to animator—and so that the viewer can always recognize the character/location. The black areas (negative spaces) serve to highlight the interior mechanical parts.

ARMS

The arm on the top looks like a collection of hydraulic pumps, while the one above looks like complex machinery that involves precision engineering. Remember, mecha robots have an outer shell with the gizmos on the inside.

HAND

Every individual bone in a human hand becomes a separate piece of metal, each connected to the next by a rivet. Note the outer casing that covers the fingers and thumb.

COCKPIT

The cockpit is always small compared to the overall immensity of the robot. It should be teaming with instrument panels. There is always a visual monitor or window so that the pilot can see what is happening outside. Those handles attached to the back of the seat are for the pilot, who may have to eject himself from the mecha if it's about to blow.

VISOR

The visor displays highly sophisticated electronics used for visual contact, radar tracking, heat-seeking, and command programming. It should look like the interior of a computer.

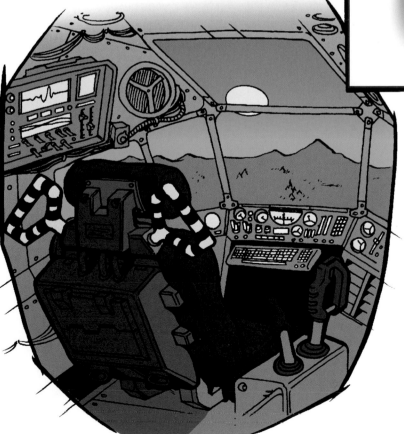

FOOT

Note the heavy treads for gripping, which are visible on the underside of the boot. They help these guys trudge over rubble.

AMAZING TRANSFORMATIONS

A transformation occurs when a mecha character, vehicle, or weapon unfolds and reassembles itself in a totally new form. Anything can transform into anything else, as long as the transformation appears to flow in a logical manner. Weapons can transform into other weapons, vehicles can transform into robots, and so on. A series of small explosions carries each step of the transformation forward.

Transformations are cool and are a great way to use the element of surprise. Imagine seeing a disabled tank on a hill. Looks like nothing. But once the enemy gets within reach, the tank suddenly transforms itself into a humongous mecha warrior and turns the tables on the enemy.

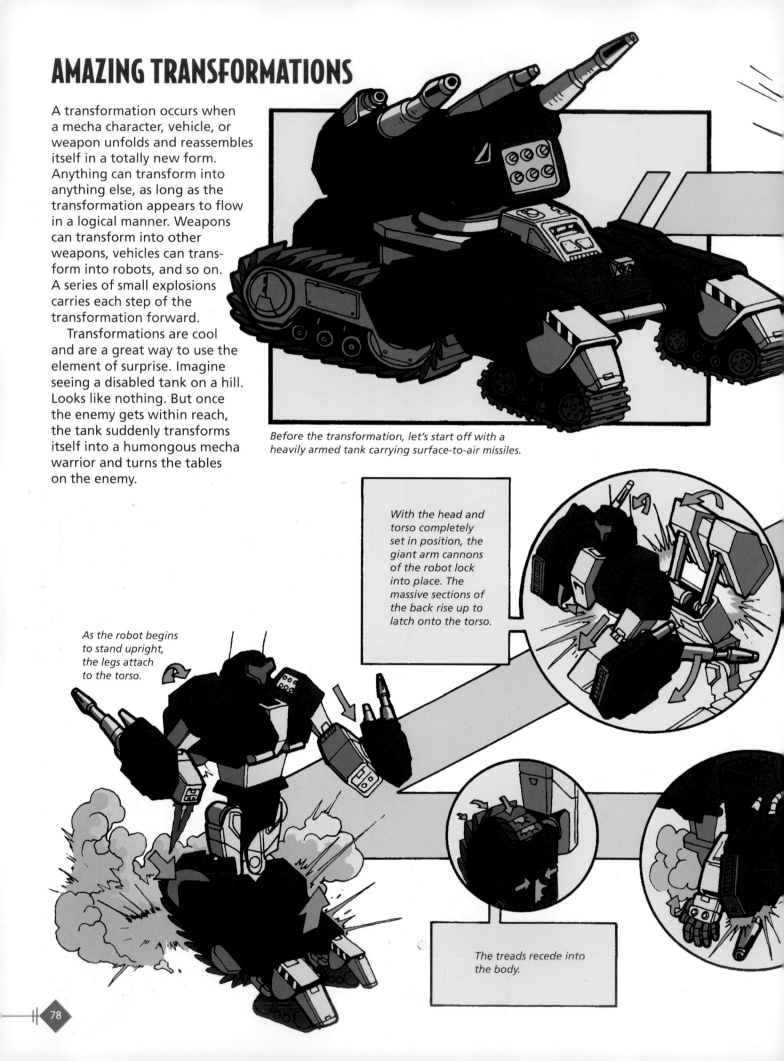

Before the transformation, let's start off with a heavily armed tank carrying surface-to-air missiles.

With the head and torso completely set in position, the giant arm cannons of the robot lock into place. The massive sections of the back rise up to latch onto the torso.

As the robot begins to stand upright, the legs attach to the torso.

The treads recede into the body.

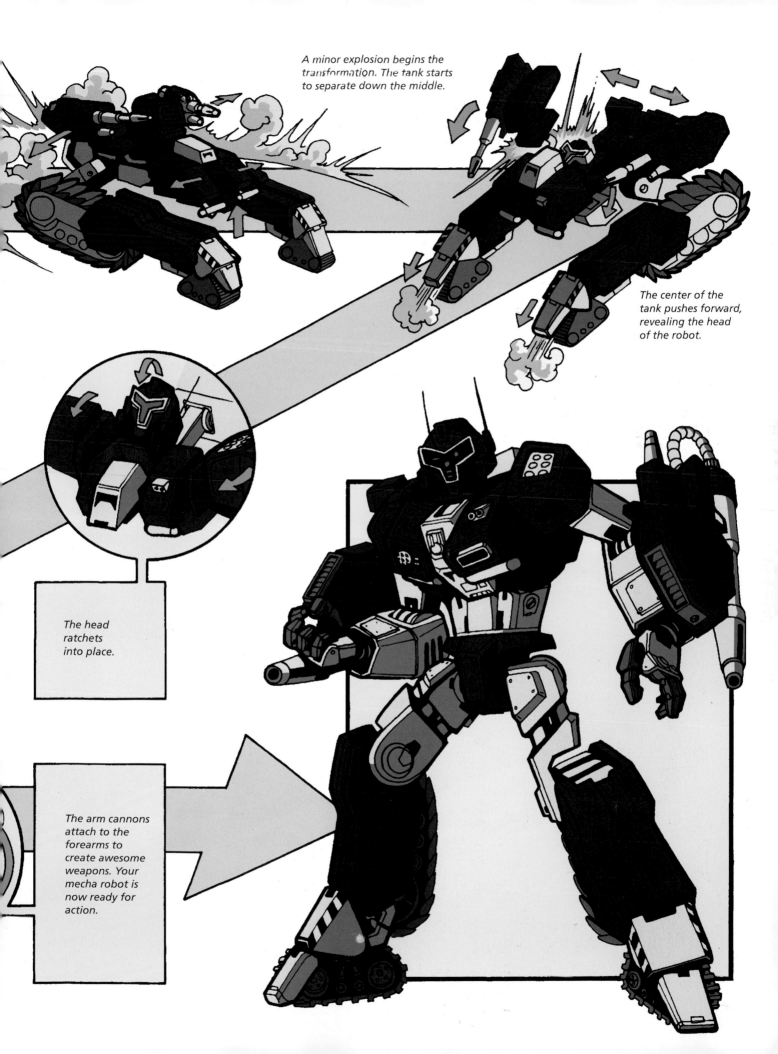

A minor explosion begins the transformation. The tank starts to separate down the middle.

The center of the tank pushes forward, revealing the head of the robot.

The head ratchets into place.

The arm cannons attach to the forearms to create awesome weapons. Your mecha robot is now ready for action.

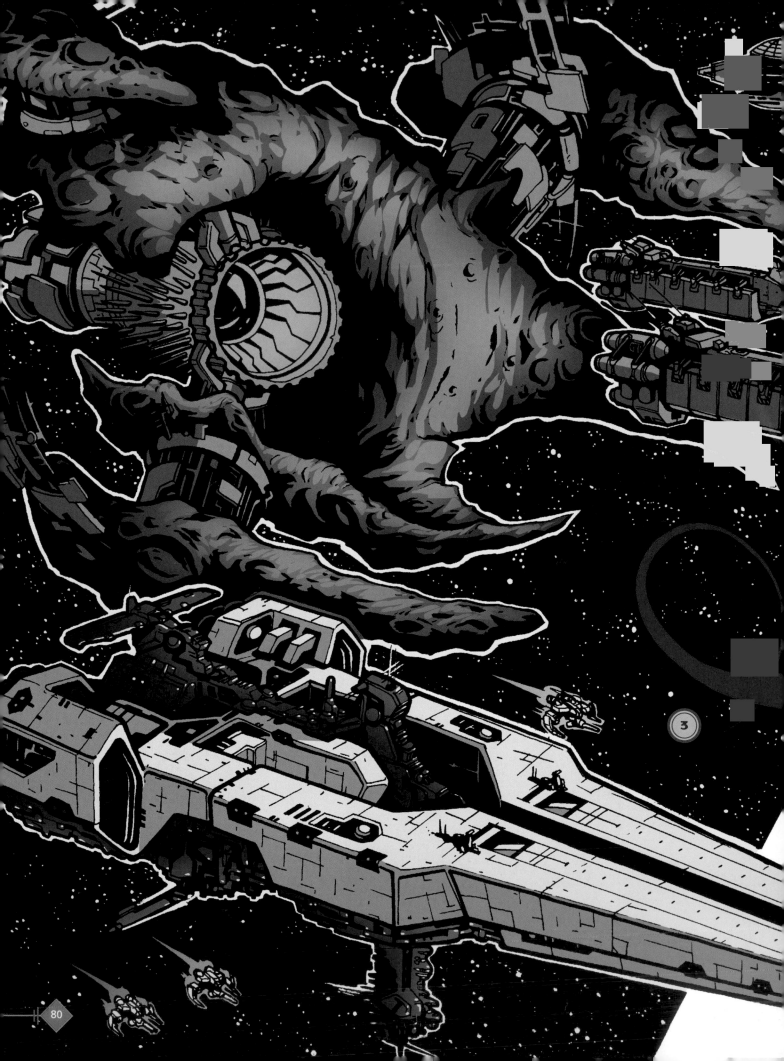

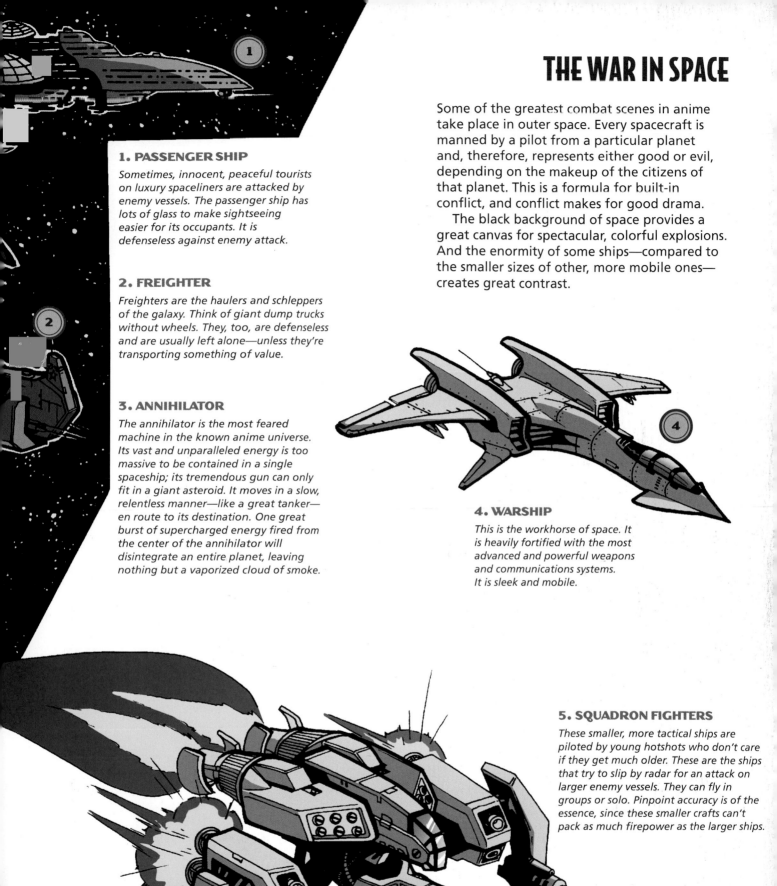

THE WAR IN SPACE

Some of the greatest combat scenes in anime take place in outer space. Every spacecraft is manned by a pilot from a particular planet and, therefore, represents either good or evil, depending on the makeup of the citizens of that planet. This is a formula for built-in conflict, and conflict makes for good drama.

The black background of space provides a great canvas for spectacular, colorful explosions. And the enormity of some ships—compared to the smaller sizes of other, more mobile ones—creates great contrast.

1. PASSENGER SHIP

Sometimes, innocent, peaceful tourists on luxury spaceliners are attacked by enemy vessels. The passenger ship has lots of glass to make sightseeing easier for its occupants. It is defenseless against enemy attack.

2. FREIGHTER

Freighters are the haulers and schleppers of the galaxy. Think of giant dump trucks without wheels. They, too, are defenseless and are usually left alone—unless they're transporting something of value.

3. ANNIHILATOR

The annihilator is the most feared machine in the known anime universe. Its vast and unparalleled energy is too massive to be contained in a single spaceship; its tremendous gun can only fit in a giant asteroid. It moves in a slow, relentless manner—like a great tanker—en route to its destination. One great burst of supercharged energy fired from the center of the annihilator will disintegrate an entire planet, leaving nothing but a vaporized cloud of smoke.

4. WARSHIP

This is the workhorse of space. It is heavily fortified with the most advanced and powerful weapons and communications systems. It is sleek and mobile.

5. SQUADRON FIGHTERS

These smaller, more tactical ships are piloted by young hotshots who don't care if they get much older. These are the ships that try to slip by radar for an attack on larger enemy vessels. They can fly in groups or solo. Pinpoint accuracy is of the essence, since these smaller crafts can't pack as much firepower as the larger ships.

SUPERFAST SUBMARINES

It's not just the skies that are filled with excitement in anime. A lot of action happens below the ocean, as well, in what's sometimes referred to as *liquid space*. You can draw anime submarines conventionally, as huge, hovering cylinders, or you can modernize them to look like underwater supersonic jets. This sleek version of a sub has massive jets in back, which are capable of moving the vessel at high speeds. The three doors between the engines on the underside of the hull open and close to let smaller underwater vehicles enter or leave the body of the sub.

LOWER DECKS

The lower decks are where the crew performs its maintenance on the sub and services smaller crafts. Since this area is lit with interior overhead bulbs, the shadows are sharp and black. The interior of a submarine has no amenities to make it look more liveable; it's always bare and industrial looking.

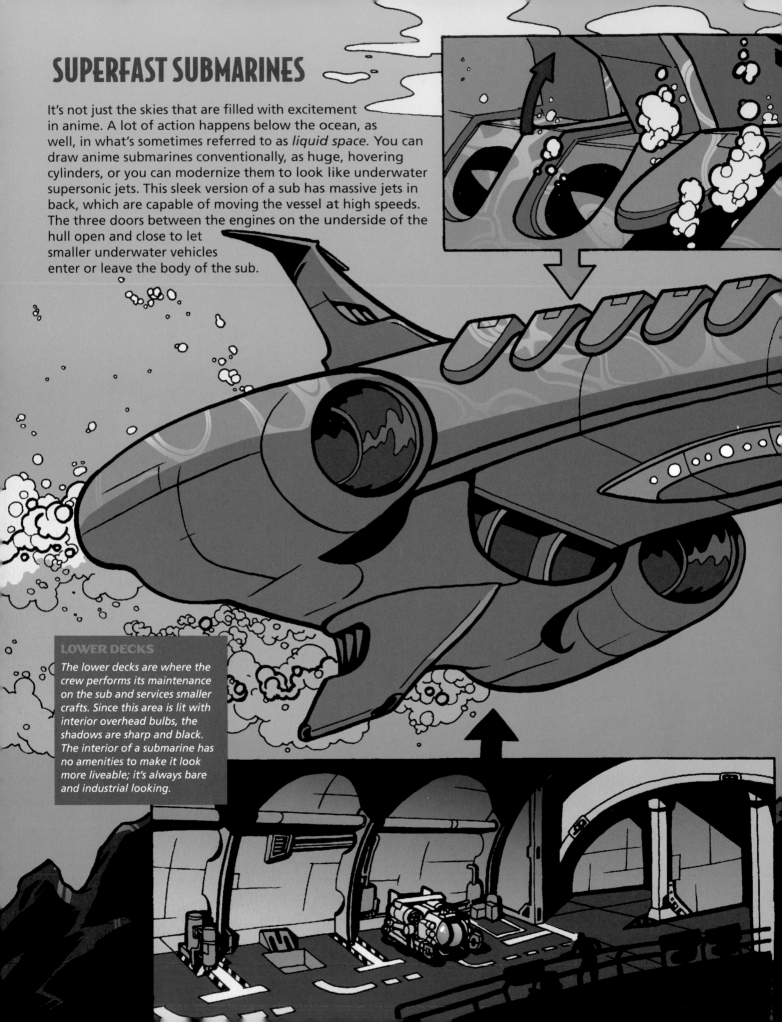

MISSILE LAUNCHERS

Missiles launch from hidden compartments on the top of the sub. Bubbles waft upward as the compartments open.

BRIDGE

Although we tend to think of submarine commanders as standing at the center of the sub, peering through a periscope, the modern submarine has a front row seat for its commander at the helm of the ship.

ATTACK CHOPPERS

Anime helicopters are fierce gun ships with fabulous maneuverability. They can hover, like birds of prey, and fire missiles into the heart of a building, a giant robot, an urban assault vehicle, or a tank. The nose drops down on the attack chopper, giving it a decidedly aggressive posture. The wings also bend down, with a similarly bad attitude.

Since different sections of the attack helicopter tilt at different angles, it's best if you break the chopper up into a few basic shapes first. In the final drawing, the blade is spinning too fast to see, so draw it as a blurry outline.

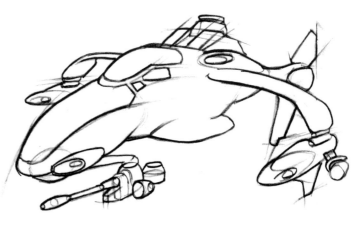

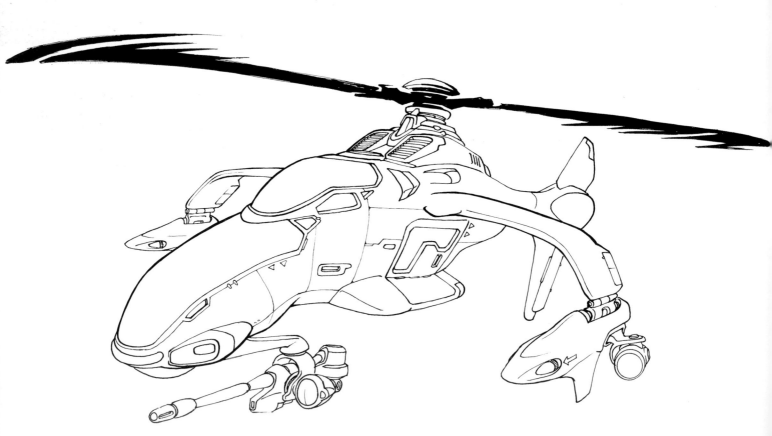

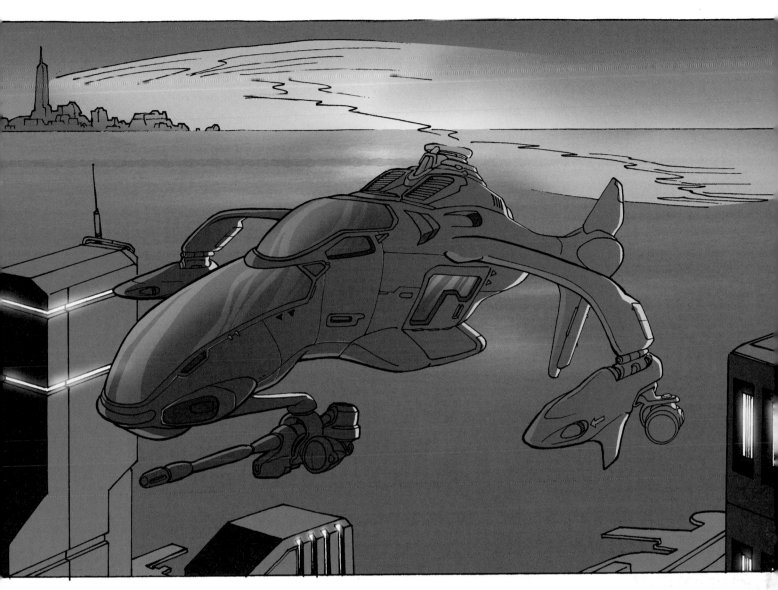

PATROLLING THE CITY

Here's the finished product: a helicopter patrolling the city, keeping the streets safe not from robbers and gangs, but from giant robots and invading armies. Much of anime takes place in a postapocalyptic world where wars rage for years. So, the patrolling helicopter is a familiar sight in the night sky.

CARS OF THE NEXT CENTURY

These zippy little cars are low to the ground and bubble shaped. By creating futuristic cars, you immediately communicate to your audience that the story takes place in another time. Anime cars are blazingly fast, so they must look as if they were designed to create or experience no wind resistance; they're aerodynamically perfect. Long, sleek lines and curves are key. Avoid hard angles and boxy shapes.

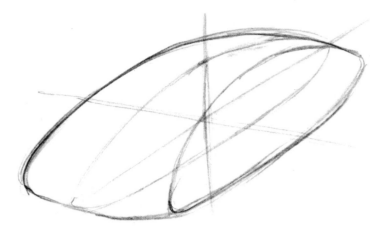

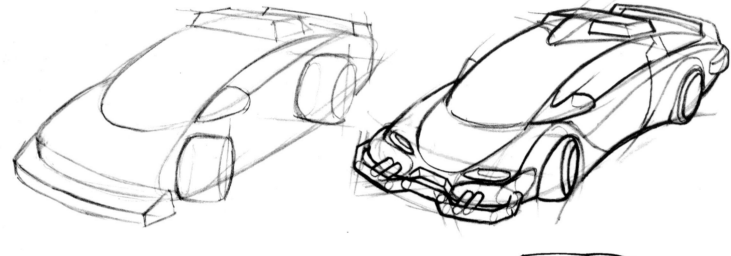

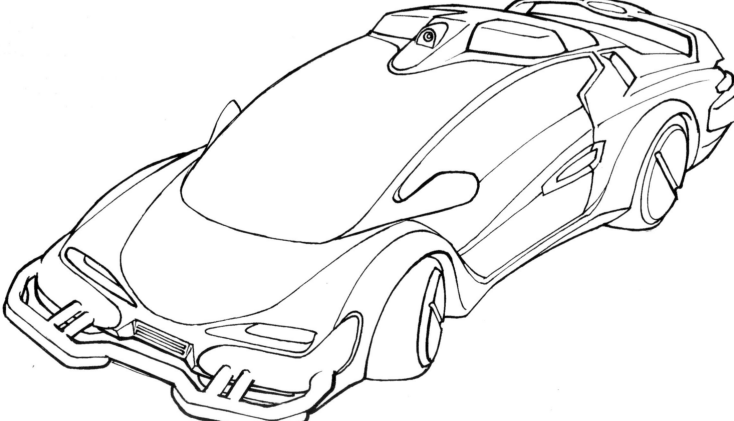

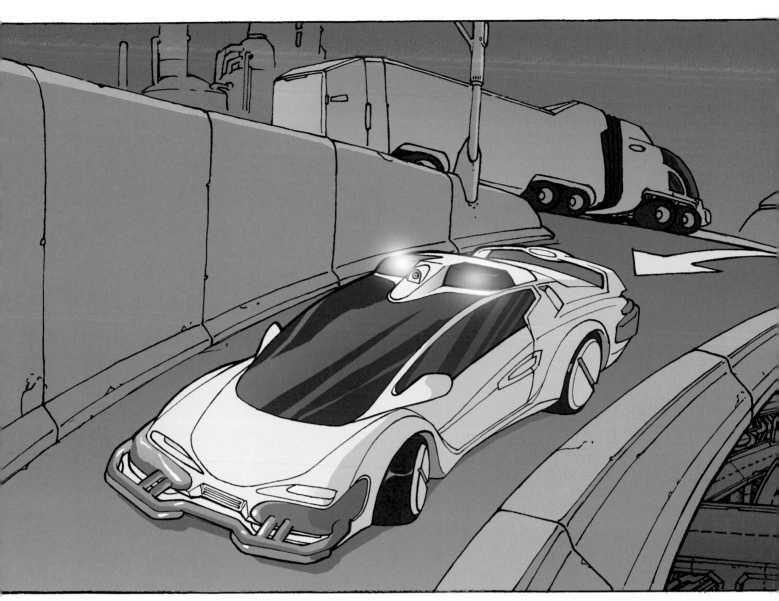

As you may have gleaned from popular sports car advertisements, one of the most attractive angles at which to show a car is the 3/4 view, which conveys the maximum amount of visual information about the vehicle.

URBAN ASSAULT VEHICLES

These military vehicles are long and impenetrable. The tires are massive and there are eight of them, suggesting that these vehicles are heavy and tough. The cannon on top is completely mobile—360 degrees around—and so can fire at anything. While the attack helicopter is used for a pinpoint air assault on a city, the urban assault vehicle is intended for the same use, only from the street.

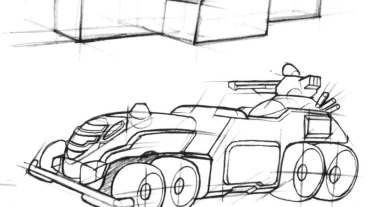

This scene depicts an all-out assault on rebel positions by supreme forces.

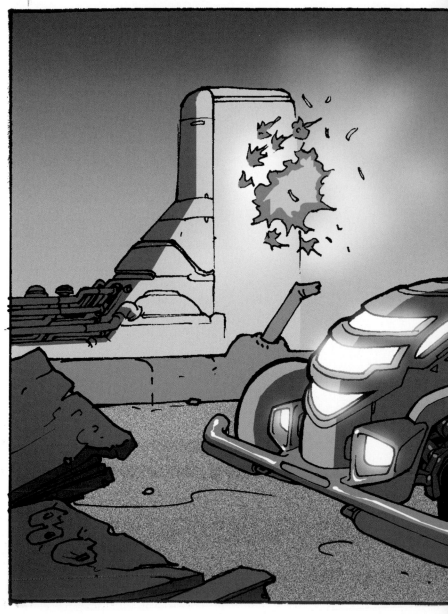

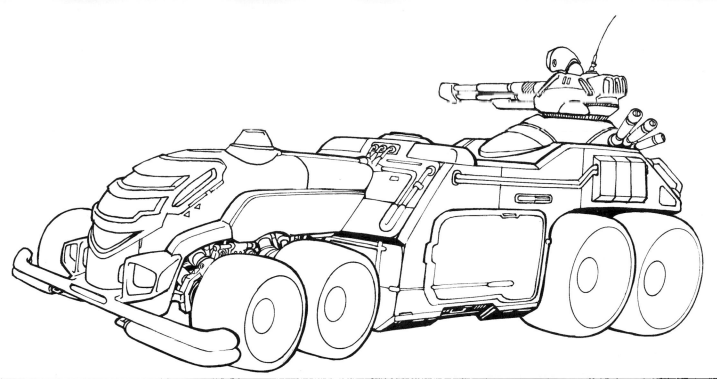

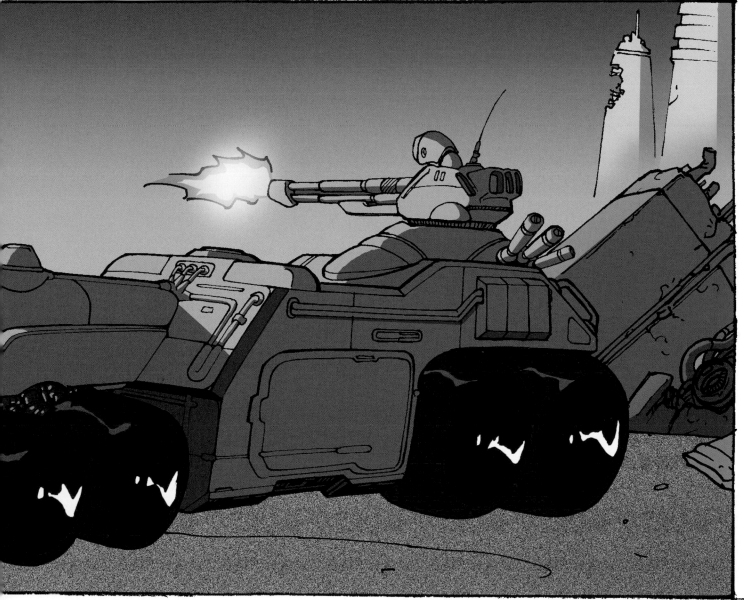

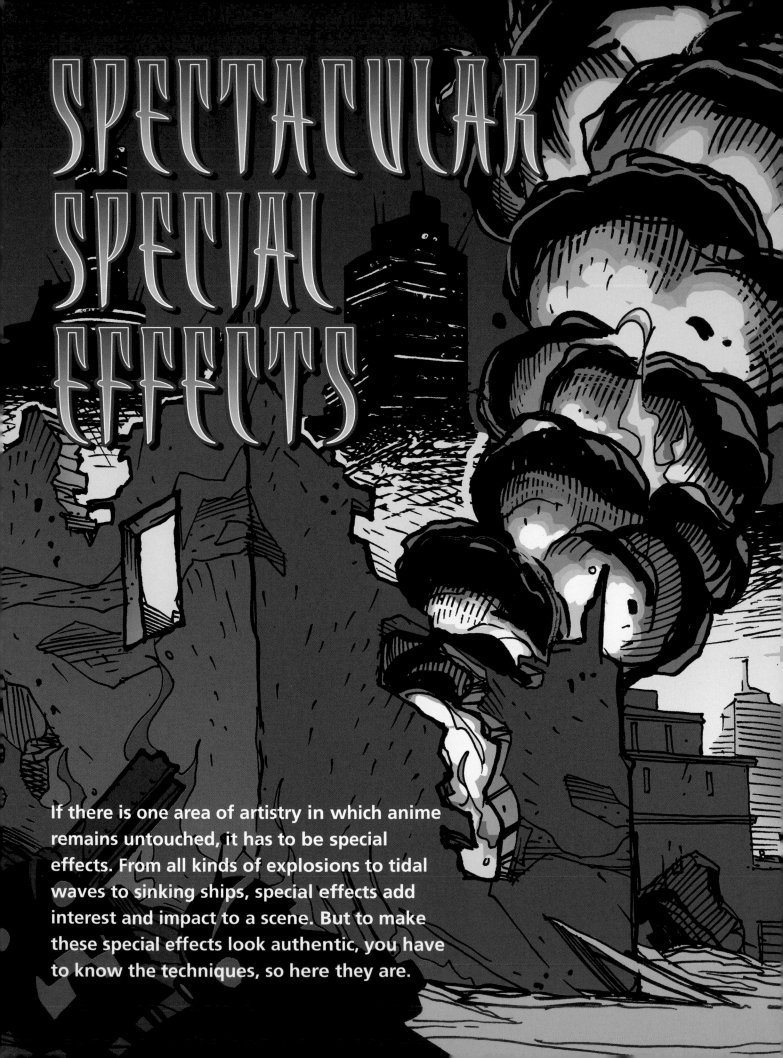

SPECTACULAR SPECIAL EFFECTS

If there is one area of artistry in which anime remains untouched, it has to be special effects. From all kinds of explosions to tidal waves to sinking ships, special effects add interest and impact to a scene. But to make these special effects look authentic, you have to know the techniques, so here they are.

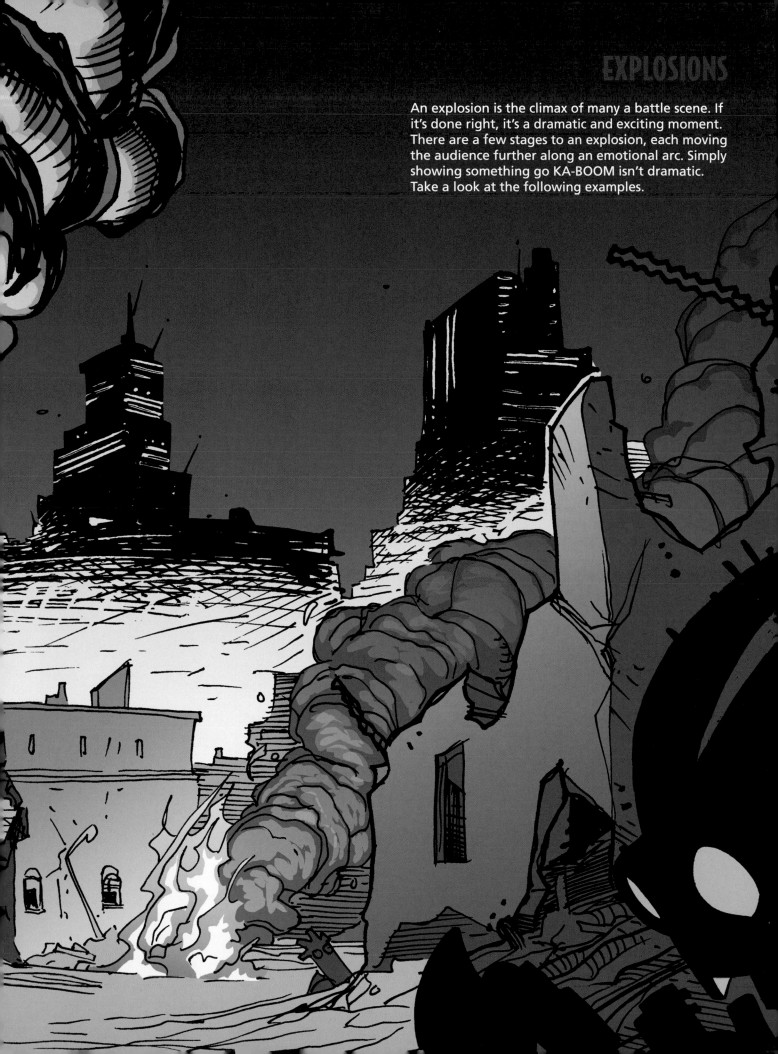

EXPLOSIONS

An explosion is the climax of many a battle scene. If it's done right, it's a dramatic and exciting moment. There are a few stages to an explosion, each moving the audience further along an emotional arc. Simply showing something go KA-BOOM isn't dramatic. Take a look at the following examples.

ENEMY ATTACK

This is the most common explosive effect, the result of either a projectile or a laser beam hitting an object.

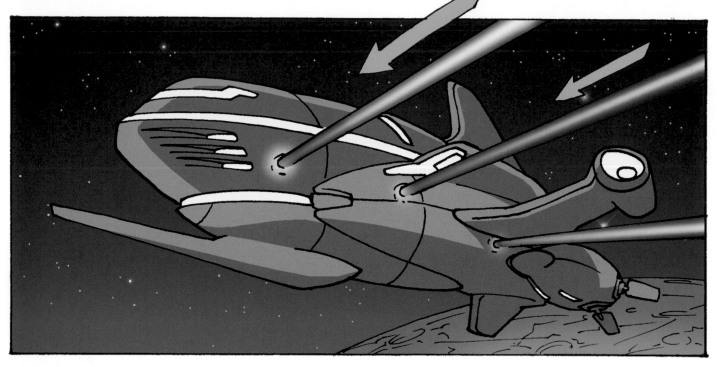

DIRECT HIT: First, establish a direct hit on the target. (If you're looking at the target from the attacking pilot's point of view, you'll often see laser-guided weapons locking onto it first.) The target doesn't begin to explode immediately but absorbs some of the energy of the hit for a moment.

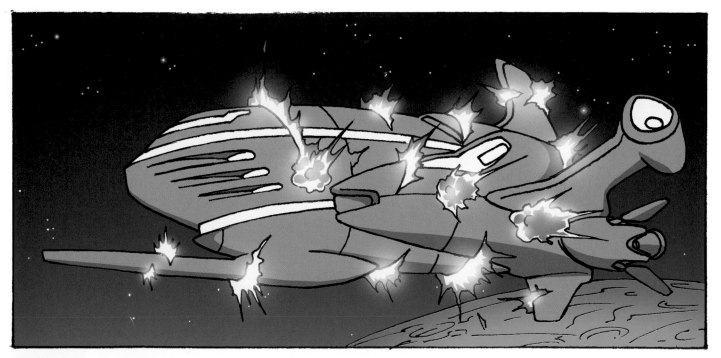

BUILDUP: Energy builds up inside the craft—rising to dangerous levels—then seeps out, causing ruptures and fissures.

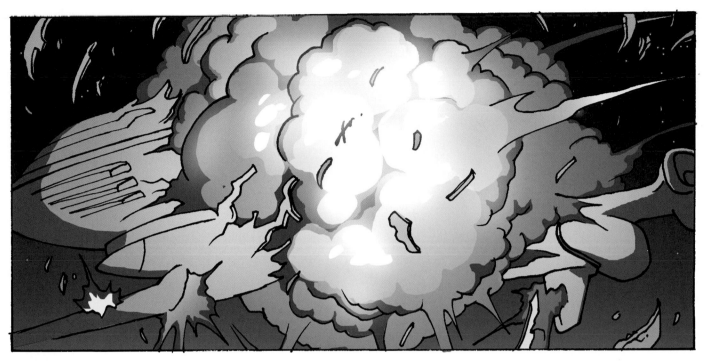

EXPLOSION: The explosion is huge and quickly overwhelms the target object. It also obscures the background.

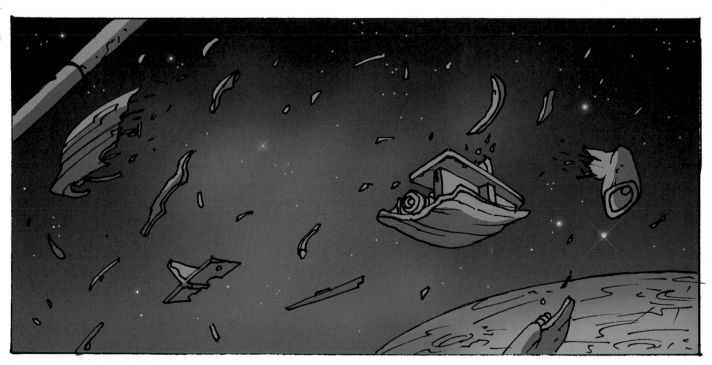

DEBRIS: As the smoke from the explosion dissipates, only debris is left. We can see the background again, which in this case is the surface of a planet. The debris needs to be scattered, not clumped together, to show that this was a clean and devastating hit.

INDUSTRIAL PLANT INTERNAL OVERLOAD

This is a very cool special effect. It happens when a mechanical system malfunctions, becomes overloaded, or gets flooded with too much energy. It's typical of giant robots that have sustained direct hits that cripple their internal systems and cause breakdowns. It also can occur at industrial locations.

The internal overload explosion has only two stages: the buildup and the explosion. In this case, the buildup is drawn out, which creates a sense of panic. At an industrial plant, the buildup might involve people attempting to flee before the explosion, adding a tension to the scene.

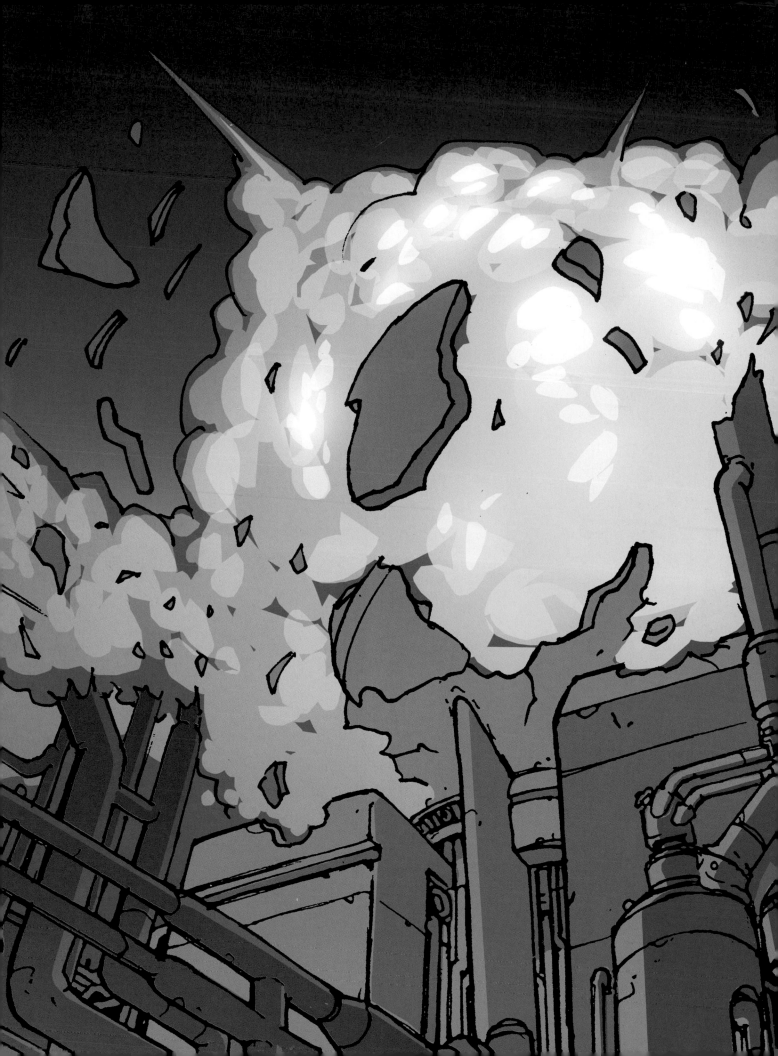

ROBOT INTERNAL OVERLOAD

Again, the buildup stage of the internal overload explosion is drawn out, which creates a sense of anticipation and nervous excitement in the audience; for example, a giant malfunctioning robot might try to escape doom but, of course, can't because the meltdown is occurring within it. The explosion itself, when it happens, is sudden and chaotic. There is a starburst at its origin, and energy lines radiate out from there, along with some debris.

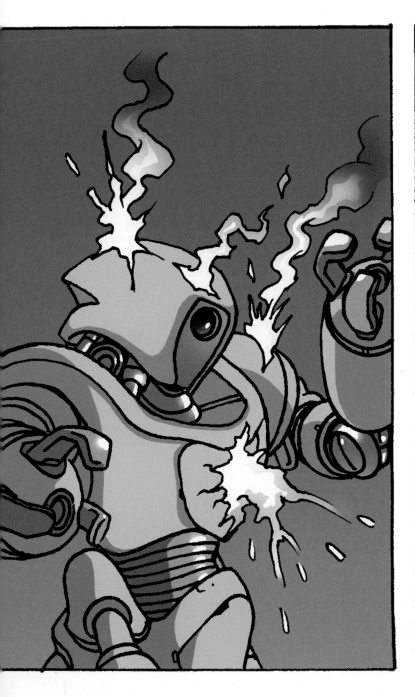

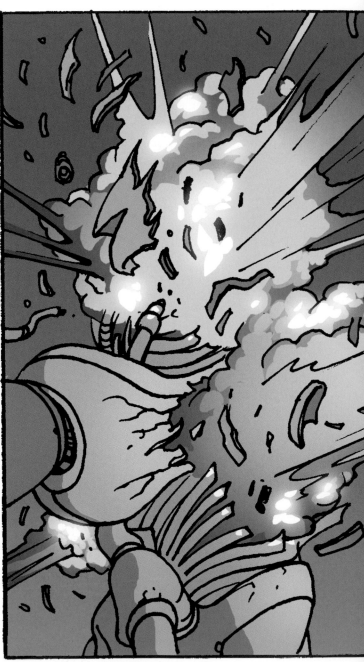

VERTICAL EXPLOSION

Seen from a distance, a huge explosion shoots straight up into the air, blowing a hole through the stratosphere and causing smoke clouds to form in concentric circles. The flash point is most dramatic if it is a peak, such as this mountaintop. (The flash point is the intensely bright origin of the explosion).

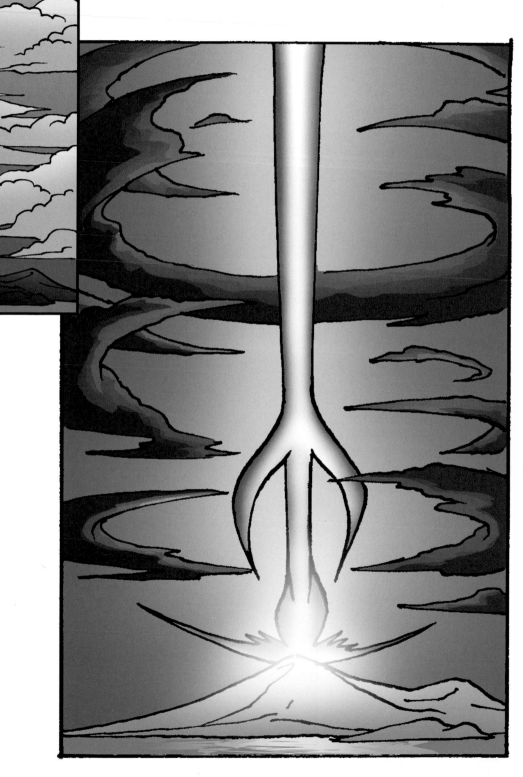

WATER

The sea may look placid, but it can be an unforgiving place with hidden dangers that offer no way out. Here are some of the popular techniques used to create special water effects.

SPEEDBOAT WAKE

Instead of using speed lines to indicate fast motion in water (as one might for a soaring jet), draw rippled water to represent the wake behind speedboats. The faster the boat, the more significant the disturbance to the water. Like all things shown in perspective, the wake narrows in the distance.

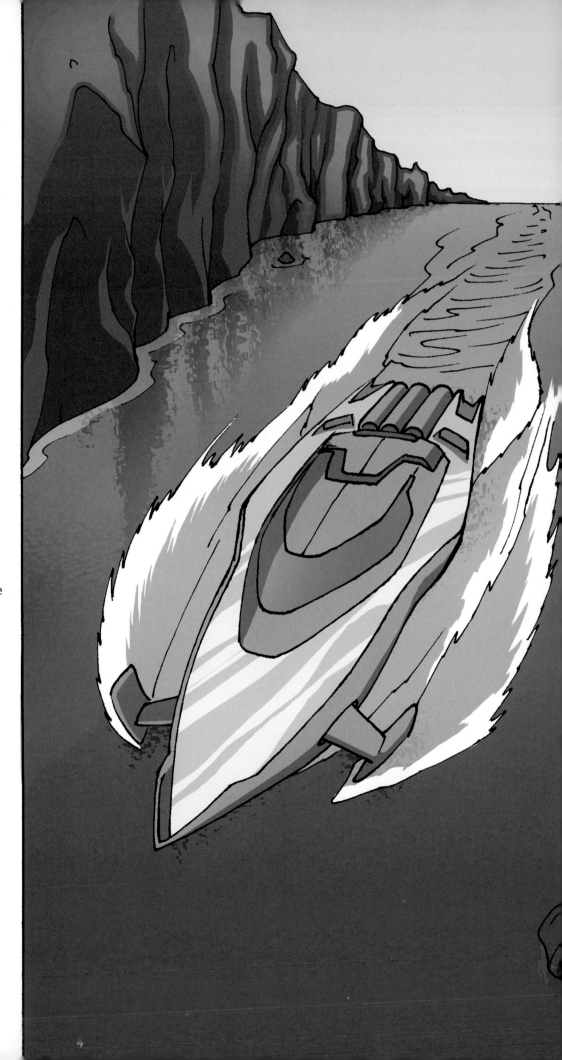

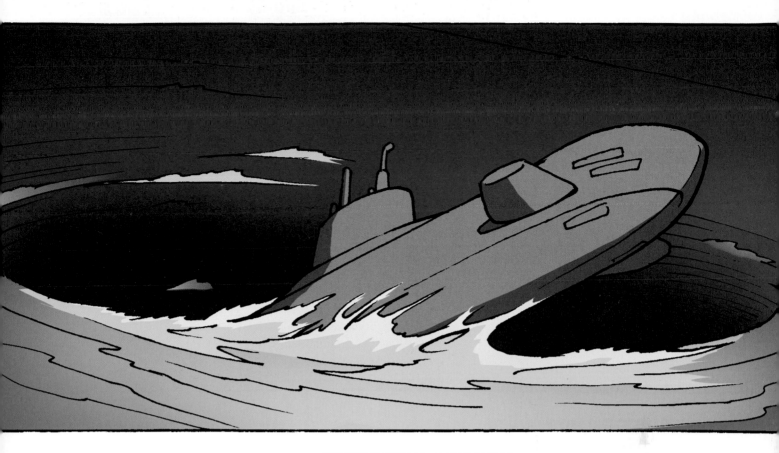

WHIRLPOOL OF DOOM

A whirlpool is the black hole of the sea. It's a relentless, irresistible force sucking everything down, down, down. The vessel must list at a 45-degree angle before it finally is pulled into the vortex and out of sight forever. Concentric circles show the swirling action.

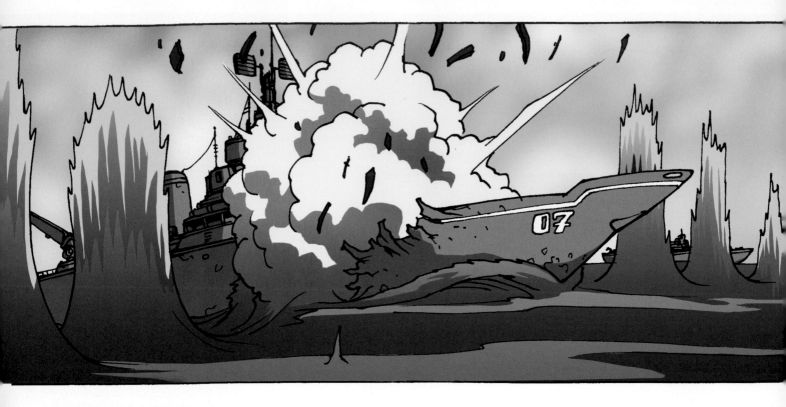

TORPEDO EXPLOSION

An explosion that hits a battleship will look like an explosion
that hits anything else. There's no difference. However, torpedoes
that miss their targets create enormous reactions: Huge plumes
of water gush hundreds of yards into the air in jagged waves.
The pattern of misses looks best drawn in a neat row.

TIDAL WAVE

Tidal waves can be caused by weather, giant sea creatures, or huge explosions. Tidal waves require the use of long shots (scenes drawn at a distance) in order to establish the scale. This shot includes lots of background, thereby showing how the boat is dwarfed against the angry monster and sea. To depict an awesome tidal wave, you only need to draw one side of the wave. By cutting it off in the middle, where it ascends, you get the impression that the wave rises up forever.

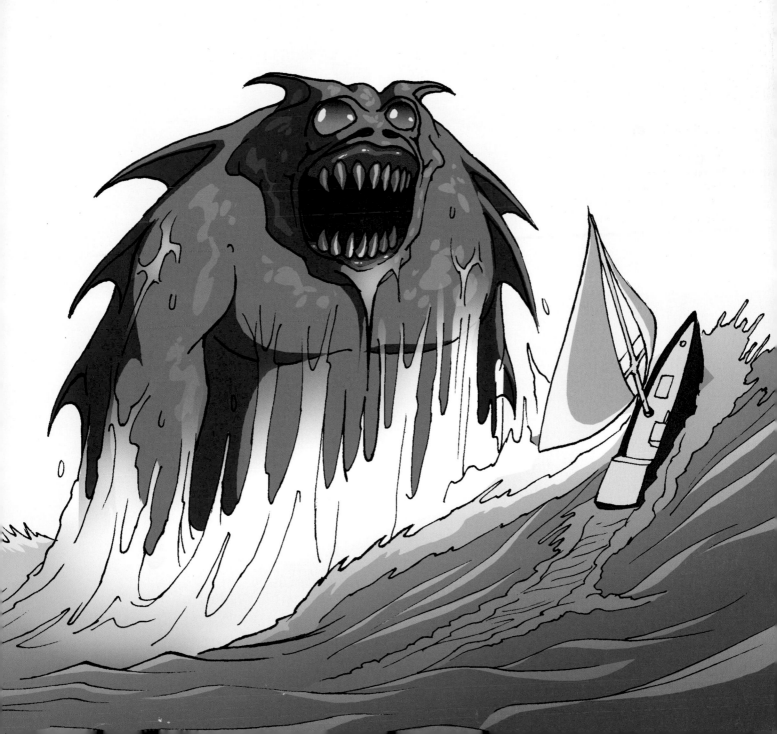

CHARACTER DESIGN

Designing a character is one of the most
satisfying things an artist can do. There are
many general rules for creating character types:
Bad guys have small, beady eyes; good guys have
jutting chins, and so on. Over the years, some of
these stereotypes have been reversed; for example,
good guys were blonde, but then blonde hair became
a symbol of coldness and was appropriated by bad guys.
These rules are *character traits,* and they're essential
for establishing a solid identity for your character.

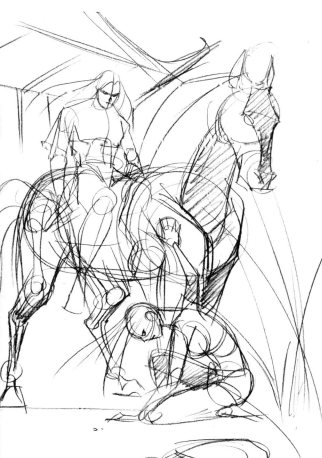

PENCIL SKETCHING

Before you begin to create a character based on a well-thought-out formula, it's beneficial to practice loose, preliminary pencil sketching. Sometimes, I think the word *sketching* should be synonymous with *imagination*. Both rely on a stream of consciousness, seeking out avenues of inspiration while ignoring dead ends. The early stages of character design, when a character is still only a notion in the artist's mind, is a wonderful point in the creative process. There are unlimited possibilities. By imposing formulaic stereotypes at this early stage of character development, you clip your own wings. Let your imagination soar. Make mistakes. Draw over them. Make more mistakes. Draw over those, as well. Somewhere in that chaotic scramble of lines may lay the gem you've been seeking. The purpose of this chapter is to demonstrate how to combine tried-and-true formulas with unfettered imagination.

GESTURE SKETCHES

Sketching is a search for form. The roundness of the horse's torso, the way its neck wedges into its chest, the positioning of its hind legs—all of this is established in the initial sketching stage. But drawing is about more than merely capturing forms and shapes. It's also about communicating attitudes. Therefore, gesture sketching—sketching that portrays the attitude of a pose—is critical.

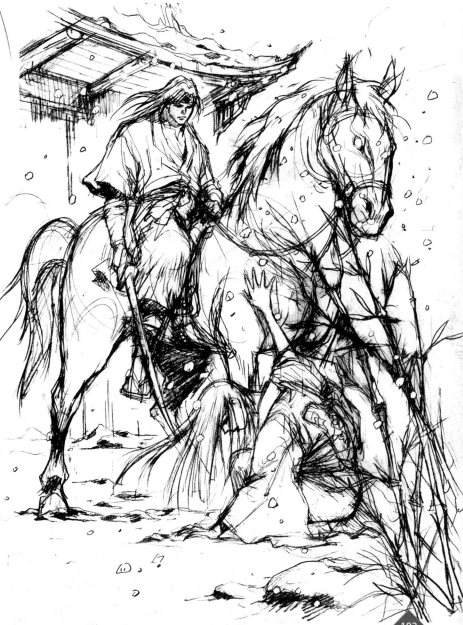

Where a character holds most of his or her weight in a pose says a lot about his or her emotions. Here, the weight of the rider is centered over his waist—a very solid and secure posture. He is of one mind, resolved and determined. The woman is respectful, humble, and perhaps, sorrowful. She leans forward in a gracious bow toward the ground. The horse's weight is over his chest, making him proud, strong, and courageous.

THE SKETCH IS THE BLUEPRINT

Laying out all of the elements in their barest forms is a great way to see if a scene will work, before you start to render it in detail. At this point, you're not married to the drawings. What often happens is that new artists spend a lot of time on one character, refining and polishing it, only to find out that the scene doesn't come together as a whole. Then they are stuck with the agonizing choice of either erasing the carefully drawn character and redrawing it in a manner that

will make the scene more effective, or keeping the character as is, in a scene that isn't quite working. You can guess which choice often wins out. By loosely sketching all of the basic elements first, you won't invest so much time as to make adjustments a heartache. This gives you the freedom to make changes. You can do half a dozen of these quick sketches, and when you've got the one you like, then get out the chisel and start sculpting, so to speak.

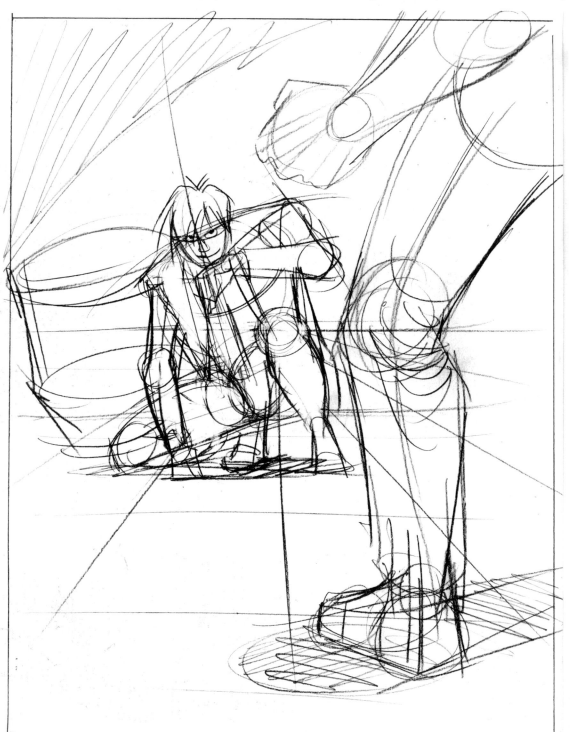

PRELIMINARY SKETCH: THE ELEMENTS

The crouching position of the fallen hero appears weak at first glance, but the vanishing lines converge on him; therefore, he actually commands center stage. The opponent in the foreground needs to be positioned to look imposing but not obscure the other figure. By doing initial sketches, you can experiment with the placement. A prop is needed to convey the location. The trash can serves this function.

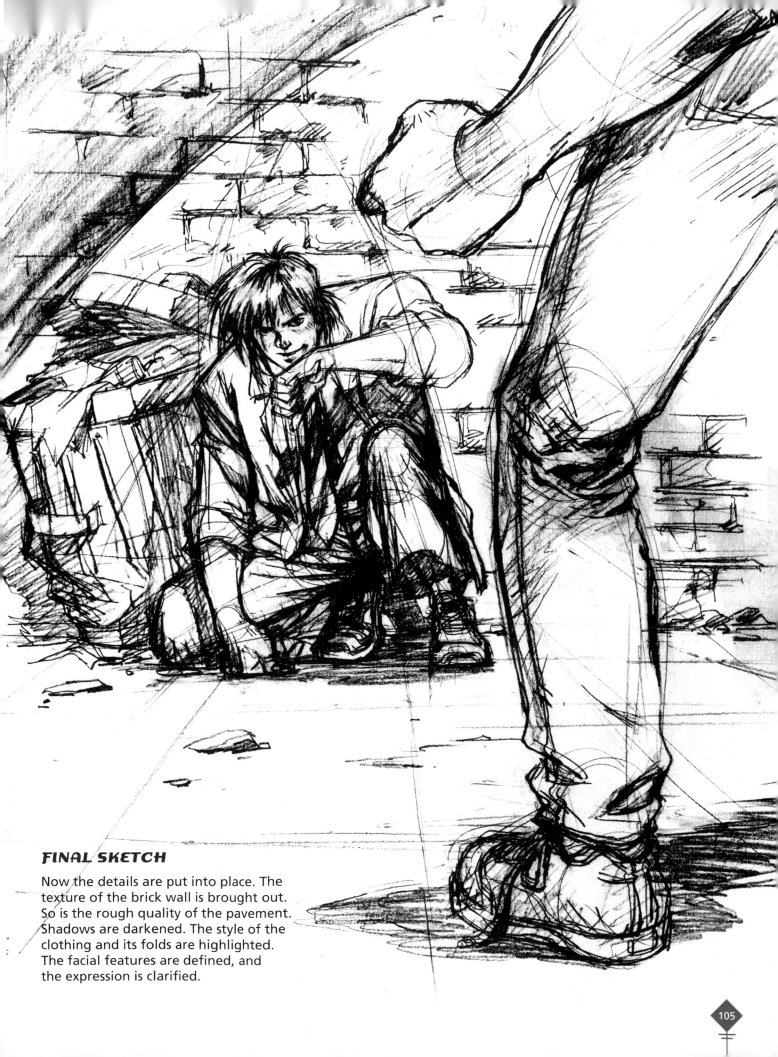

FINAL SKETCH

Now the details are put into place. The texture of the brick wall is brought out. So is the rough quality of the pavement. Shadows are darkened. The style of the clothing and its folds are highlighted. The facial features are defined, and the expression is clarified.

POSE AND GESTURE

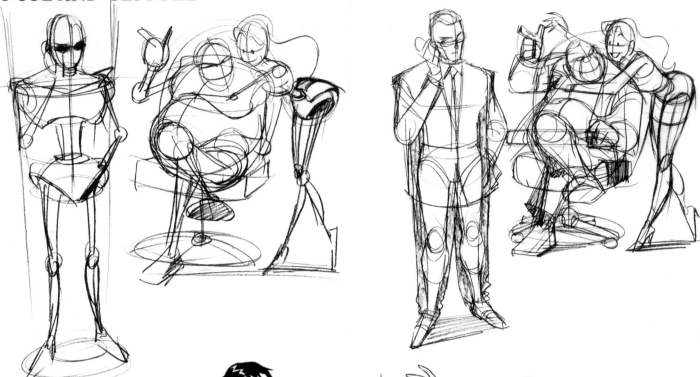

The initial sketch isn't necessarily "cleaned-up" immediately into a finished drawing. Often, loose sketches are followed by more sketches, each one becoming more refined, until the characters reveal themselves. Of course, a clean-up phase is always necessary for the final drawing.

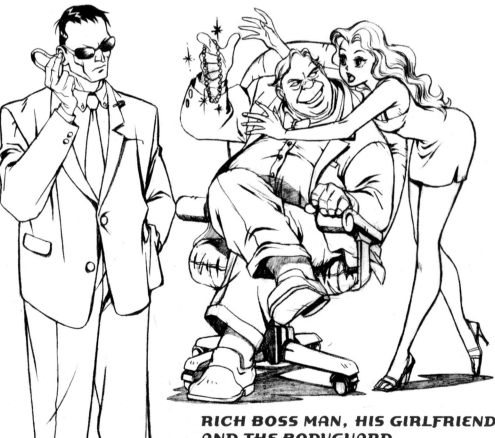

RICH BOSS MAN, HIS GIRLFRIEND, AND THE BODYGUARD

Note the importance of gestures and poses in establishing the roles and pecking order of the characters. The rich boss reclines, as if he owns the world. The girlfriend hangs all over him, as if being physically close to him will make her rich. The Bodyguard stands stiff and at attention.

SKETCHING DETAILED SCENES

You're drawing the interior of a spacecraft. You've got two pilots at the helm. You know the instrumentation and the computer consoles will have to be convincing and intricate. Wait! Don't start designing all the computer systems, panels, and grids at this point. Instead, start by blocking out the general areas and shapes in the scene, such as the pilots, seats, front console, windows, background objects seen through the windows, overhead control panels, cockpit door, and so on. Your characters (and how they fit into the image)—not the instrumentation details—are going to be the focus of the scene, no matter how cool all that technology will eventually look.

Once you're comfortable that you've convincingly integrated the characters into the scene, you can start subdividing the general shapes into smaller ones, adding such things as monitors, buttons, compartments, and the like. The gadgetry should frame the characters and be part of the environment.

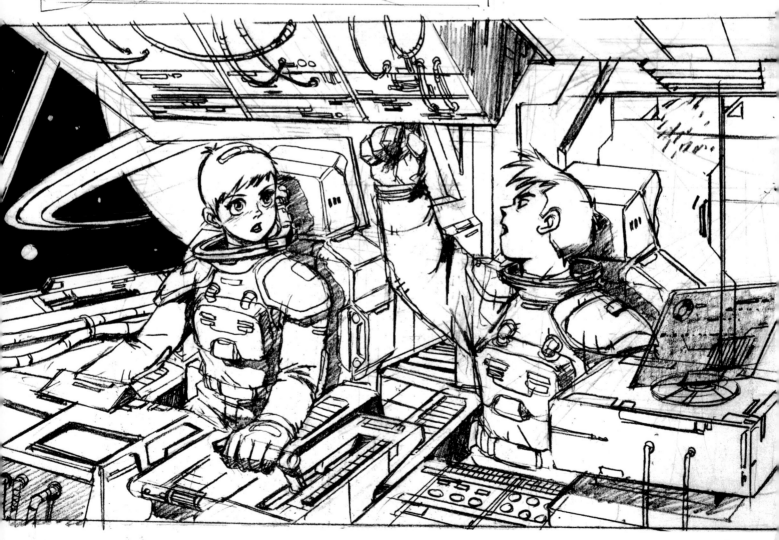

CHARACTER TYPES

There are a number of common anime character types. For example, anime is unafraid to cast mature characters to play many key roles. Middle-aged and older characters make great villains. There is a useful built-in age gap between younger heroes and older villains: Young idealists are automatically at odds with older, sinister characters, who are entrenched in a system that they built and that enables them to keep all the power for themselves.

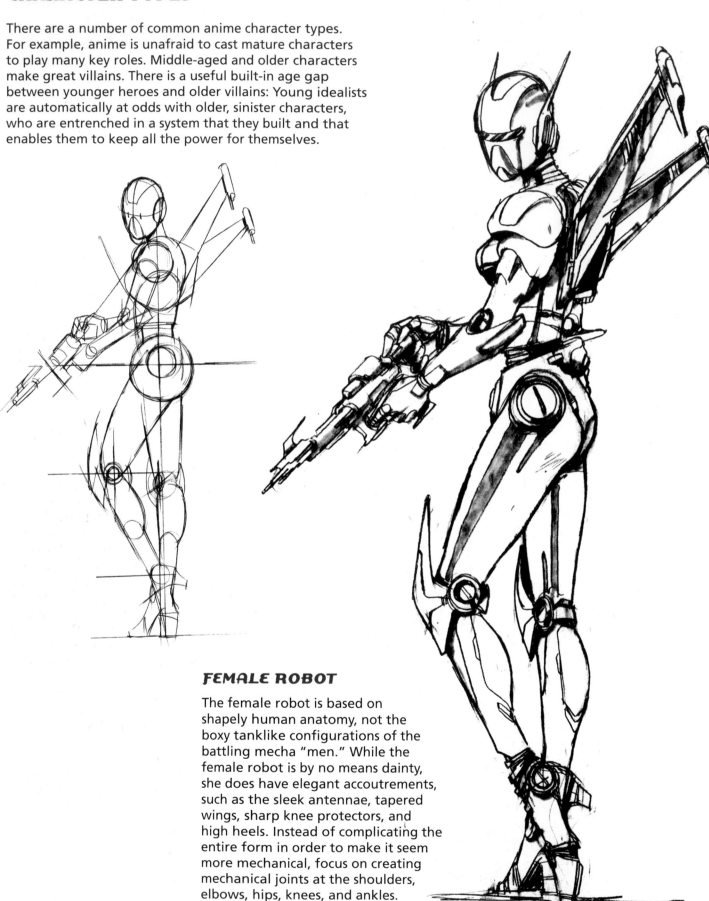

FEMALE ROBOT

The female robot is based on shapely human anatomy, not the boxy tanklike configurations of the battling mecha "men." While the female robot is by no means dainty, she does have elegant accoutrements, such as the sleek antennae, tapered wings, sharp knee protectors, and high heels. Instead of complicating the entire form in order to make it seem more mechanical, focus on creating mechanical joints at the shoulders, elbows, hips, knees, and ankles.

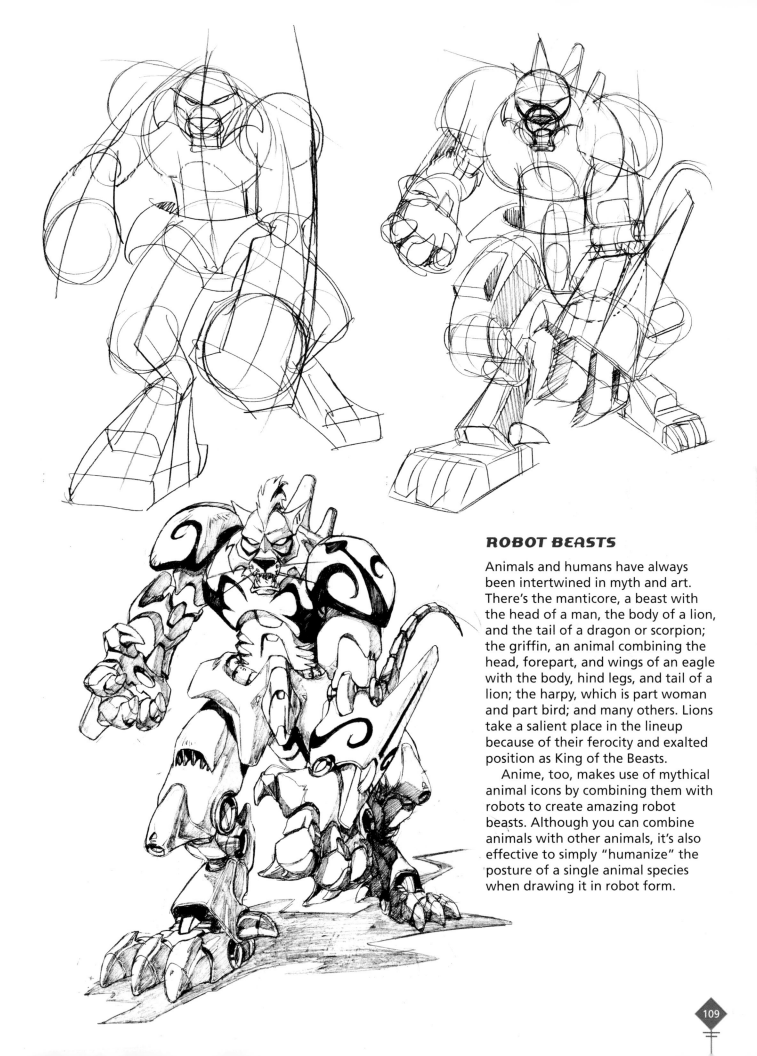

ROBOT BEASTS

Animals and humans have always been intertwined in myth and art. There's the manticore, a beast with the head of a man, the body of a lion, and the tail of a dragon or scorpion; the griffin, an animal combining the head, forepart, and wings of an eagle with the body, hind legs, and tail of a lion; the harpy, which is part woman and part bird; and many others. Lions take a salient place in the lineup because of their ferocity and exalted position as King of the Beasts.

Anime, too, makes use of mythical animal icons by combining them with robots to create amazing robot beasts. Although you can combine animals with other animals, it's also effective to simply "humanize" the posture of a single animal species when drawing it in robot form.

RUTHLESS SCIENTIST

The pointy-nosed scientist is a sinister character. Several devices contribute to this impression. His face is bony and thin. He looks at his colleague (the ruthless intelligence officer) with a shifty, sideways glance through narrow eyes. He sports a thin-lipped smile, the trademark of a villain. Plus, he wears a bulky and oversized protective biohazard suit, indicating that whatever life form he's creating in the lab is very, very dangerous.

Note also that the intelligence officer behind him has a crusty face that shows no softness, an extreme haircut, and similarly narrow eyes. His decorated uniform shows that he's in the seat of power and won't give it up easily.

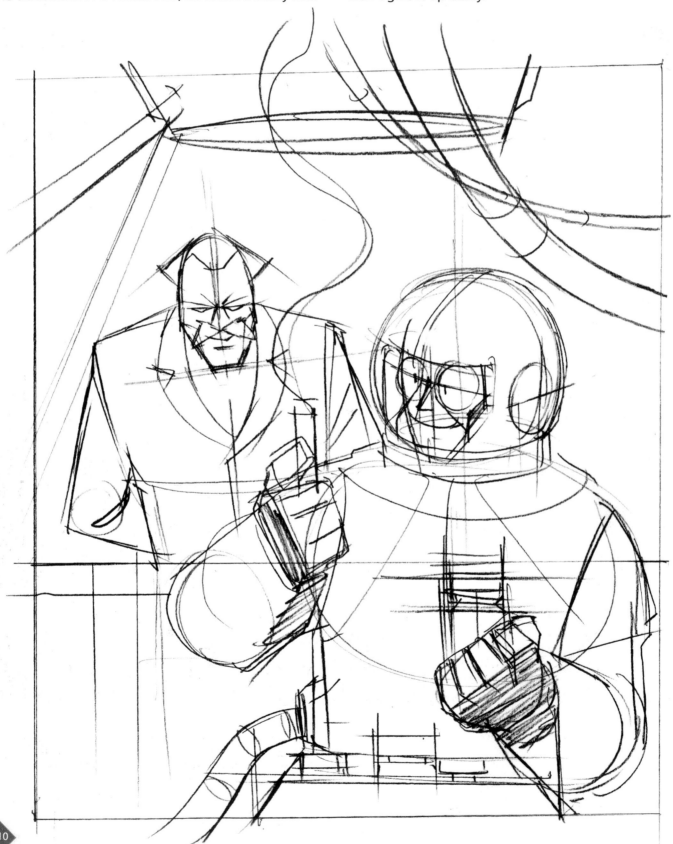

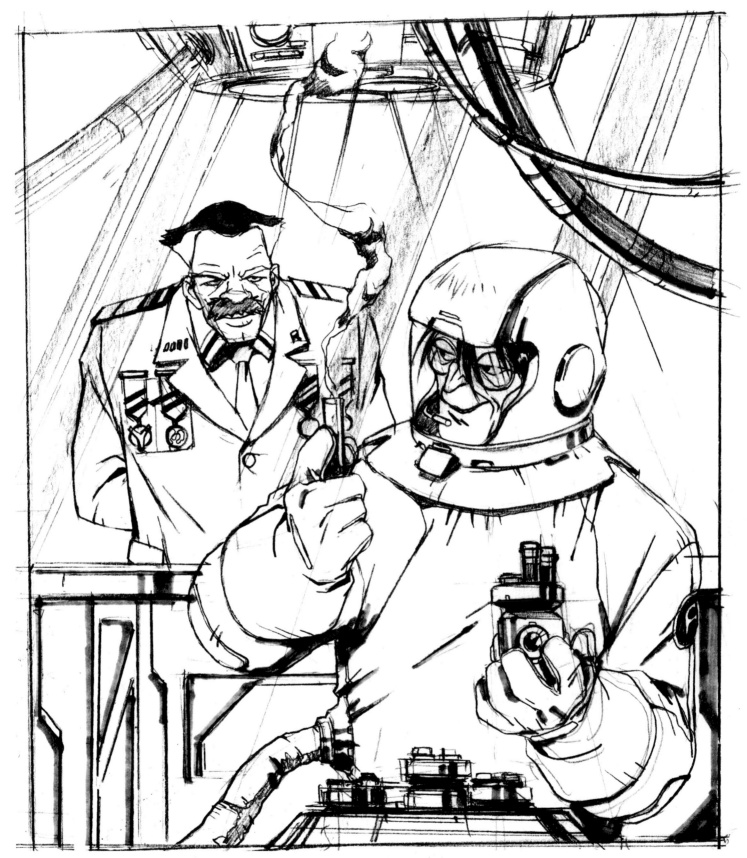

COMPOSITION

By partially overlapping two characters, you link them together visually, which underscores a theme. In this case it's that these two bad guys are working together for the same evil purpose.

DRAWING WOMEN'S CLOTHES

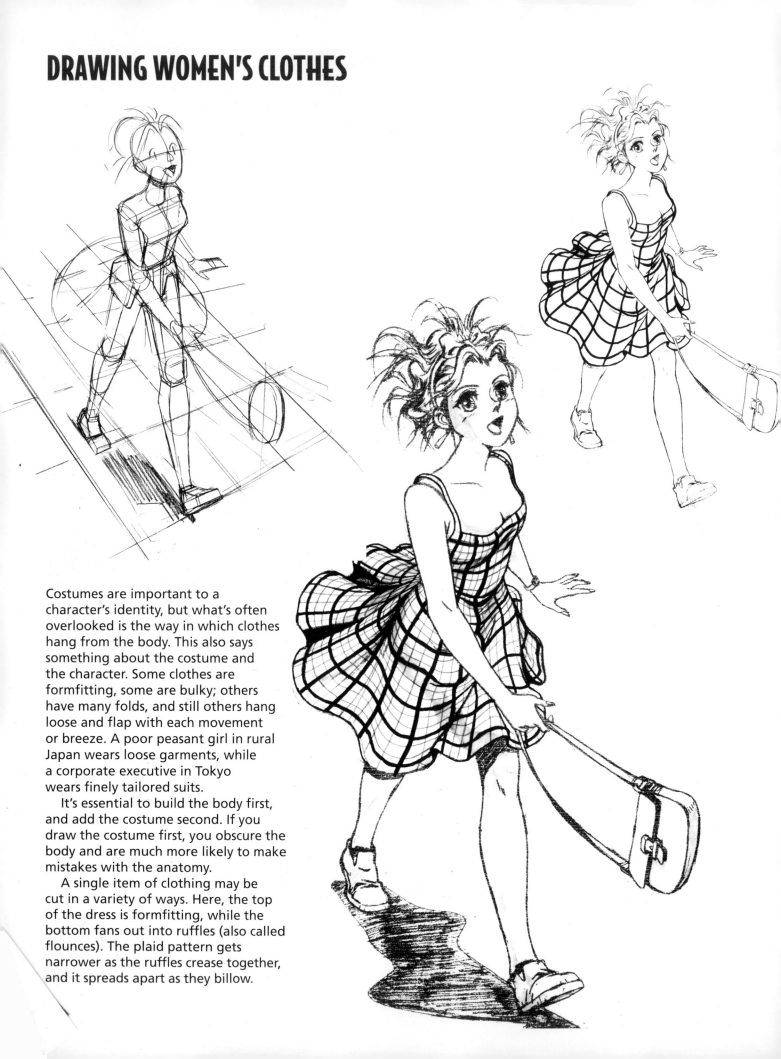

Costumes are important to a character's identity, but what's often overlooked is the way in which clothes hang from the body. This also says something about the costume and the character. Some clothes are formfitting, some are bulky; others have many folds, and still others hang loose and flap with each movement or breeze. A poor peasant girl in rural Japan wears loose garments, while a corporate executive in Tokyo wears finely tailored suits.

It's essential to build the body first, and add the costume second. If you draw the costume first, you obscure the body and are much more likely to make mistakes with the anatomy.

A single item of clothing may be cut in a variety of ways. Here, the top of the dress is formfitting, while the bottom fans out into ruffles (also called flounces). The plaid pattern gets narrower as the ruffles crease together, and it spreads apart as they billow.

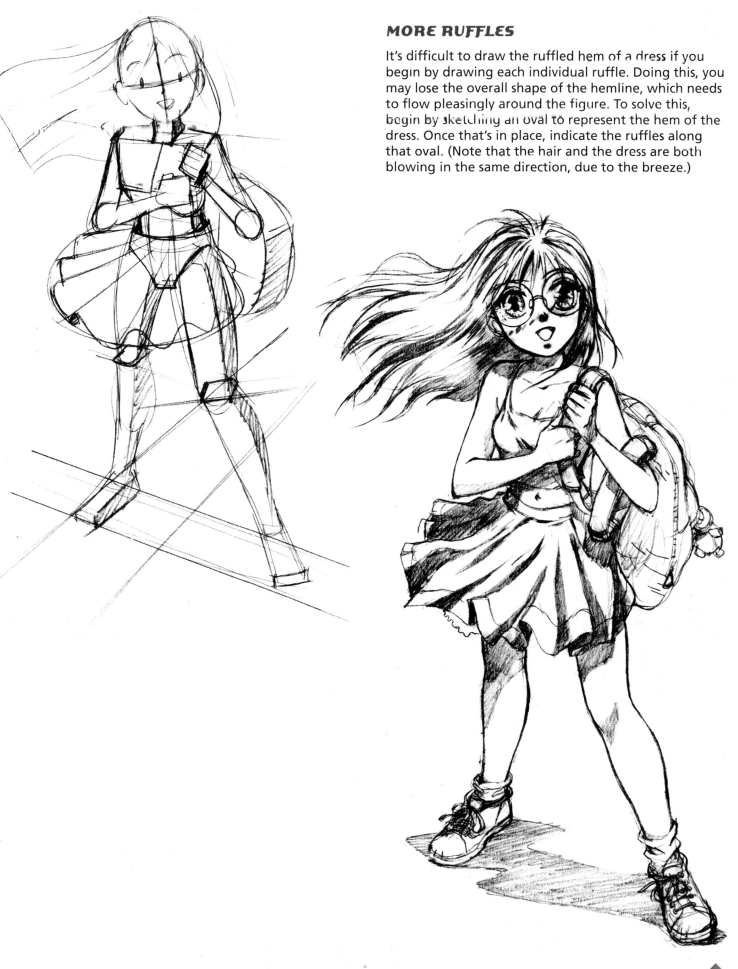

MORE RUFFLES

It's difficult to draw the ruffled hem of a dress if you begin by drawing each individual ruffle. Doing this, you may lose the overall shape of the hemline, which needs to flow pleasingly around the figure. To solve this, begin by sketching an oval to represent the hem of the dress. Once that's in place, indicate the ruffles along that oval. (Note that the hair and the dress are both blowing in the same direction, due to the breeze.)

TRADITIONAL COSTUMES AND CHARACTERS

THE KIMONO

Worn as far back as the 8th century and as recently as today, the Japanese kimono is an ancient, elegant, traditional garment. It appears in many anime and manga stories that either are based in the past or convey traditional themes. The kimono isn't a day-to-day piece of clothing in Japan anymore but is still used for special occasions, such as weddings. It has a wide sash, called an *obi,* which is tied in a decorative fashion, as shown below. The fabric of the kimono typically has a beautiful pattern, with nature scenes being some of the most common designs. Traditionally, sandals are worn with the kimono.

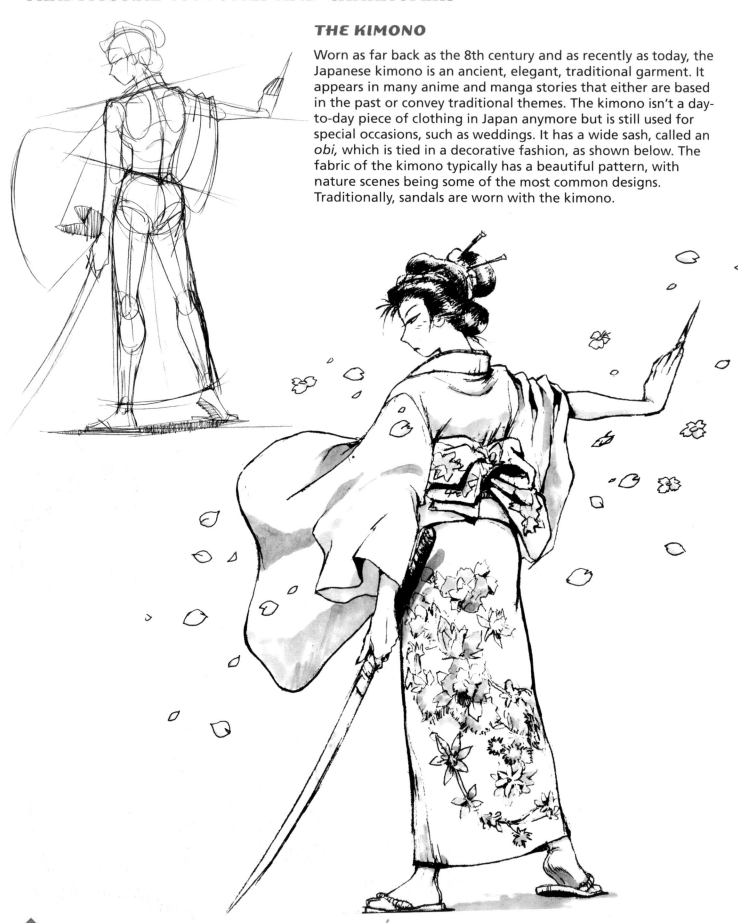

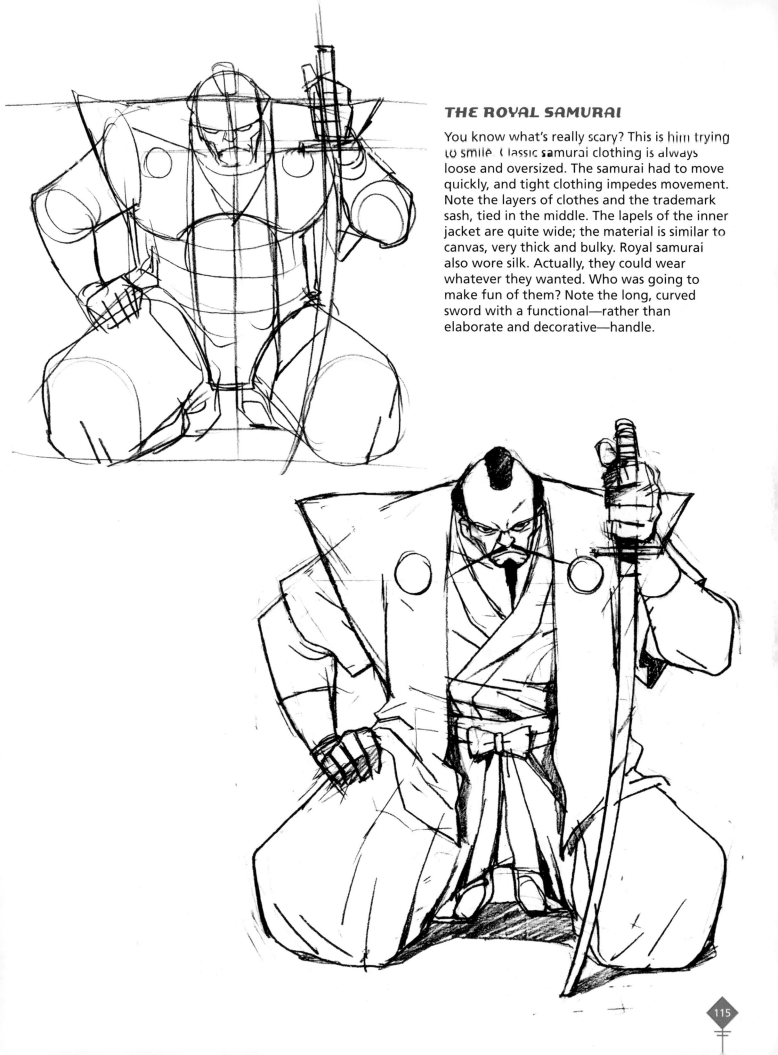

THE ROYAL SAMURAI

You know what's really scary? This is him trying to smile. Classic samurai clothing is always loose and oversized. The samurai had to move quickly, and tight clothing impedes movement. Note the layers of clothes and the trademark sash, tied in the middle. The lapels of the inner jacket are quite wide; the material is similar to canvas, very thick and bulky. Royal samurai also wore silk. Actually, they could wear whatever they wanted. Who was going to make fun of them? Note the long, curved sword with a functional—rather than elaborate and decorative—handle.

CHARACTER GROUPS

Costumes also define the roles of characters who are part of a group, helping to distinguish them from one another. With a royal family, for example, garments can help highlight the royal hierarchy. Capes, robes, gowns, and boots are all a part of the mix. Pageantry is very important. These people spend some serious time in front of the mirror. The dry cleaning bills must have been murder.

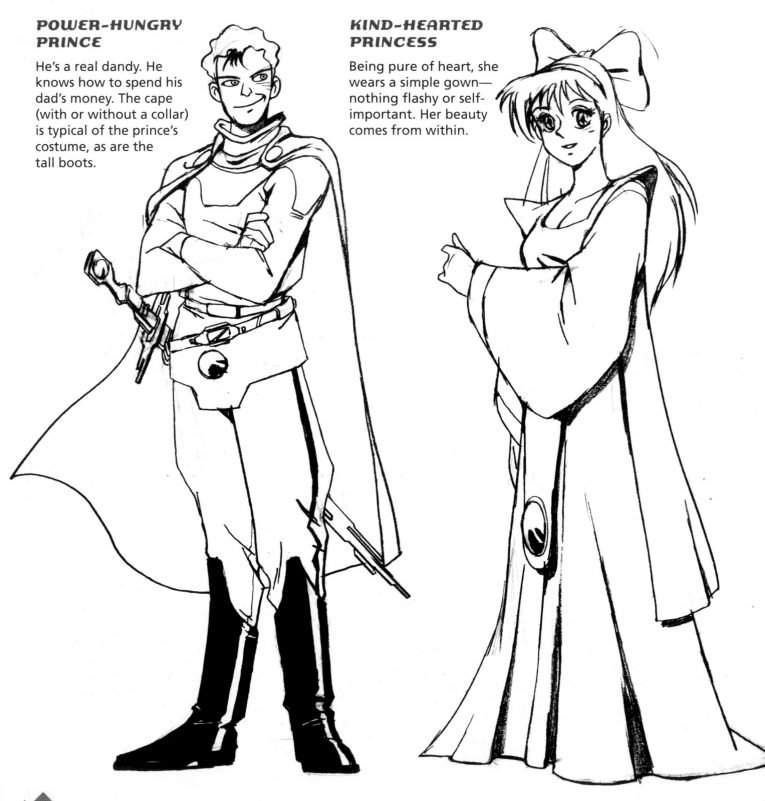

POWER-HUNGRY PRINCE

He's a real dandy. He knows how to spend his dad's money. The cape (with or without a collar) is typical of the prince's costume, as are the tall boots.

KIND-HEARTED PRINCESS

Being pure of heart, she wears a simple gown—nothing flashy or self-important. Her beauty comes from within.

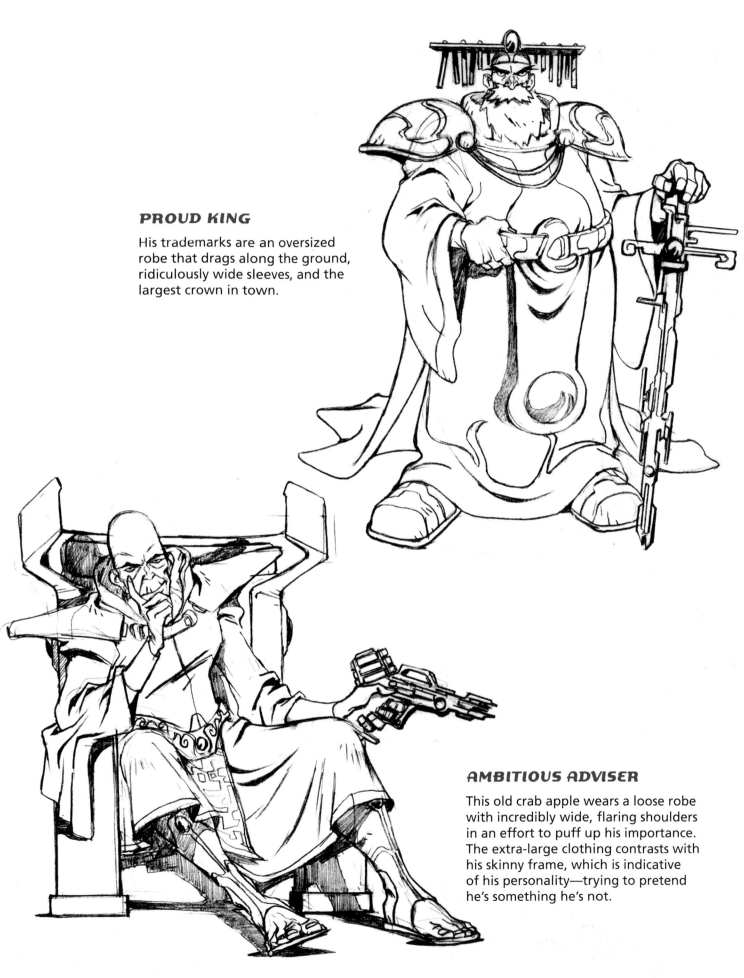

PROUD KING

His trademarks are an oversized robe that drags along the ground, ridiculously wide sleeves, and the largest crown in town.

AMBITIOUS ADVISER

This old crab apple wears a loose robe with incredibly wide, flaring shoulders in an effort to puff up his importance. The extra-large clothing contrasts with his skinny frame, which is indicative of his personality—trying to pretend he's something he's not.

117

ANIME CRIME-FIGHTING TEAMS

One of the reasons for teams of heroes is marketing related. You can attract a wider audience if you feature four heroes than if you feature one. And the potential for character licensing also multiplies. Coldhearted business reasons aside, teams are inherently exciting to watch. There's an energy that you can't match when four characters have chemistry between them.

A typical formula for casting a team of heroes might be something like this: one part brainy leader, one part bulky enforcer, one part marginally moral weapons specialist, and one part mutant with supernatural

powers. It's important that for each strength or talent a team member has, he or she also has a counter-balancing weakness. For example, a mutant character might have supernatural powers, such as the ability to shoot energy from his fingertips; however, because of his odd appearance, he'll always be an outsider—even in his own group.

Some team groups have characters that are very similar to one another, such as the team in the famous *Sailor Moon* series, which is a band of teenage girls. The characters are so charismatic that more is better.

STANDARD TEAM

This team features the brainy computer whiz kid, the brawny guy, the weapons specialist, and the mutant with supernatural powers.

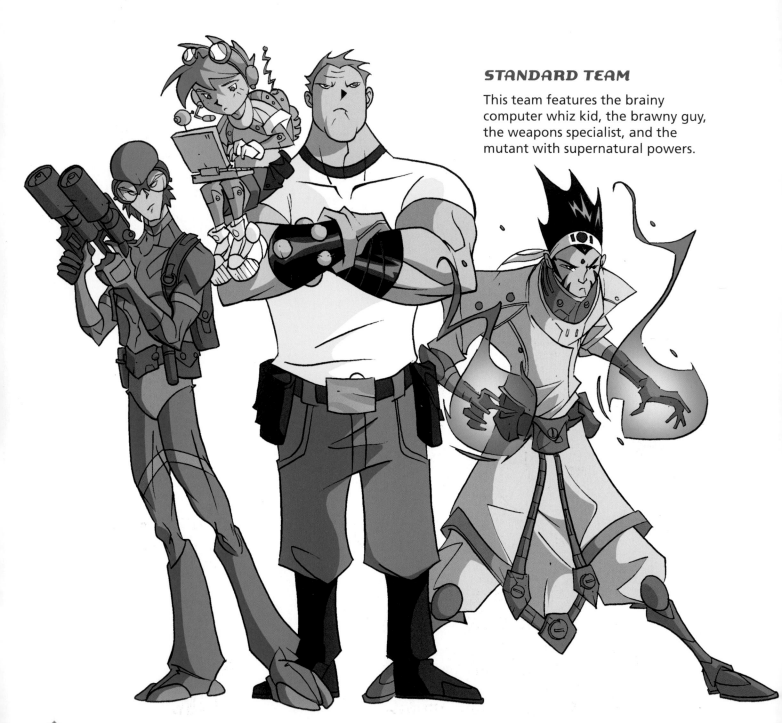

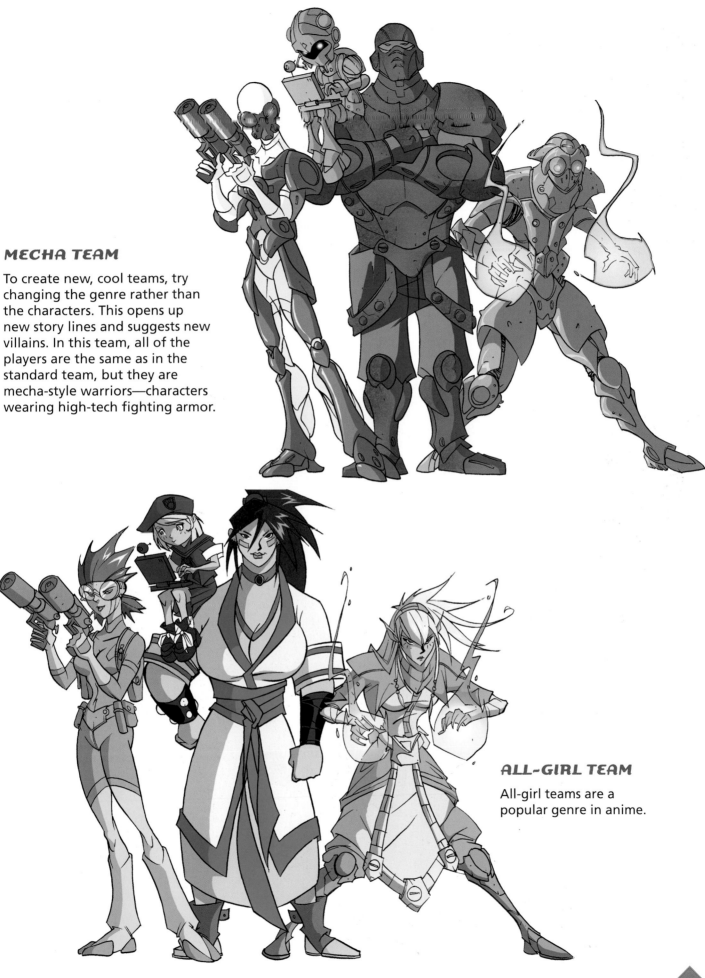

MECHA TEAM

To create new, cool teams, try changing the genre rather than the characters. This opens up new story lines and suggests new villains. In this team, all of the players are the same as in the standard team, but they are mecha-style warriors—characters wearing high-tech fighting armor.

ALL-GIRL TEAM

All-girl teams are a popular genre in anime.

VARYING THE AGE OF A CHARACTER

At each stage of life, a character takes on new personality traits. Preteens are optimistic and idealistic. Teenagers have a bit of the rebel in them. Adults have become corporate, sometimes even scheming. Mature adults have become wise, power-mad, or eccentric. And the elderly have seen it all and are weary of the world's ways.

A sudden, conservative shift takes place in the transition from teen to adult. This is reflected in clothing, hairstyle, eyewear, and the growing disdain for income taxes. Gravity takes its toll on the face of the more mature adult, primarily at the bottom of the jaw (where the cheeks begin to sag) and under the eyes.

THE BODY AT DIFFERENT AGES

The body gets taller with age, peaks at adulthood, then shrinks. This is combined with a change in posture. For old men, the neck becomes shorter, thinner, and sometimes doesn't even show due to the hunched-over elderly posture. In men, too, the shoulders get broader from boyhood to adulthood, then begin to narrow again.

Also be aware that as characters become older, they also become more rigid. On mature adults, the clothing should be looser.

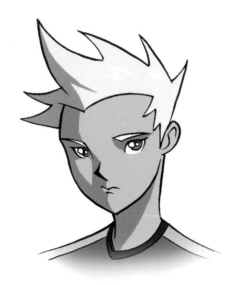

PRETEEN BOY

Large forehead, bright eyes, no facial creases or wrinkles, and a full face are all preteen traits. On a boy, the forehead starts off large. (It will get smaller as the character grows to adulthood, then take up a larger proportion of the face again as an old man.)

TEENAGE BOY

Here the face is sleeker, the eyes more intense.

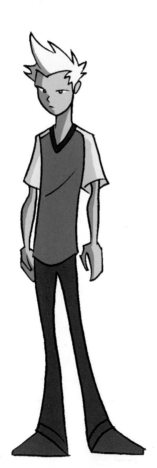

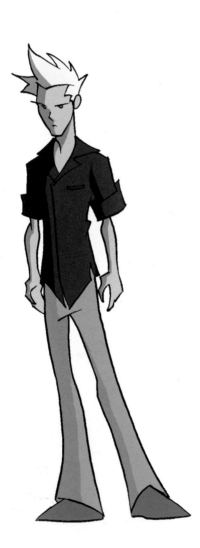

ADULT MAN

In adulthood, the face becomes angular. The forehead is considerably smaller and the chin more pronounced. The hairline recedes.

MATURE ADULT MAN

The face becomes thinner and sallow, bags form under the eyes, age spots appear, the signs of gravity begin to show. The hairstyle can be wild, and facial hair can be pronounced.

OLD MAN

The skull becomes much larger than the jaw, which recedes. Hair loss is almost complete. The head droops due to fatigue. The eyebrows become massive.

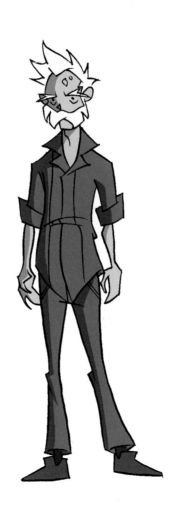

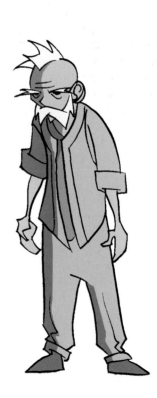

THE FEMALE BODY AT DIFFERENT AGES

The shoulders and hips fill out as a preteen girl becomes a teenager and then an adult. The preteen girl sports a boyish hairdo that becomes fuller as a teen and more restrained as an adult. Also, the preteen girl's face starts off round, becomes sleek as an adult, and turns round again in old age, due to fat accumulating on the cheeks and gravity pulling the flesh down around the jaw. For old women, the neck becomes shorter, thinner, and sometimes doesn't even show due to the hunched-over, elderly posture.

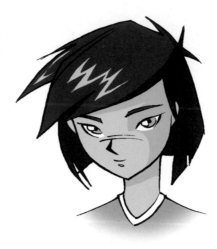

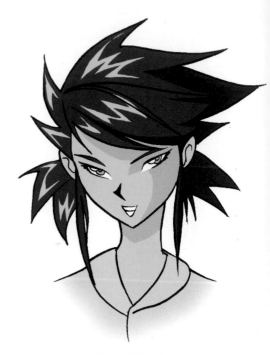

PRETEEN GIRL

TEENAGE GIRL

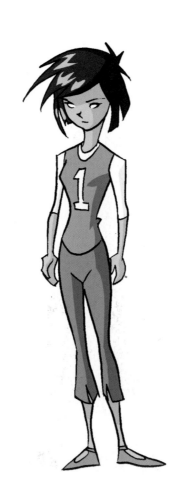

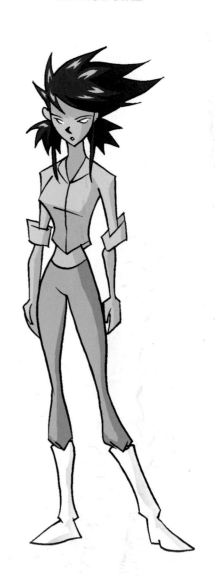

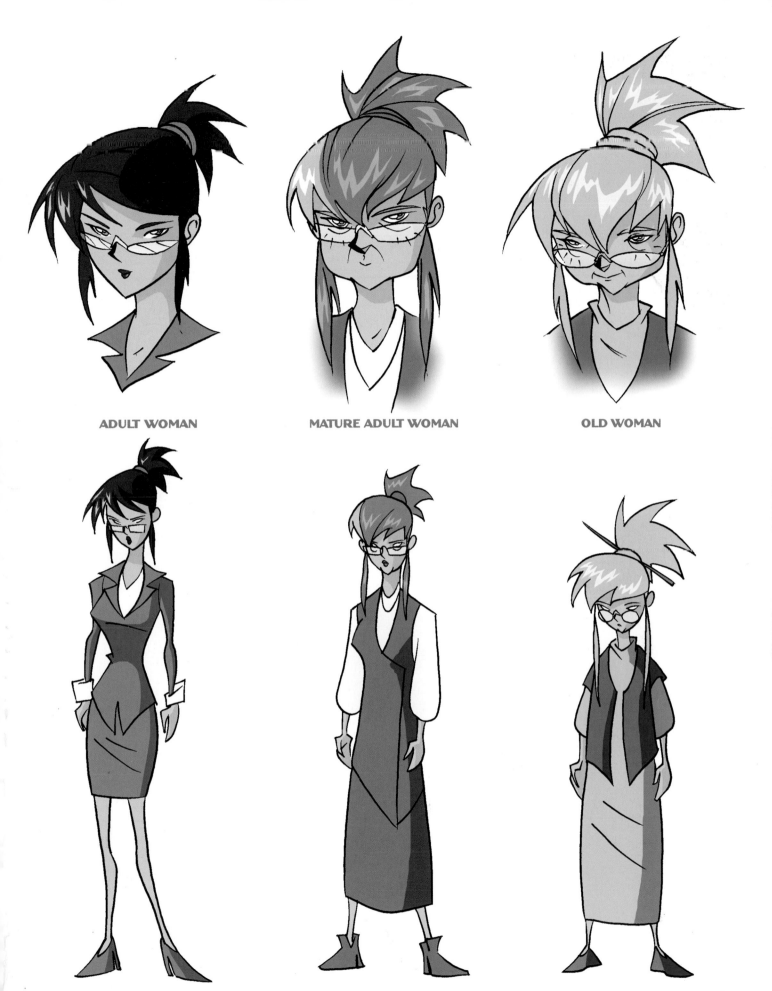

ADULT WOMAN MATURE ADULT WOMAN OLD WOMAN

OLDER CHARACTERS

Older characters typically bring elements of wisdom and expertise to a story. They also interact well with young characters, who look up to them for guidance. Grandparents take on a more prominent role in anime than they do in western animation. Generally, they wear loose clothing (for comfort) that is layered (they get cold more easily). Unless they are rich or royalty, they're rarely conspicuously attired.

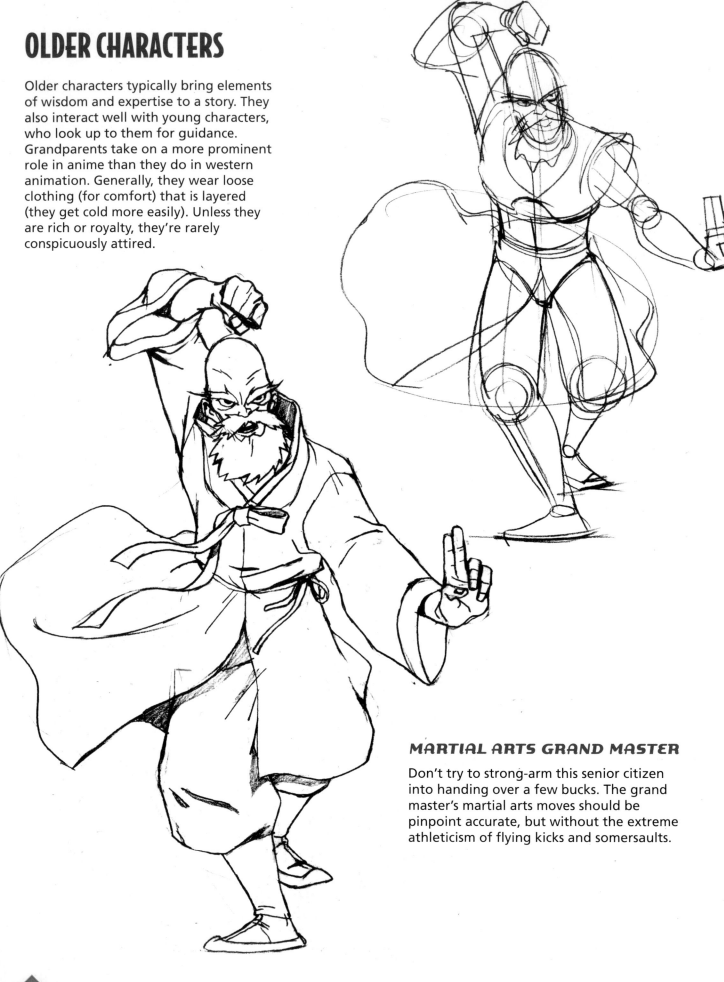

MARTIAL ARTS GRAND MASTER

Don't try to strong-arm this senior citizen into handing over a few bucks. The grand master's martial arts moves should be pinpoint accurate, but without the extreme athleticism of flying kicks and somersaults.

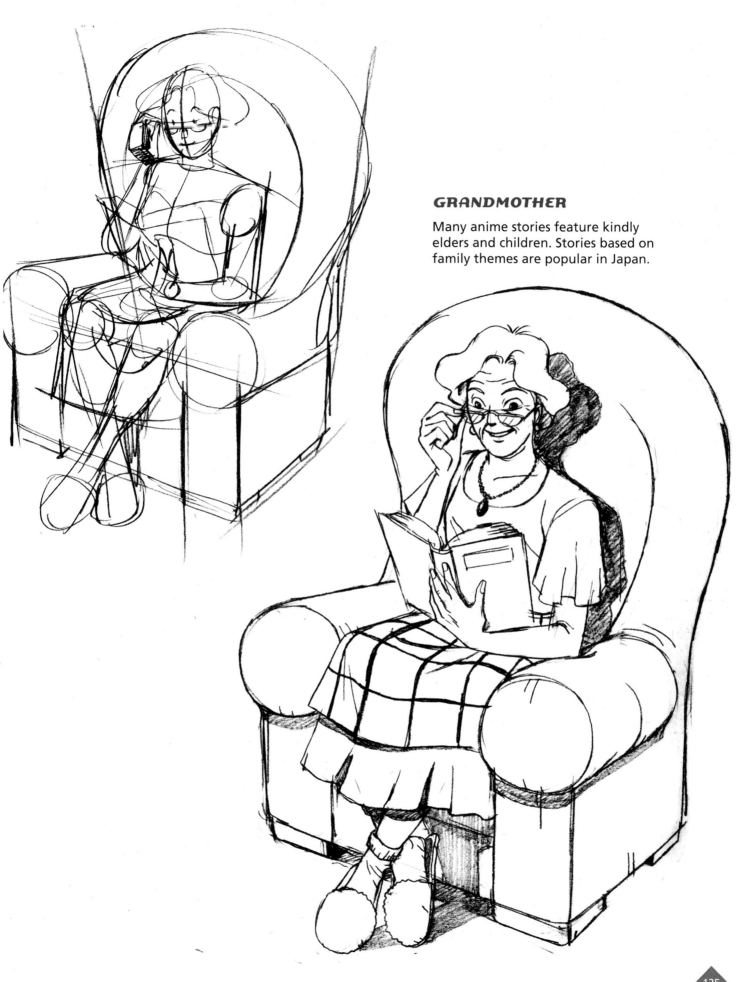

GRANDMOTHER

Many anime stories feature kindly elders and children. Stories based on family themes are popular in Japan.

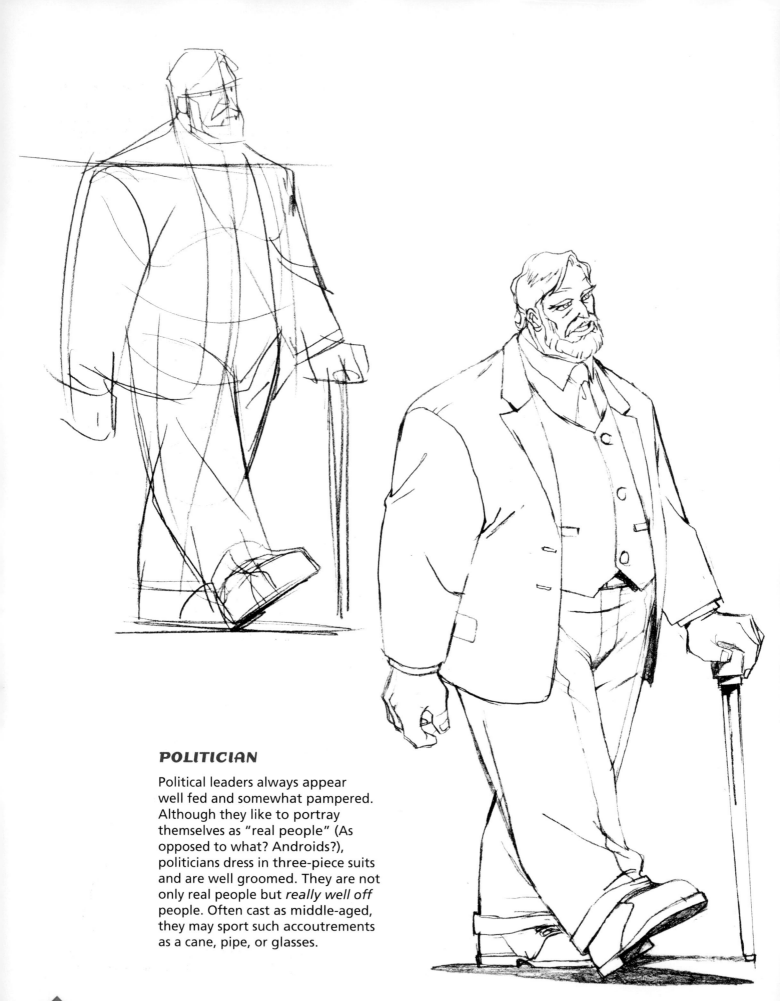

POLITICIAN

Political leaders always appear
well fed and somewhat pampered.
Although they like to portray
themselves as "real people" (As
opposed to what? Androids?),
politicians dress in three-piece suits
and are well groomed. They are not
only real people but *really well off*
people. Often cast as middle-aged,
they may sport such accoutrements
as a cane, pipe, or glasses.

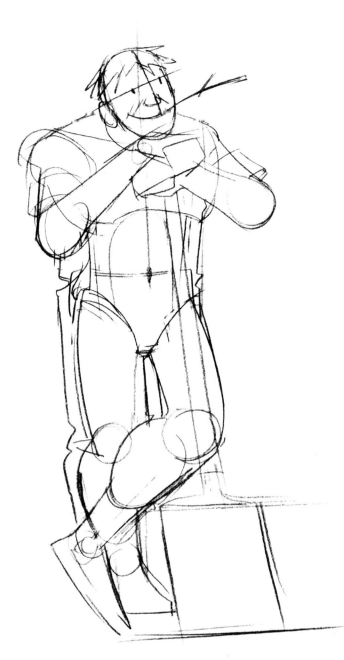

FARMER

Peasant characters are popular types in anime. The stereotypical farmer is a hardworking, cheerful individual, although his hardships are plenty. His clothes are always utilitarian and rough. Don't confuse him with the rancher, who is a businessman and may become wealthy due to his expanding herd. The farmer, by contrast, is always struggling to get by.

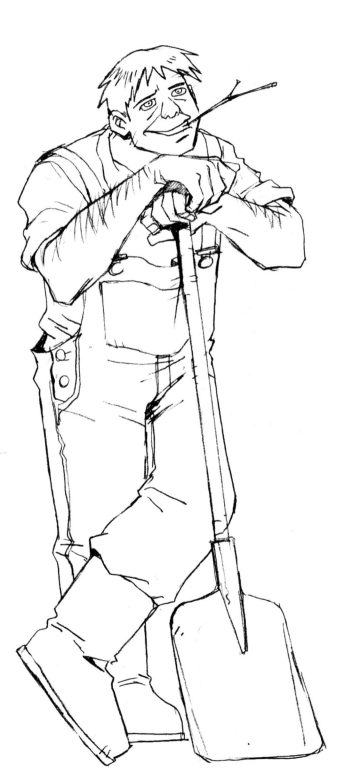

STORYBOARDS

Storyboards are a vital step in the animation process. They provide a visualization of the script in sketch form. Every single camera shot is storyboarded by the storyboard artist before the animators begin their work. When the storyboards are completed, they're sent to the layout department to be refined and translated into camera moves. These get sent to the background painters while the animators begin their work, also using the layout department's detailed drawings of the scenes for reference.

Animation is such a visual medium that it makes inherent sense that a script would be sketched out before being animated. But every live action film is storyboarded, too. This lets the director and creative team "see" the film in advance and begin to interpret it visually. Since film is a visual medium, creating an exciting visual experience is of paramount importance.

Below is a high-voltage, action sequence that has been storyboarded to demonstrate pacing, buildup, climax, and resolution.

SCENE 1, PANEL 1

establishes the environment. We're in space, but not the vast emptiness of interstellar space. We're by a large planet. We see the underside of the planet, which is more dramatic than looking down at it.

• ACTION

• DIALOGUE

SCENE 1, PANEL 2

shows a small spaceship streaking into frame toward the planet, its rockets in our faces.

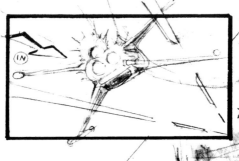

• ACTION

• DIALOGUE

SCENE 1, PANEL 3

we see that following the small ship is a giant robot that enters the frame, firing away at the little craft. The camera pans up, leaving the giant robot out of the frame as we come upon the small ship, which is heading for the planet.

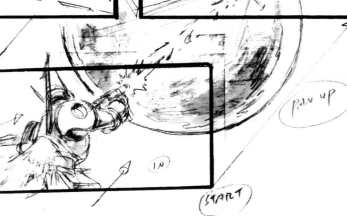

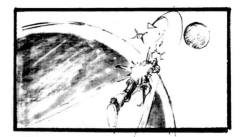

SCENE 1, PANEL 4

has the giant robot reentering the frame, still tailing the small ship, which as indicated by the directional arrows of the storyboard artist, is circling the planet looking to land.

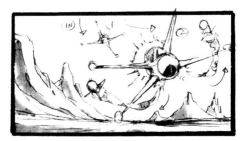

SCENE 2, PANEL 1

has the little craft flying toward us and firing two missiles from the rear as the giant robot (the smaller figure in this scene) enters the frame, following it.

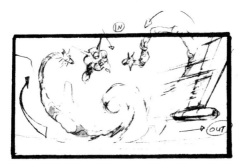

SCENE 2, PANEL 2

the small craft continues O.S. (off screen) while its missiles zero in on their target: the giant robot.

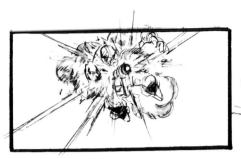

SCENE 2, PANEL 3
A direct hit! The robot takes a powerful blow.

SCENE 2, PANEL 4
has the robot crashing to the ground and exploding.

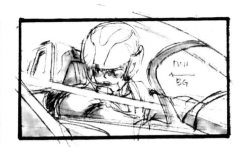

SCENE 3, PANEL 1
shows the pilot in the small craft glancing over his shoulder in reaction to the blast of light from the explosion. The background pans (meaning it moves behind him from right to left, making it appear that his ship is moving from left to right).

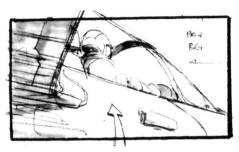

SCENE 3, PANEL 2
has the little ship moving away from us at an angle. The background pans.

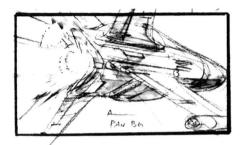

SCENE 3, PANEL 3
shows a burst from the rear rockets.

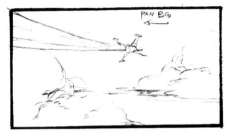

SCENE 3, PANEL 4
is the final shot of the little ship blasting away into the clouds.

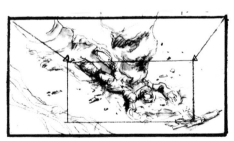

SCENE 4, PANEL 1
has a down shot of the destroyed robot on the planet surface. A "zoom in" is indicated to show the smoldering remains.

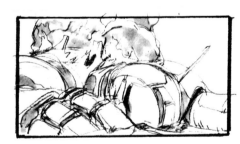

SCENE 5, PANEL 1
is a close-up on the back of the robot's burning head. He's done and finished.

SCENE 5, PANEL 2
a pilot opens the hatch from inside the robot and climbs out.

SCENE 6, PANEL 1
the pilot begins to remove the helmet.

SCENE 6, PANEL 2
reveals that the pilot is a pretty girl.

SCENE 6, PANEL 3
finishes with a smile of accomplishment across her lips.

BACKGROUNDS

There are a few common settings in anime, especially pastoral and urban scenes.

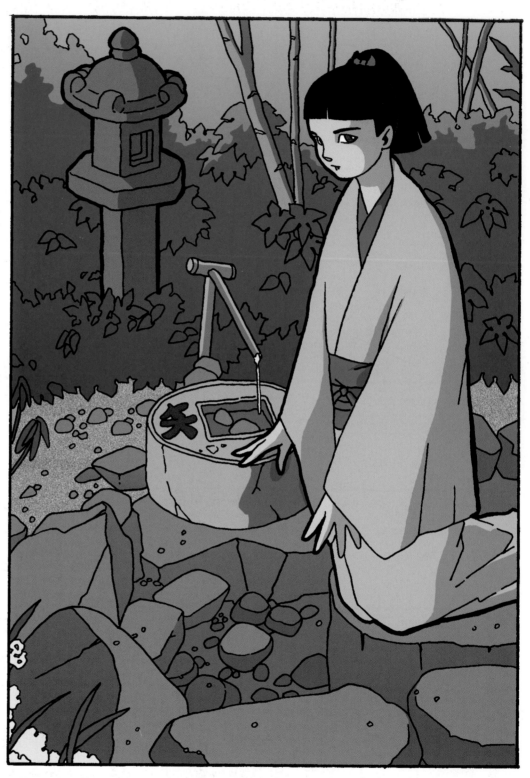

PASTORAL

Pastoral scenes are festooned with flowers and foliage. They're gorgeous, but a nightmare for anyone with allergies. These settings are, in a way, fantasy scenes that substitute nature for the supernatural. Calmness and serenity prevail. There are no sharp angles. All of the shapes are organic. It's a perfectly balanced combination of humans at harmony with nature—rock gardens, outdoor sculptures, water, trees, flowers, and so forth. Enchanting creatures sometimes also abound.

URBAN

Skyscrapers, high-rise buildings, windows, billboards, paved streets, sidewalks, crowded storefronts, cars, and buses are typical of city scenes. The tall buildings crowd out much of the skyline, unless the scene is drawn at a distance. Urban landscapes are, by definition, built on geometric forms with angles and straight lines. Note that the angled lines of the buildings converge as they recede into the distance (see pages 64–65).

In this picture, the father and son are in the foreground, the large billboard occupies the middle ground, and the flat office buildings make up the background.

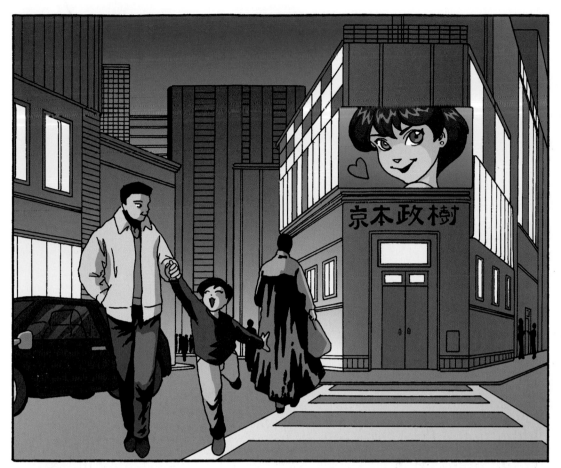

PASTORAL

The countryside by the rice paddies is a popular location in anime. It establishes the canvas for themes stressing traditional attire, manual labor, familial ties, nature and animals, small-town life, and the yearning for something better in a faraway city.

To give the illusion of depth, backgrounds generally focus on three layers: foreground, middle ground, and background. The foreground is often found in the corners of the scene, giving way in the middle ground to the main subject, which in this case is the girls working in the rice fields. The background is the foliage, the sky, and the clouds.

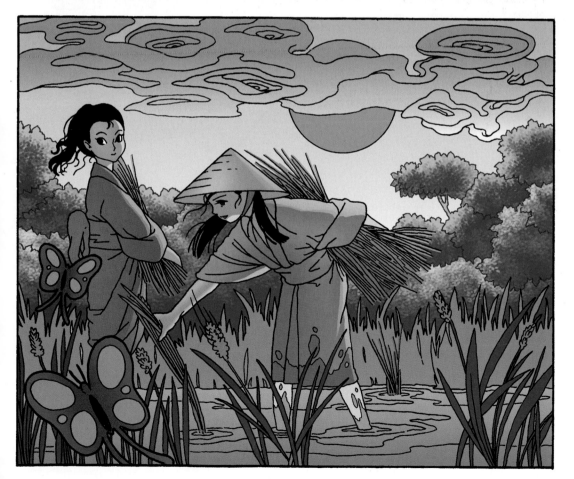

COOL STUFF

Many animation students begin to wonder what a real animation studio looks like and how the world of anime actually functions. So, let's take a quick tour to familiarize ourselves with some of the things one is likely to find in any professional animation studio, and then move on to some conversations with anime industry professionals.

ANIMATION DESK

An animator's desk is funny looking. It's impractical for any use other than animation. For example, it's almost impossible to make a good sandwich on it, although many a brave soul has tried. The large drawing surface is angled and houses a translucent animation disk, through which a light can be shined at various strengths. Animators need to have a light shining under their drawings so that they can see at least three poses at a time, in order to plot out a sequence of actions. The desk has many shelves to file away the sequences on which the animators work.

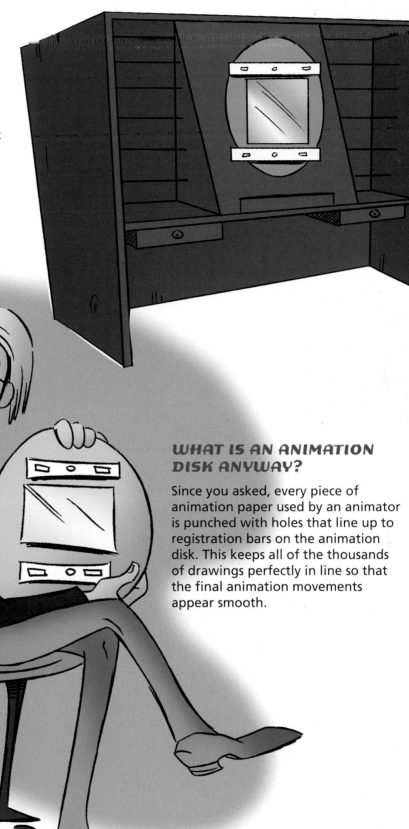

WHAT IS AN ANIMATION DISK ANYWAY?

Since you asked, every piece of animation paper used by an animator is punched with holes that line up to registration bars on the animation disk. This keeps all of the thousands of drawings perfectly in line so that the final animation movements appear smooth.

LIGHT BOX

Character designers and conceptual artists not involved in actual animating per se, but who come up with characters and story ideas, can use light boxes instead of animation disks. (They are also used by manga artists.) They sit on top of drafting tables and are boxes with translucent plastic surfaces through which a light shines and on which the artist places his or her drawing.

FIELD GUIDE

This is a plastic, see-through sheet placed on the registration pegs of the animation disk. It shows animators the boundaries of the frame so that they don't draw in an area that won't appear in the film. The field guide also has certain camera notations that are helpful to animators. The animation paper on which the animators draw goes on top of the field guide.

MIRROR

Animators typically have mirrors on their desks, which they can angle to get a good look at themselves. It's not that they're vain; they sometimes need to see certain expressions in order to draw them. With a mirror on the desk, an animator has a model on call 24 hours a day who doesn't charge a thing!

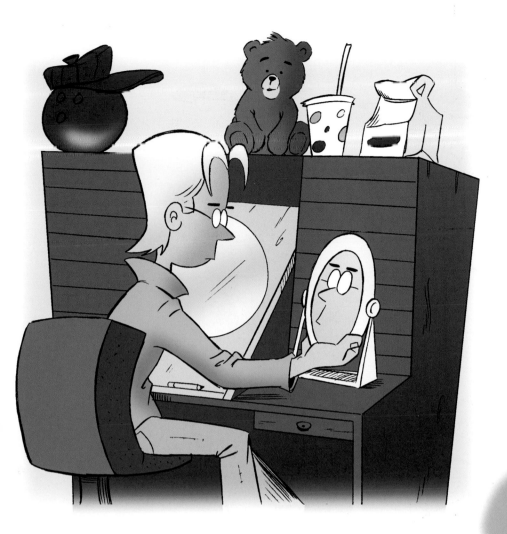

STOPWATCH

Animation is all about timing. Things need to move at convincing speeds. If a character is going to toss a football to a pal 15 yards away, how long will that take? That's what the stopwatch is for. It's used by animators, who literally play-act certain actions, and time them, in order to mimic them accurately when animating.

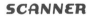

SCANNER

With the right software, the computer scanner can scan in many layers of a scene: foreground, background, and the characters. The scanner also enables the artist to "clean up" original pencil drawings on the computer, eliminating any unnecessary stray lines. It can do almost anything, except make change. For that, you need an upgrade.

ART SCHOOL

Many talented young artists dream of someday turning their love of anime into a profession. But how will they ever become as good as their idols, especially if they live in the West and not in Japan?

As an author and artist, I've been asked many times to comment on the need for aspiring animators to attend art school. Anime is a drawing skill. As with any skill, you can't help but improve if you have the proper training. There is a common, erroneous assumption that art is merely free expression and that it cannot be taught. But have you ever looked at a collection of Leonardo da Vinci's sketch notes? He studied the human skeleton until he knew more than most anatomists today.

Art has been taught methodically for, literally, hundreds of years. It's a skill, just like architecture. And just as with architecture, there are many rules that, when followed, can lead one to draw well. You can try to discover these rules on your own or blaze a new trail, and you can be successful that way, too. However, it's already laid out for you, at your disposal, in art school. A good art school will give you the tools you need to become an anime artist, or any other type of artist/cartoonist.

First-year art students can be surprised at how much work art school is. I still remember my first day of art school. Everyone in class was joking around. In walked a quiet gentleman who said nothing. He ambled up to the drawing

board and started to draw a diagram of the human figure. We didn't even know who this guy was, so we kept talking. About halfway through his drawing, the man turned to us and said, "Why aren't you taking this down?" Well, I don't recall whether he said anything else the rest of the day, though I doubt it, but I do remember scurrying to copy his endless stream of diagrams.

Of course, things get easier as you learn and get acclimated to your surroundings. And not every professor is so laconic. Eventually, you'll be joking and yucking it up with them, too. Those students who are dedicated have nothing to fear, but if you think art school is going to be an easy stroll through college, better fasten your seatbelt.

A good art school needs to offer the basics—and a good amount of them. The difference between an art school and the art department at a liberal arts college is that while a liberal arts college art department might only offer two courses on life drawing, an art school may offer seven. Which student, upon graduation, will be better equipped to draw the human figure?

LIFE DRAWING

Life drawing is the basis of all art, and the instructors will work side by side with you, drawing over your drawings, showing you where you zigged when you should have zagged. It's amazing and humbling to watch them work. If you keep at it, pretty soon you may find yourself amazed at the improvement in your own work, too.

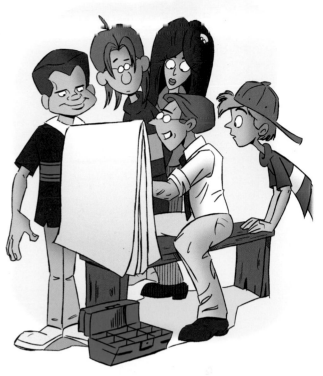

PERSPECTIVE, COLOR, DESIGN, ETC.

Perspective, color, and design are also essential. Art schools that lean toward animation as a specialty may also offer courses in character design, layout, rendering, animation, and computer animating. Art schools that offer live-action film courses are also worth serious consideration, as live-action film courses (as well as film history courses) will help you to develop a cinematic eye.

NETWORKING

It's positively mystifying out there as a young artist. You wonder how in the world you're ever going to find your career path. If you were to become a doctor or a lawyer, the signposts along the way are pretty clear. However, you can't pick up a newspaper, peel open the classifieds, and find an ad reading: Anime Artist Wanted.

Art schools are noted for being very involved in helping their students find work. Many have counselors to help answer questions. In many cases, your teachers will be working professionals, instead of professional teachers. In addition, local businesses scout undergraduate talent from art schools for freelance work, which will help you to gain experience, make some spending money, and build a portfolio—which you'll need upon graduating. Many corporations, including behemoth media giants from Hollywood, send recruiters to art schools. But what really counts is that you'll find yourself surrounded by your peers, who will, in turn, end up being your professional colleagues and contacts in the real world.

WHEN WEST MEETS EAST
THE RULES OF THE ROAD FOR WORKING AS AN ANIME ARTIST IN JAPAN

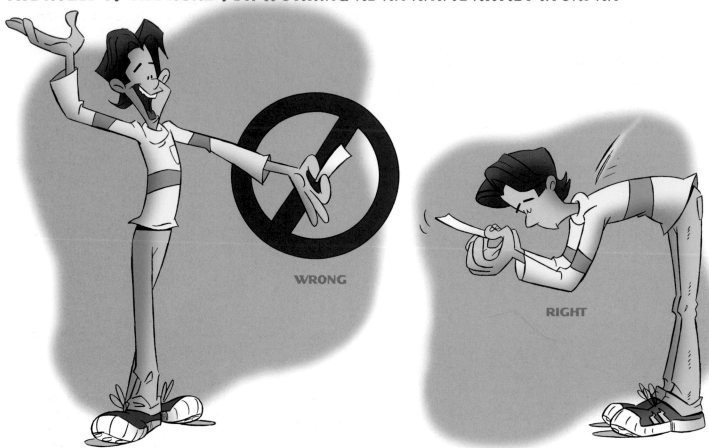

WRONG

RIGHT

When my first book on Japanese comic book art *(Manga Mania: How to Draw Japanese Comics)* came out, I received many responses from people who enjoyed the section explaining basic Japanese terms one might use when visiting Japan. However, some anime devotees dream of going further, working for an anime studio in Japan; or they're at least curious to know what it would be like. This means integrating oneself into the fabric of Japanese society, both socially and professionally. Hiromi Hasegawa is the international relations manager at a prominent Japanese animation studio. Here, she explains, exclusively, how interpersonal relationships function both on a social and professional level inside a typical Japanese anime studio, explaining the acceptable Japanese ways of behaving in various situations.

Greeting Someone You're Meeting for the First Time
Hiromi Hasegawa: Say *Hajime Mashite . . . desu* [How do you do? My name is . . .] and maybe *Yoroshiku onegai shimasu* [I will be owing much to you] with a bow. If you have a *meishi* [business card], present it using both hands and with a bow. Say your name and the latter phrase above—it's a very handy phrase actually—when you hand it. For example: *Hasegawa desu Yoroshiku onegai shimasu.*

If the other person is also holding a *meishi* for you to take, hold your *meishi* with your right hand and receive the other person's *meishi* with your left hand at the same time with a bow. Always with a bow. But be advised that you don't have to be nervous. Just be friendly. A smile will always do.

Entering Someone's House
HH: Say *Ojama shimasu* [Please excuse my intrusion]. Normally, you take off your shoes. Don't open closed doors unless you ask first if it's okay to see. They may be closed for a reason.

Bringing a Gift When Invited to Dinner
HH: Hold out the gift with two hands and say *Dozo* [Please] at the entrance, or when you're shown into the dining room. Maybe adding *Kyowa domo arigato gozaimasu* [Thank you for inviting me today].

Paying a compliment:
Subarashii (desu) = (It's) Wonderful

Sugoi (desu) = (It's) Amazing

Omisore shima shita! = I'm not worthy! (half-jokingly)

Receiving a compliment:

Le ie, son na = No, no, not at all (shake your head both ways)

Arigato gozaimasu = Thank you very much (say with a bow)

Kyoshuku desu = I deeply appreciate it (to show a bit of modesty, you can scratch or stroke the back of your head with a bit of bowing—that's the gesture for shyness or embarrassment)

Workplace Attire (Dress Clothes)

HH: Suits and ties are not mandatory, but it's advised to wear comfortable but clean looking clothes. Jeans are normally okay, depending on the situation and occasion. T-shirts and shorts are not really advisable unless it is really hot outside. However, animation studios are normally very lax, so you can pretty much wear anything you want. But no pajamas, please.

Addressing Your Superiors at Work: How Formal or Informal Should You Be?

HH: Addressing with -*san* [Mr./Mrs./Ms.] will normally suffice. But, normally, use the surname not the first name, unless you're really close to that person. At some workplaces, you address the person with their title, such as *Murahama-shacho* [President Murahama] or just *Shacho*.

Applying for a Job: What Questions Can You Ask about Salary and Perks Without Being Thought of as Aggressive?

HH: You can certainly ask if it's *jikyu-sei* [paid-by-the-hour system] or *dekidaka-sei* [payment-at-piece rates]. But ask these questions after you hear the description of the work first. To ask about *yu-kyu* [paid holidays] and *bo-nasu* [bonus], say . . . *wa donna guai desho ka?* [What is the situation with. . . ?]. A more direct way of asking is . . . *wa arimasuka?* [Do I get. . . ?]

It's a tricky business, asking those questions, because you don't want to sound too aggressive. However, the industry is pretty severe salary- and working conditionwise, to be honest. So it's important to ask those questions and know what you will be getting and on what conditions before you take the job. Otherwise, you'll end up working like a dog and sleeping like a log.

Asking for a Promotion or Raise at Work

HH: You might want to wait at least a few months (possibly half a year) before you start asking for a promotion or salary raise. But it also depends on your contract, too. If it's a three-month contract, you can ask toward the end of the contracted period. Do your best to show what you are capable of during those months. Also, since animation is a result of intense teamwork, your "teamworkman-ship" is also valued. Try to get along with your colleagues. (See the hints below.)

Handling Office Gossip

HH: If somebody tells you gossip, listen to it with nods, but try to make no comments on whatever you hear, let alone spread it around the office. It's always better to keep your stand neutral (by not expressing your opinion strongly), especially when you're in a foreign country. Sorry to sound rude, but Americans are usually considered to be strongly opinionated, and Japanese people feel intimidated if the opinion is strongly and flatly expressed.

Some useful neutral-sounding phrases are:

So desu ka? = Is that so?

Naruhodo = I see

Muzuka shii desu ne = That's a difficult situation to handle

Nantomoienai desu ne = I don't know what to say

But if you want to give advice or comments, try to put it in a very soft way:

Shita hou ga iikamo = It might be better to . . .

Sonna ni shinpai shinai de = Please don't worry too much

Kitto daijobu deso yo = It's probably going to be all right after all

Asking for a Date

HH: Normally, people won't ask you directly for a date in Japan. People usually go out in groups for dinner. So, try to join the group that your sweetheart is in. Sit close and chat. When you think you're getting a good feeling back, ask for her or his cell phone number or email address. That's where you start:

Keitai bango/email adoresu oshiete kuremasuka? = Can I have your cell phone number/Email address?

Issho noshokuji/eiga ni demo ikimasen ka? = Do you want to go out for dinner/a movie or something?

Kanojo/Kareshi wa iru? = Do you have a boyfriend/girlfriend?

Mattemo ii? = Can I be one?

AN AMERICAN DIRECTOR IN JAPAN:
AN INTERVIEW WITH SCOTT FRAZIER

Scott Frazier is a sought-after guest speaker at anime cons (conventions). He has the distinction of being one of a handful of American-born animation directors who has worked successfully overseas in Japan. He has directed *Susie-chan & Marvy* and *Quo Vadis 2,* and has worked on the productions of *Hoshi Neko Full House, Shurato, Bubblegum Crash,* and many others. Here, in this exclusive interview, he relates his experiences as an American director working in Japan.

Christopher Hart: How did you make the leap from being an American-born animation director to directing animation in Japan—and speaking fluent Japanese?
Scott Frazier: I developed a great interest in anime, and in 1987 there was no work going on in the United States that I was interested in, so I felt that the only way I could work on something really interesting was to move to Japan and work in the anime industry. I went to a language school and an animation school, then started

working at various jobs around the industry until I managed to get enough experience to start doing what I wanted to do—direct.

The language is a never-ending learning process, just as any language is. It's very important to use it everyday on the street and on the job in order to become fluent.

CH: Was it difficult to gain the trust of your Japanese colleagues? After all, you were an outsider working in their art form.

SF: It was very difficult. The Japanese are totally uninterested in having a foreigner work in an anime style, as they have an entire country full of people who can already do that. In order to get somewhere, an artist has to work in an original style—which can be anime influenced—that is unique so that [the Japanese anime companies] can't get it from somewhere else. Anime companies look for originality more than the ability to work in a specific style.

The different ideas that I can bring to a project, ideas that nobody else has, are what make [Japanese anime companies] interested in working with me.

CH: Does a typical animator in Japan have as much artistic freedom as his or her counterpart in the United States?
SF: It varies by company and project and director. I would say that they are pretty much equal in terms of freedom. The amount of freedom a Japanese director has tends to be significantly more than an American director, though. The Japanese director has absolute control over every aspect and can even modify the script—change whatever he feels like—and is guaranteed final cut.

CH: Are anime artists in Japan freelancers, or is there a studio system in which each artist works for a large company for most of his or her career? Do they have agents, the way that some animators in the States do?
SF: Most key animators, directors, and character designers in Japan are freelancers, but they tend to stay with one or two companies if they can. Inbetweeners [the most junior assistant animator], background painters, and other workers tend to be studio employees. There are no agents, all jobs being handled through personal connections.

CH: Animation has always played second fiddle to live-action film in the West. Are the big animation directors in Japan as famous as the live-action directors there?
SF: Some of the greatest directors— Miyazaki, Otomo, and Oshii, for example—are known by many people. Miyazaki, particularly, is very famous, being seen as one of Japan's greatest filmmakers —and rightly so.

CH: What anime would you recommend every aspiring anime artist see in order to be well-rounded and informed?
SF: All of Miyazaki's movies. Otomo's *Akira*. The *Patlabor* movies.

CH: What are some of the cultural differences of working as an artist in Japan versus working as an artist in the United States? Is it difficult to know when to speak out with your creative differences?

SF: Artists in the United States tend to have more ability to speak out and argue points. Japanese artists follow the rules they are given to the best of their abilities.

CH: What is it that pulled you away from traditional animation and drew you toward anime?
SF: I saw more experimentation and dramatic storytelling in anime than in American animation, and I was interested in that. I wanted to make films, not just cartoons, and anime was the only place they were doing that in animation, which is a medium I prefer.

CH: What are the most common questions you are asked at anime conventions, and can you briefly answer some of them here for the benefit of my readers, who may not have the opportunity to travel to see you?
SF: "How can I get a job in the anime industry?" The most important things to keep in mind are that if you want to create something of your own, and most artists do, it doesn't matter where you are or what style you work in: You have to keep at it and it will happen. It's no easier to create an animated show in Japan than in the United States or Europe or anywhere else. Take the knowledge in this book and apply it to your own ideas and develop your own style. Everybody has to start somewhere!

A JAPANESE DIRECTOR IN JAPAN:
AN INTERVIEW WITH MAHIRO MEADA

Mahiro Meada is a renowned Japanese animation director who has graciously agreed to share his inside knowledge of the anime industry. Meada directed *Final Fantasy: Unlimited* and other shows. Before becoming a director, he worked in many important capacities in anime, including as a storyboard artist, key animator, and layout artist. He has worked on such classic titles as *Macross the Movie: Do You Remember Love?*, *Nadia of Mysterious Seas,* and *Wings of Honneamise.*

Christopher Hart: Many artists begin to draw when they're quite young while others accidentally discover their talents at a slightly older age. How old were you when you discovered your talent for drawing?

Mahiro Meada: I loved to doodle since my early childhood. When I was in elementary school, I used to do mimicry of manga on my school notebook and show it around to my classmates. Also, I was fascinated by the animated shows that were on television weekly. Once I learned that the basic principle is exactly the same as riffling through a stack of still pictures, I tested myself using the edges of the notebook and textbook pages. I wondered, How can I draw to make the characters move so lively? That was just child's play and also for my amusement. By the time I was in high school, I realized that such an aspect marked one of my important talents. I became aware of the fact that I wanted to be able to draw pictures that anyone could appreciate.

CH: How did you become a successful anime director? Did you go to art school, and did you study film and animation? What was your first job in anime?

MM: I started to wish strongly to entertain people with the imaginations and fantasies that I always had. In order to do that, I thought animation was the best medium in which I could express my talent. To realize my dream, I wanted to become a director. However, since I was living in the countryside, I didn't have anyone to ask for advise. I didn't know how I could work in the anime industry, but there were two things that were clear to me at that time: (1) The studios producing commercial animation were mostly gathered in Tokyo, and (2) I loved to draw but [worked] only in self-taught style, so I never had a proper basic training.

So, I decided to study at an art university in Tokyo. I majored in film, but I was not a very good student. However, one thing that I learned at the university was that I could get in touch with various kinds of genres beside animation, such as live-action movies and photography, paintings and sculpture, theatrical productions,

and artistic performances, and so on. Also, a lot of people I met—my friends and teachers—broadened my view.

My first job in anime was *Super Defense Fortress Macross* (the first television series), and I was working part time.

CH: What directors and films have been the greatest influences on you and your work?

MM: It's a difficult question. There are many directors and titles that I admire so it's difficult for me to choose. Sergei Eisenstein's *Ivan the Terrible* (1943, 1944, 1946), Fritz Lang's *Metropolis* (1927), Werner Herzog's *Aguirre: The Wrath of God* (1972), Masaki Kobayashi's *Harakiri* (1962) and *Kwaidan* (1964), Richard Fleischer's *Fantastic Voyage* (1966), Ridley Scott's *Alien* (1979) and *Blade Runner* (1982).

CH: As a director, do you still draw, or do you conduct yourself more in the position of overseeing other departments?

MM: I oversee each division and make judgments on all kinds of things. The decisions I make range from what will actually be shown on screen to sound effects, logo designs, and designs for publicity. I also draw myself (since my career began as an animator). When I give instructions as a director, I believe it is most effective to make the corrections myself, directly, by drawing.

CH: In the West, animation is thought of almost exclusively as a kid's product.
MM: Why is it? I sometimes wonder, too, since comic books and animated movies are all originally from the West. I believe what is important to consider here is the history of manga in Japan. The development of early manga is very similar to that of movie development. Or rather, manga and movies were taken as a new form of entertainment with an edge. The tradition of adults enjoying and appreciating entertainment was remixed together and reborn. (During the Edo period, under the rule of a long-stable government, urban city culture and the maturity of popular culture has formed and supported the base for this development.)

First, the camera frame (angle) of manga was fixed. It was like an early stage of cinema, filming an entire theatrical production from a fixed point of view. Gradually, more flexible camera angles were integrated, making it possible to have various emotional expressions and sophisticated themes.

Variations of manga developed —such as (graphically emphasized) *gekiga* with more complex scenarios and themes geared for adult readership, and *shojo* (girls) manga with literary sophistication. Japanese manga matured as an entertainment genre that is acceptable for adults to read. And that brought down the defiance for animation—that is, to enjoy a tale accompanied by illustrations— indicating that it is not just something for kids but for adult

enjoyment, as well.

Yet another big movement is the contribution of television. The animation programs for television —a newly arising media—have always been (and still are currently, too) incredibly tightly scheduled. And unbelievably low budgeted. How is it possible to create good titles under those restrictions? Those who have worked on early television shows were the ones who dropped out from the movie industry's strict system but were young and highly motivated.

In the new energetic media's spirit of freedom, enterprising (in a sense, experimental) anime projects and trials were brought out on television—something that would be inconceivable nowadays. And those titles were engraved on people and children's hearts, and unknowingly changed people's awareness of animation's potentials. Thus, between this fortunate crossing over between manga and cinema was born the Japanese anime, I believe. When different cultures mix together, there is a great chance of some-thing completely new being born.

CH: Many of the people reading this book will be dreaming of someday visiting Japan and, perhaps, someday working in anime. What would your advice be to them?
MM: As I've mentioned previously, many of the animation studios are in Tokyo. Tokyo is an interesting city but might not be a very comfortable place to live. So I think the big question is whether you can get accustomed to living in Tokyo. Also, compared to the price level, salaries for animators, in reality, are unjustifiably low. So the less experience you have in anime, the more (financial and other) difficulties you may encounter.

With this in mind, if you still have the eagerness and vigor to create animation, you will be welcomed. There may be some language problems, but generally speaking, the people here are friendly.

CH: What new directions would you like to see anime take in the future? What possibilities and challenges that are on the horizon—technical or otherwise— are of special interest to you?
MM: It's a very difficult question. A whole lot of problems are piling up. We are in a chaotic stage, unable to tell in which direction we should head. Above everything, the financial problem is the biggest. This problem has always been around and there is no ideal solution. But I feel the current situation is still too wrong. We need a proper business model to overcome the current obstacles of evershrinking budgets and projects that no longer take risks of exploring new ideas and possibilities. Production studios also have to be sensitive to the needs of the market. We need to draw in more funds to revitalize the production line.

However, one thing that should be noted is the undeniable fact that the originality of our projects stems from our adaptability to a low budget, efficiency of a small staff, and the momentum arising from the short production periods given to us.

As for the subject matter, I personally have so many projects I would like to work on. However, from an objective point of view, the whole anime industry is in a blind alley of "dinosaur evolution." More complex stories, detailed screens, repeated motifs, titles of higher and higher quality are produced/ released. On the other hand, these titles are targeted for particular groups of fans. We need more solid story lines that can be understood and loved by more people.

I would like to add stronger frameworks to Japanese anime's already-existing characteristics and maniac elements. I believe this will be more appealing as a product for the international market. Originality and universality, combining these seemingly contradicting elements is what is needed now.